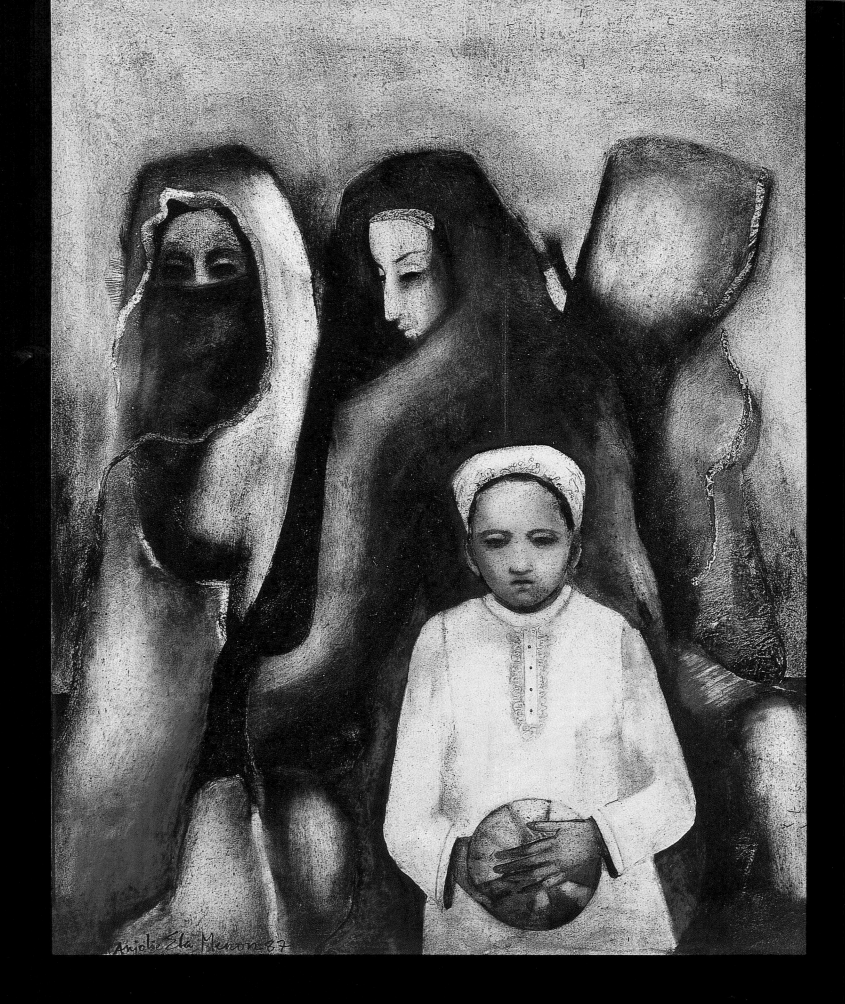

expressions & evocations

Contemporary Women Artists of India

 marg publications

expressions &evocations

Contemporary Women Artists of India

Edited by Gayatri Sinha

Jehangir Nicholson has extended generous financial support
to this publication in keeping with his commitment
to promoting and preserving contemporary art in India

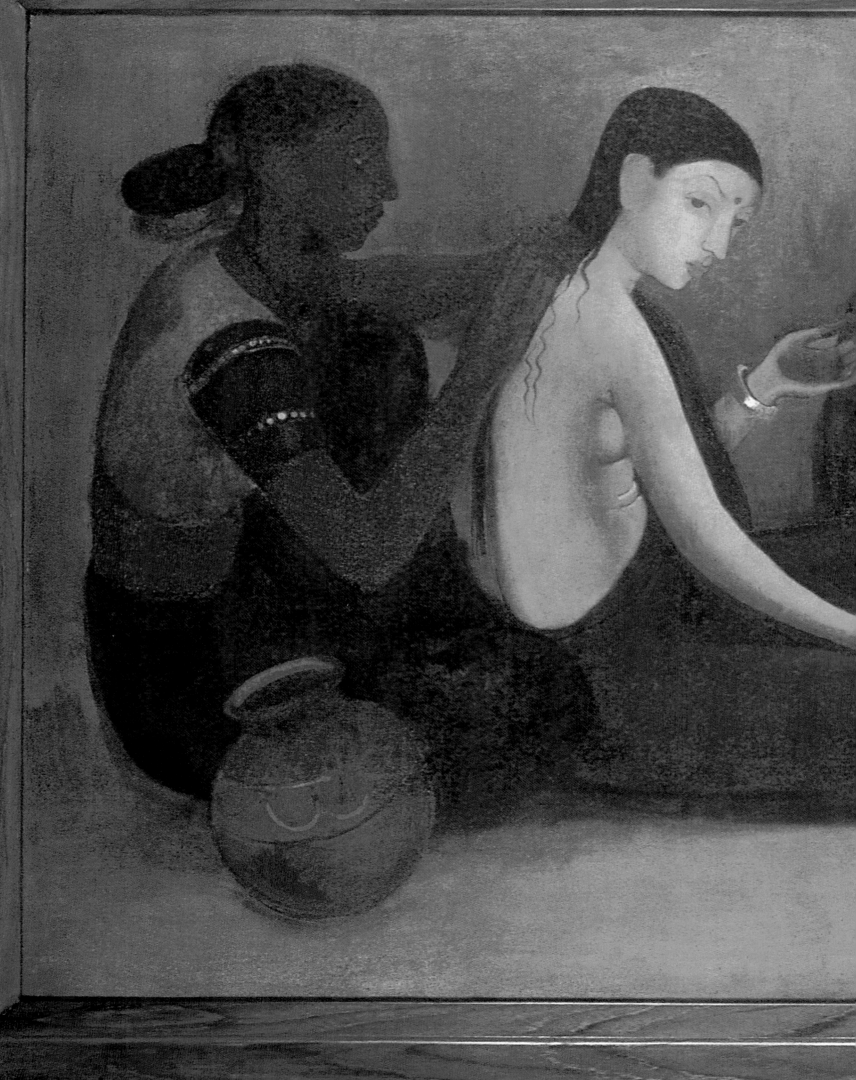

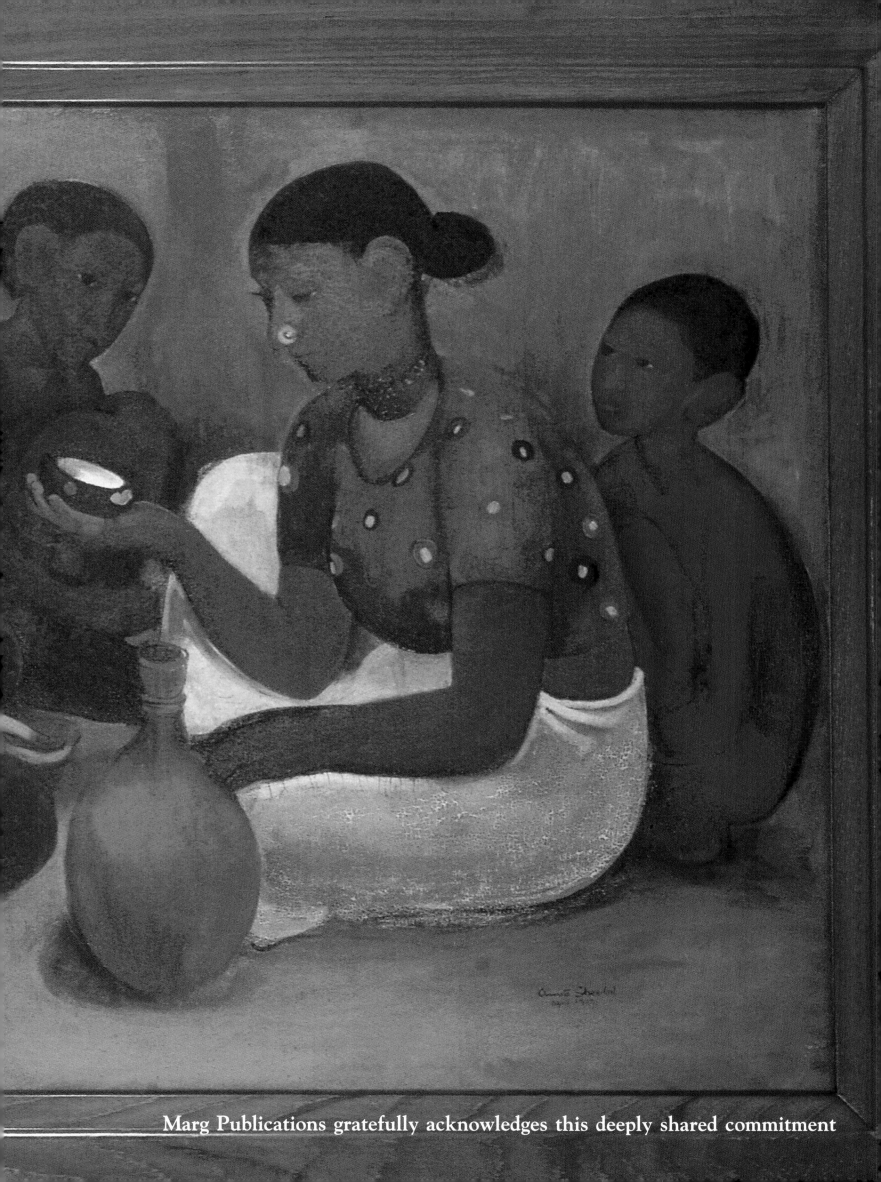

Marg Publications gratefully acknowledges this deeply shared commitment

General Editor
PRATAPADITYA PAL

Senior Editorial Executives
SAVITA CHANDIRAMANI
RIVKA ISRAEL

Editorial Executives
ARNAVAZ K. BHANSALI
L. K. MEHTA

Copy Editor (Consultant)
MEHER MARFATIA

Design and Production Assistants
GAUTAM V. JADHAV
VIDYADHAR R. SAWANT

Executive Manager - Finance
K. P. S. NAMBIAR

Design Editor
SUBRATA BHOWMICK

Price: Rs. 1750.00 / US$ 59.00

Copyright Marg Publications, 1996.

ISBN: 81-85026-34-3

Library of Congress Catalog Card Number: 96-900303

Published by J.J. Bhabha for Marg Publications
on behalf of the National Centre for the Performing Arts
at 24, Homi Mody Street, Mumbai 400 001.

Colour processing by Khurshed Poonawala
at Comart Lithographers Limited, Mumbai 400 025.

Black and white processing by
Tata Donnelley Limited, Mumbai 400 025.

Printed by A. S. Vadiwala at
Tata Donnelley Limited, Mumbai 400 025, India.

Illustrations on previous pages

Page 1
Mothers by Anjolie Ela Menon. 1987.
Oil on masonite; 120 x 90 centimetres.
Private collection.

Pages 2-3
Composition by Anupam Sud. 1972.
Etching; 49 x 91 centimetres.

Pages 4-5
Bride's Toilet by Amrita Sher-Gil. 1937.
Oil on canvas; 86 x 144.50 centimetres.
Collection of National Gallery of
Modern Art, New Delhi.
Photograph: Sunny.

Contents

ARPITA SINGH

Anjolie Ela Menon

माधवी.96

Amrita

नीलिमा

Sayed

L. Malani.

Latika Katt

Navjot

Arpana

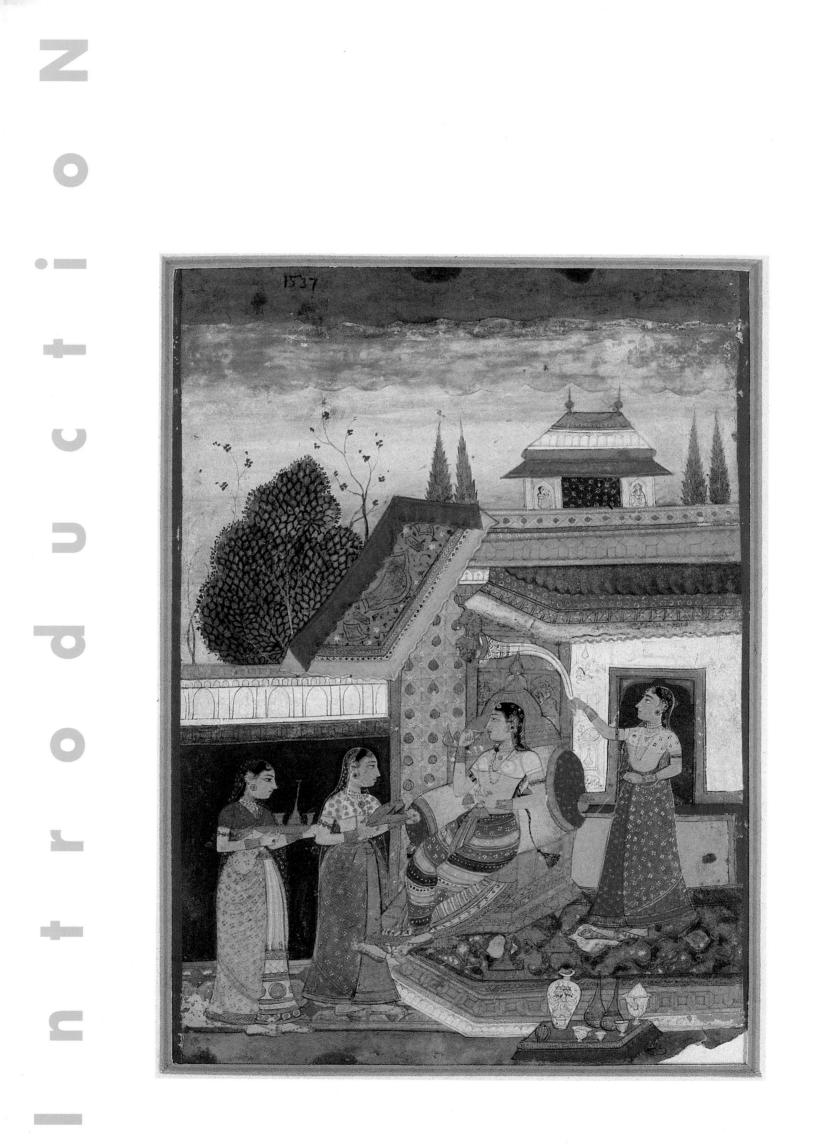

Gayatri Sinha

Any study of Indian women artists has to face some compelling questions that arise in feminist art historical discourse. How valid is a listing based on gender alone, covering just six decades of Indian art history? Gender as the primary condition dominates other considerations of language, style, or school. Again, although most of the artists within this volume did much of their significant work from the 1970s onwards — the watershed decade for feminism in India as in the West — much of their art is not consciously feminist, nor does it reflect uniform thematic and ideological concerns.

The woman as artist has antecedents in Indian art that are frequently touted but historically chequered and do not afford a continuous well-documented tradition. The Mughal period painting (*circa* 1760) at Bharat Kala Bhavan, Varanasi, of a woman artist painting a group confirms what writers and commentators have described as painting being one of the accomplishments of well-born women. Vatsyayana in the *Kama Sutra* (second century AD) describes among a woman's sixty-four artistic accomplishments, writing and drawing, tattooing, fixing stained glass on the floor, picture making, trimming and decorating, carpentry, architecture, and making figures and images in clay. In Kalidasa's *Abhijnanasakuntalam,* the women of the king's palace amuse themselves with painting, and references to women and the arts abound in Sanskrit literature.

However, outside the domestic sphere, in the village household in which women enjoy pride of place in the artisanal framework, it is not known if women were part of the organizational structure of temple building, stone sculpture, mural painting, or the metal casting ateliers. The generous support of women to early

Buddhist art and the outstanding historical examples of Sembiyan Mahadevi of the Chola period, or the Mughal queens Nur Jahan and Jahanara, is of woman as patron, rather than practitioner of the arts, although we have shadowy knowledge of women painters in the Mughal age. Unlike Western women artists of the seventeenth, eighteenth, and nineteenth centuries, there is no documented tradition of Indian women artists before the twentieth century. We have very little by way of names, faces, and histories. Consequently, when women artists in India do announce their presence with Amrita Sher-Gil in the 1920s they avoid the pitfalls of their sisters in the West who, as artists competing in a male-dominated sphere, were relegated to the domain of the decorative, precious, sentimental, miniature, and other decidedly "feminine" traits, which served to divide active, virile male participation from the limited, circumscribed female one in art.

Women artists, especially in their interpretation and depiction of women, work against the erected edifice of woman as subject in Indian art. Bharata's *Natyashastra* classified women in the categories of *devi, nayika, ganika* (goddess, heroine, courtesan), which were well entrenched in art (figure 1). This stereotype may have been remodelled with the onset of colonial education in the 1850s but it is notable that not until Amrita Sher-Gil was there an attempt to alter the image of the *nayika* or the conventional method of presenting women. Even her illustrious forbear Raja Ravi Varma, who distanced himself from the classical modes of representation of the Shilpashastras, as interpreted by one or other school of painting or sculpture, and adopted instead more Westernized models, actually painted well within the defined framework of the idealized woman as *nayika* and *devi*, as located within the selective confines of a high-born patriarchy. Although Ravi Varma is today classified as a modern artist, he did not really break with established ways of seeing; on the contrary his art was the art of affirmation of a halcyon Hindu ideal.

Amrita Sher-Gil's most recurrent image was the woman — the enduring muse of classical Indian art. Her blend of Western and Indian models, the French school training, and the

1

A Lady Taking Pan.
Rajput school.
Eighteenth century.

Tempera on paper;
22.30 x 15.50 centimetres.
Collection of the National
Gallery of Modern Art,
New Delhi. Photograph: Sunny.

An example of the Padmini *nayika*, the one most favoured in Indian poetic convention, who is lotus-like, beautiful, and modest, and who has close associations with the Vaishnav avatars, Lakshmi and Radha.

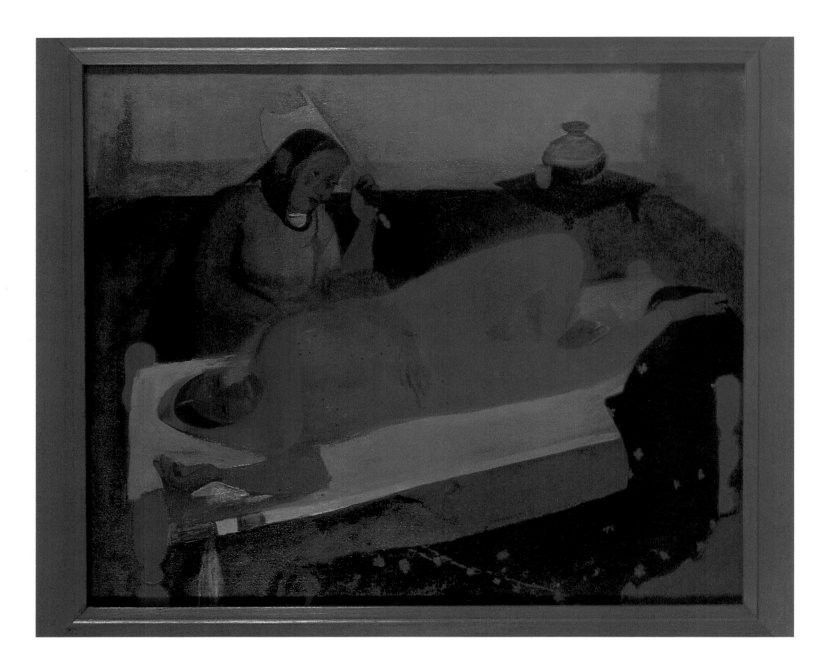

inspiration of Ajanta wall-paintings and Pahari miniatures, create a more eclectic, but decidedly "Indian" image, in which the transition from idealized type to "woman" is pronounced. This is well demonstrated not only in the more obvious features of skin tones, sitting postures, and the khaddar-textured clothing of some of her figures, but also in a few of her paintings, notably *Woman Resting on Charpoy* (1940), (figure 2), in which the inward self-preoccupation of the woman, combined with her open-legged stance, its provocative sexuality, though fully clothed, and heavy, even languorous limbs, breaks with the conventional miniaturist traditions in presenting the *nayika,* the object of possession and desire. The bed and sexuality, as we have seen from the seventeenth-century *Chaurapanchasika* series onwards, have occupied a focal place in the presentation of the

nayika-bhed, but Sher-Gil apparently fractures, in fact subverts convention, even as she uses the same elements. The elegant decorative *takht* or bedstead of miniature painting becomes a strung charpoy, the diaphanous gown-clad Padmini *nayika* becomes a somewhat rustic creature dressed in thick cloth, and instead of waiting despondently or looking beyond the frame in keen anticipation, Amrita's woman is in a deep reverie. Further, the woman in her oeuvre is not recognizably the *devi, nayika, ganika,* or *pativrata* (dutiful wife) of Indian artistic and literary convention, and to this extent the shift to an image that is at once modern, recognizable, and "common" is achieved with electrifying spontaneity.

Sher-Gil's own antecedents among women artists were wives or sisters of British officers, who exhibited at amateur art society exhibitions in Bombay, Madras, and Calcutta, as well as Simla and

2
Woman Resting on Charpoy by Amrita Sher-Gil. 1940.

Oil on canvas;
72.40 x 85 centimetres.
Collection of the National Gallery of Modern Art,
New Delhi. Photograph: Sunny.

Painted a year before Sher-Gil's death, this painting apparently uses the conventional elements of miniature painting with a striking modernism.

3
Portrait of a Lady by Raja Ravi Varma. 1893.

Oil on canvas;
120 x 86.30 centimetres.
Collection of the National Gallery of Modern Art,
New Delhi. Photograph: Sunny.

Ravi Varma's portraits of richly bejewelled women confirmed their status in a high-born patriarchy.

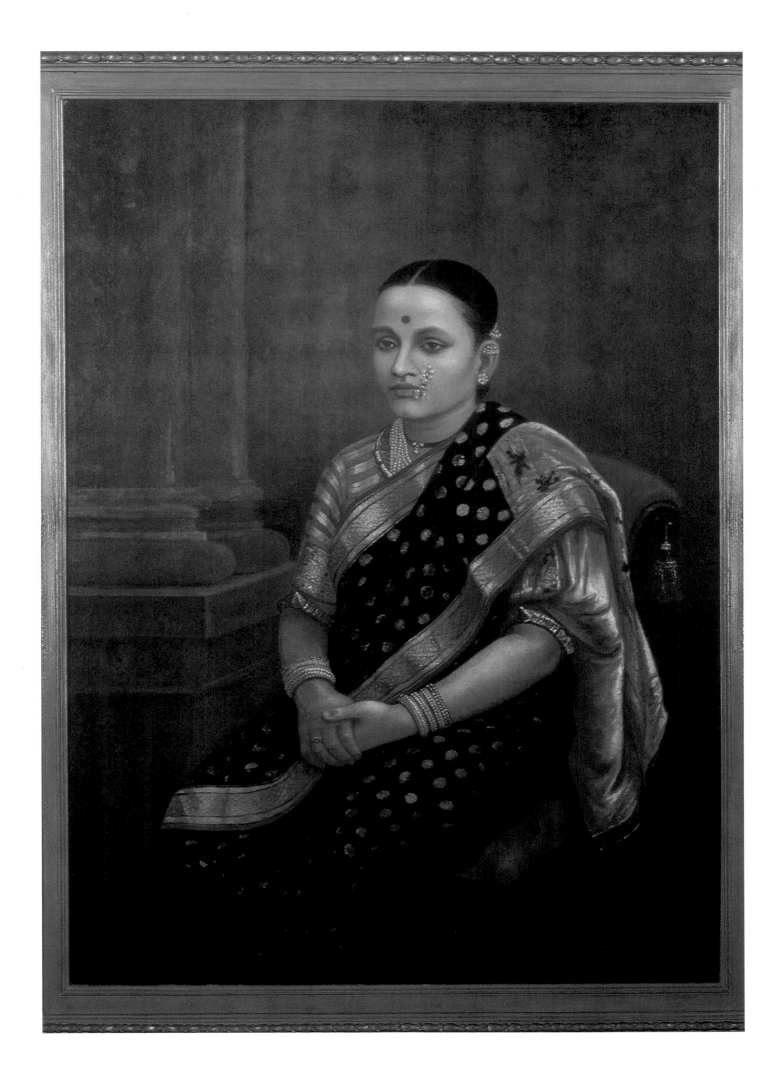

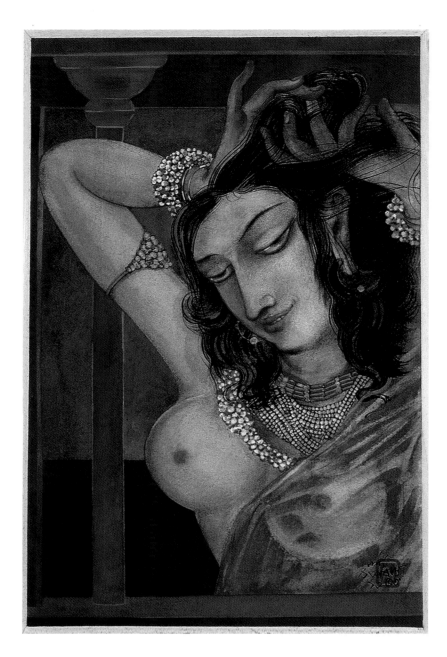

4
Ritu-Samhar by
Nandalal Bose.

Wash and tempera on paper;
33.40 x 21.70 centimetres.
Collection of the National
Gallery of Modern Art,
New Delhi. Photograph: Sunny.

Bose painted the subject of
Kalidasa's poem with its strong
erotic overtones, in a style
inspired by the Ajanta paintings
and the miniature convention.

5
Thorn by N. S. Bendre. 1955.

Oil on board;
168 x 119.30 centimetres.
Collection of the National
Gallery of Modern Art,
New Delhi. Photograph: Sunny.

The figure pulling the thorn from
her foot draws on a
conventional image, used in
Mathura sculptures, the
Khajuraho reliefs, and in the
painting *Shakuntala* by Raja
Ravi Varma.

Poona, from the mid-1860s onwards. Parsi women from Bombay followed their initiative and a few of them were students of Raja Ravi Varma. At the Calcutta Art Exhibition of 1879, the presence of women could not be ignored. According to Partha Mitter, "The most remarkable feature of the show was the presence of twenty-five women artists, most of them Bengali and married."[1] Art tutors who taught women in the privacy of their homes were also fashionable at the turn of the century. However, the larger mantle of Western art education brought with it its own residue of social attitudes and prejudices, including condescension towards women artists.[2]

Condescending attitudes and the circumscribed role of women in public life cast a long shadow on the lives of nineteenth-century women artists. As a consequence, documentation on early women artists is thin. Mangalabai Tampuratti, like her illustrious

brother Ravi Varma, followed in the family tradition of amateur painting. "Being a woman Mangalabai was not allowed the latitude enjoyed by the two brothers but her portrait of Ravi Varma now in Trivandrum is ample proof of her skill," adds Mitter.[3] Notably, Ravi Varma commissioned the services of Mangalabai to fulfil the important Gaekwad commission of fourteen paintings of works based on Hindu myths. These were tentative early steps, even though women already had a marked, if socially "degraded" presence in music, theatre, and dance, and had begun to enter the area of the infant technological marvel, photography. Zenana photographic studios had opened in the last two decades of the nineteenth century. In 1882, Deen Dayal himself opened a zenana photo studio, run by an Englishwoman.[4]

There was also a strong emotional/moral rhetoric in turn-of-the-century art practice. Through theatre,

film, and even the Western academic painting tradition, the national idol that came to be perpetuated had its own distinct role for women. At Chicago, Raja Ravi Varma was awarded for painting faithfully "high caste ladies",[5] informed of the right morals and acceptable social demeanour (figure 3). Here, Ravi Varma's self-appointed position was to invoke images consonant with a once glorious past. In the creation of a national/cultural stereotype he accorded a key role to the portrayal of feminine attitude and sensibility. That Ravi Varma struggled hard to create feminine images acceptable to the Indian and British ruling elite is evident from the "classical *nayikas*" that he evolved. As Tapati Guha-Thakurta writes, "The representation of women must have posed a critical challenge in the artist's project. The challenge lay in mediating images that were 'western' in conception and 'life like' in appearance, to make them meaningful as 'Indian'

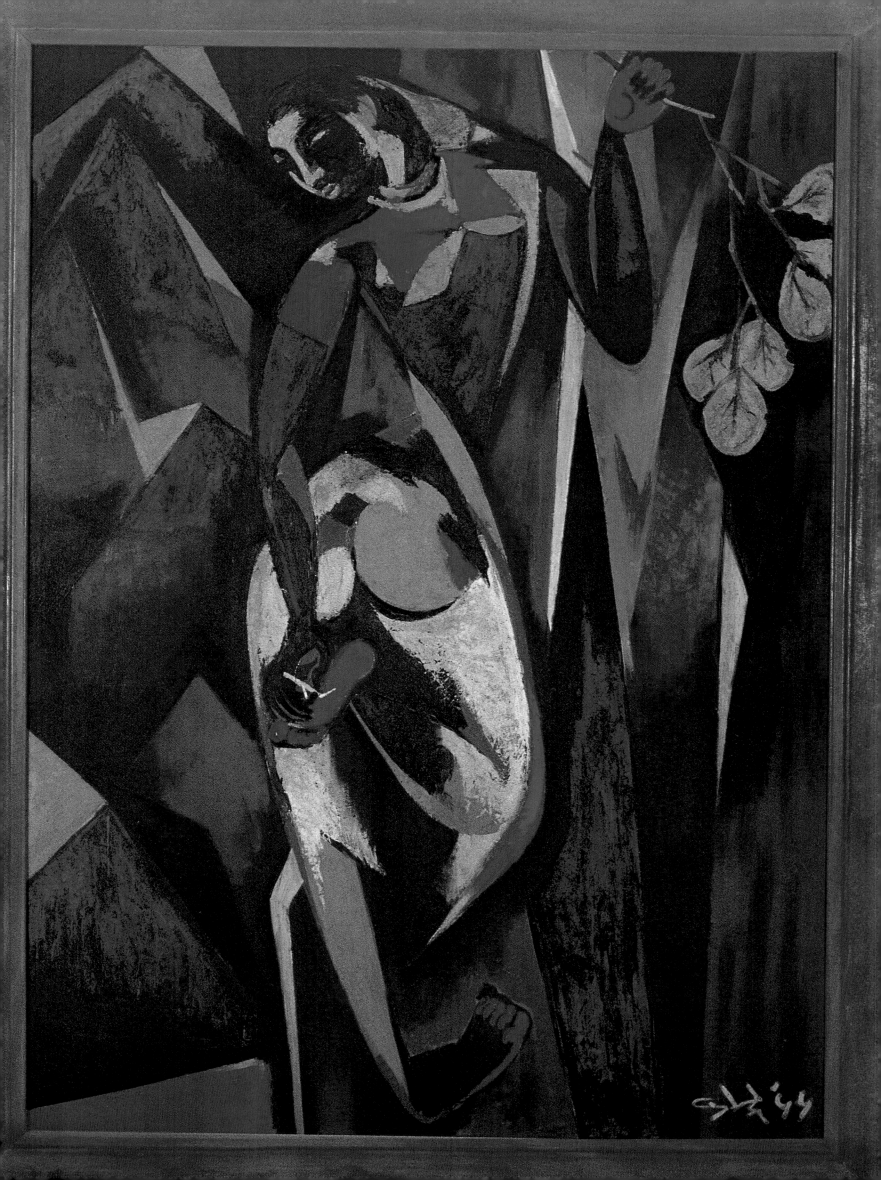

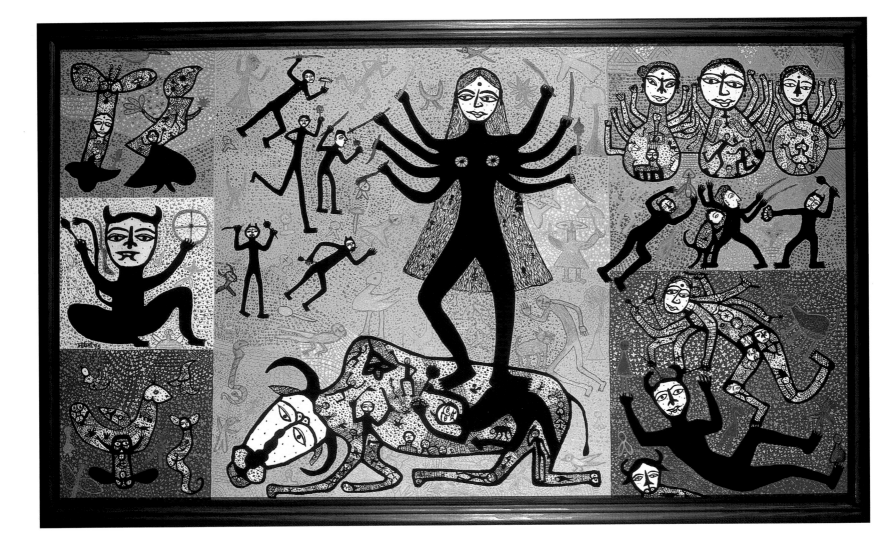

mythic and cultural symbols."[6] The idealization or reinvention of the Mother Goddess figure as Bharat Mata further compounded the representation of woman as the Indian ideal — long suffering, nurturing, unpolluted, even as the winds of violation blew all around her.[7] The image of Mother India, with her poor half-starved children as in the case of Sher-Gil, or ascetic as painted by Abanindranath Tagore, or else surrounded with the symbols of progress: harvested crops, mills, the railways, happy children, as in the calendar art of independent India, reified the modes of representing women.

Yet, even as the image of woman was being idealized, both at the hands of Ravi Varma and the Bengal school, the actual social status of women was being re-examined. Raja Ram Mohun Roy's initiative against the practice of sati and the inheritance rights of women brought women's issues to the forefront in the 1820s and 1830s, as did

Ishwar Chandra Vidyasagar with his campaign for widow remarriage. Towards the end of the century the emancipation of women became one of the planks on which the Congress waged the freedom struggle; a women's section was added to the Indian National Social Conference in 1903, and it held the first Women's Conference in 1909. Widow remarriage, women's education, the evils of dowry, and the purdah system were all vigorously addressed in the political debate of the 1920s, and continued to motivate reform and political action right till the 1950s.

The early twentieth century also witnessed the participation of women in journalism and creative writing, often with strong nationalistic overtones. In 1909, Bhikaji Cama edited the monthly *Bande Mataram,* published from Geneva. During the Quit India movement Aruna Asaf Ali edited the Congress monthly *Inquilab*; in 1938 the All India Women's

Conference published the English paper *Roshni*.[8] In late nineteenth century Bengal there was a flurry of writing and publishing activity, with writers like Pankajini Basu, Priyambada Debi, Nirupama Debi, Dharendra Bala Singh, and the legendary Binodini Dasi among others. Although some women writers published anonymously, they wrote of the travails of widowhood, love, and social pressures and strictures. Cornelia Sorabji (1866-1954), the first woman to graduate from Bombay University, presented another aspect in her opposition to women activists and the Swadeshi movement. Victorian mores were also operative, as seen in the censorship exercised over the publication of the erotic Telugu classic *Radhika Santwanam* in 1911, and the raging controversy which surrounded it for the next three decades.[9]

The rise of women in the fine arts was, even until the 1950s, quite chequered, and frequently informed by the spirit of nationalism of male

6
Goddess by Madhvi Parekh.
1995.

Here, Parekh redefines the
Mahishasuramardini figure,
using the aspect of divine *leela*
to enforce a sense of childlike
play. The figure placements on
either side of the central image
reinforce a convention popular
in Indian art, which is still used
in contemporary calendars.

7
Girl in a Floral Dress by
Arpita Singh. 1985.

Watercolour;
42 x 29.50 centimetres.

Singh evokes feminine elements
and space in the work,
especially in her use of
embroidery-like strokes and a
generous use of floral patterns.

relatives. The Indian Society of Oriental Art, founded
in 1907, held its first exhibition in 1908, but not
until its 1915 exhibition did it present two women
artists, including Sunaini Devi, a member of the
Tagore family. In 1919, Rabindranath Tagore
brought Nandalal Bose to Santiniketan to organize
Kala Bhavan. Soon several women were involved in
teaching at Kala Bhavan: Stella Kramrisch took art
history, Liza Van Pott sculpture, Gouri Devi, the
daughter of Nandalal Bose, design. Early women art
students at Santiniketan included Sucheta Kripalani
and Jaya Appasamy. One of the first art groups to
emerge that proposed a radical break with the
Bengal school, was the Calcutta Group of 1940.
Among its circle was Kamala Das Gupta, the wife of
Prodosh Das Gupta. Though in later years she
actively aided her husband, she was a sculptor in her
own right. Women artists began to participate in
exhibitions both solo and in teams; for instance

Cumi Dallas and Roma Mukherjee, who painted *Penitence of Krishna* for the Calcutta exhibition of 1949.

Despite the apparent thrusts and parries of the women's movement in the political arena, women's art was not aided along a similar trajectory. Notwithstanding Amrita Sher-Gil's privileged social status, as artists women were not consciously cultivated or accorded political or private patronage in the manner of Ravi Varma, Nandalal Bose or, later, M. F. Husain. The transition from painting for private pleasure as a genteel pursuit to one of trained professionalism was not easy, despite the output of artists like Reba Hore, Damayanti Chawla, Shanno Lahiri, and Amina Kar. Some efforts even met with hostility. When the Paris-trained Kamala Roy Chowdhry exhibited her nude drawings in Calcutta in the 1950s a hostile press described her as an invert and a threat to public morals.

On a more fundamental level, the contentious issue of modernism and representation of the feminine continued to dog Indian art. Women artists in the 1950s did not have a uniformly fertile milieu of indigenous modernism on which to draw. The thrust towards indigenism, despite Sher-Gil, the Progressive Artists' Group, and the influence of the School of Paris, continued. In 1948 Barada Ukil wrote, "The future of our national Art-culture will depend not so much on acquiring technical knowledge in art but on the assimilation and application of our history, sociology and philosophy in the works of art of the country which must constitute as the natural background for reorientation of art of our country."[10] Even a decade later, Ukil's words had a prophetic ring. Throughout the mid-1950s and the early 1960s, works on the Radha-Krishna or Shiva-Parvati theme perpetuating the age-old convention of women as bashful *gopini*s and regal queens, both distant and desirable, continued to be both painted and awarded at national fora (figures 4 and 5).

Against the twin encumbrances of a highly codified representation of the feminine in classical and some contemporary art, and the absence of a language to "write" the body, the nascent women's art of the 1950s attains a renewed significance. The early pioneers, as they must be acknowledged, struggled with establishing a means, a methodology, and use of materials. As one of the earliest Indian printmakers, Devayani Krishna prepared her own plates and worked the press especially designed by her husband Kanwal Krishna; when metal surfaces were short she used what was available, even cardboard. Pilloo Pochkhanawala struggled to get the right kind of tensile aluminium alloy, which would express her aspiring forms. Meera Mukherjee plotted tentative progress by living and working with tribal communities, a veritable artistic and anthropological journey, in very trying conditions. As post-colonial artists and women, their gradual quest for a creative linguistics was emblematic of change. The abstracted mystical symbolism of Devayani Krishna, the strong, muscular forms of Meera Mukherjee of women labouring within the Nehruvian definition of progress, mark a discovery of the self, the community, and nationhood. They also mark a sharp break with the inherited feminine prototype of the robust beauties of Ravi Varma and the Western academic tradition on the one hand and the "emaciated spirituality embodied in elongated limbs, drooping heads and bleary eyes"[11] of Abanindranath Tagore on the other. We can read in them an early feminist initiative of the kind that returns redoubled with women painting in the 1970s and onwards.

Women became a visible presence in art colleges in the 1950s. The institution of the Delhi College of Art in 1942, the fine arts faculty at the M. S. University, Baroda in 1950, and schools like the Sarada Ukil School and later Triveni Kala Sangam, in Delhi, provided avenues for training. That decade saw a trickle of artists — Meera Mukherjee trained in Calcutta and Germany, Nasreen Mohamedi trained in St Martin's, London, Veena Bhargava in Calcutta, Anjolie Ela Menon from the J. J. School of Art in Bombay and the Ecole des Beaux Arts Paris, and Arpita Singh in Delhi, to name a few.

In the 1960s emerged Kishori Kaul, Latika Katt, Anupam Sud, and Nalini Malani, who were almost contemporaneous with Ira Roy, Nilima Sheikh, Mrinalini Mukherjee, Gogi Saroj Pal, and Arnavaz Vasudev. In the 1970s and 1980s the floodgates of participation by women artists had opened. Thus it is notable that the participation of women has peaked on at least two key scores, with the earliest notions of "modernity" and progress in the decade after Independence, and then during the politically volatile 1970s, when women in unprecedented numbers actively protested against the issues of violence, inflation, and social injustice.

With the artists of the 1960s and 1970s a few signifiers become immediately apparent. By and large, women's art grew in relative isolation of the few movements [The Calcutta Group (1940), the Progressive Artists' Group (1947), Group 1890 (1963), the group of printmakers Group 8 (1968), and what is loosely described as the Neo-Tantra movement]. Women worked on the fringes of these movements, yet their grasp of their aesthetic space was firm and considered. During the varied impulses of modernism of the 1950s and 1960s and the thrust towards indigenism conspicuously free of a Western paradigm (as formulated by Group 1890), most Indian women artists were, with a few notable exceptions, in the wings. That women addressed the creative tensions of the individual and the age outside an ideological dialectic may, with hindsight, have been a source of strength.

From the early 1970s women artists developed haltingly through a selective interrogation of social beliefs, recollection and memory, myth, and a contemporary symbolism. Time, histories, and presentational modes were frequently scrambled in this quest. Arpita Singh who worked in abstraction for a long time developed a textural complexity and finesse that is evident in her later figurative painting. Nasreen Mohamedi followed a solitary quest in which recurrent patterns, both meditational and highly conceptual, that recall the work of Agnes Martin, were developed. Anupam Sud, who also studied and worked on the threshold of the 1960s was a founding member of Group 8 and built up in her prints an unusual technique which creates the illusion of the third dimension, which she exploits as an emotive space.

The process of narrating personal and collective histories had started, and in this women artists proved extremely inventive. Arpana Caur and Gogi Saroj Pal used artistic and literary convention, of the *nayika bhed* and its rendition in Pahari miniatures to subversively show up its stifling role-playing and constricting architecture. Pal renders the *nayika* a figure of parody; Caur releases (even as she de-sexes) the woman from her environs. While Pal and Caur draw from the wellspring of Hindu myth, Madhvi Parekh (figure 6) and Arpita Singh devise their own fables. Parekh's childlike reverie for all its playful abandonment lends its mythical birds and snakes, everyday objects and frisky children, demons

and goddesses, a looming iconicity. Singh assumes an Alice in Wonderland perspective of being overwhelmed by "the world at her doorstep" in which time and size are skewed and friends and family, both dead and living, reappear, like their own silent interlocutors. Singh enacts the private dialogue within the public miasma, blurring the spaces to create an unrelieved tension.

In a more confrontationist vein Navjot and Latika Katt interrogate contemporary Indian society: the city and the subject, particularly when pitted against convention. Again, Nalini Malani has in some of her earlier paintings such as *Of Monsters and Angels: a Fable* scrambled history to place figures from the miniature tradition in modern times. In every case here, there is the evolution of a methodology which in fact comprises one of the more interesting aspects of present-day Indian art. Nilima Sheikh assimilates Persian, Japanese, and Chinese painting techniques to paint her subjects with a warm, even protective, empathy.

How do women paint women? One of the most contentious issues in feminist art history is the representation of the feminine by male artists, especially the nude. In classical Indian art, while the female form has been imbued with the spheres of fertility and nourishment, the male's sphere has been one of contemplation and inner strength. Sher-Gil's confident handling of the nude form which dealt, like the Impressionist, Walter Sickert, "joyously with gross material facts", set the tone. However, very few Indian women artists, notably Vasundhara Tewari, use a nude model today. In the hands of Nalini Malani the nude is frequently fraught in emotional contortion. She wrote, "I am curious about the possibility of painting states of one's mind. . . . Here, I refer to emotions that grip one in the ordinary context of one's life: oppression, anxiety, self absorption, anger."[12] Arpita Singh's occasionally nude multi-limbed goddesses and the middle-aged nudes of her recent painting have an earth-like gravitas, a kind of monolithic presence. It is in the hands of Anjolie Ela Menon that the nude is treated as a recurrent image, with other leitmotifs entering and exiting her frame. Drawn as she is to the petrified historical moment, Menon's pale, long-limbed nudes hark back to early Italian art, for instance, Botticelli's *Truth,* with the brooding faces of Romanesque art and Russian icons. Yet their sensuality is frontal and open to the avid gaze.

In the context of a very different artist, Nalini Malani, Adil Jussawalla had written of her work of the 1970s: "Nalini's bodies are all female. Put another way Nalini presents us with the female as body and body alone, a male's eye view which is further accentuated by the physical placement of bodies; they are all seen from on top. In other words, the nature of aggression, even when presented in terms of a claustrophobic room or an occluding wall, is intimately male."[13] Closer in time, Navjot inspects feminine sexuality in terms of deviance and autoeroticism, as in her series *Images of Women* (1995).

The individual and the world also come in for close scrutiny. Consider the work of artists marking the history of the nation — peasants and fields, factories and portraits of politicians — variously by D. P. Roychowdhury, Nandalal Bose, Husain, Ramkinkar, Gieve Patel, and Satish Gujral: a celebration of public spirit and public sector enterprise. Despite the socially reactive work of Nalini Malani, Arpana Caur, Navjot, even Arpita Singh and Latika Katt, it would not be wrong to define a "female space" in art which is the space of reverie, warmth, and resistance. Relationships between women (mothers, daughters, maidservants), the stresses and rhythms of a woman's body, the reversal of myth, and an occasional celebration of motherhood are some common themes. Nalini Malani in her series of paintings *Recollections* (1978) appears as a girl child, caught in a moment of emotional crisis. Anupam Sud has consistently interrogated the male-female attraction and bonding. Gogi Saroj Pal's beast-women play out a range of emotional dialogue with the viewer: their intent is to directly engage, even as they invite, mock, or delude. Indeed, it is the shifting point of view assumed by the artist, of mother, child, lover, or detached interlocutor, that lends its own tensile, sensuous quality to women's painting.

In this process associations of feminity have been renewed and rejected. The act of embroidery in Arpana Caur, the Bengali *kantha*-like stitches of Arpita Singh, and Gujarati needlepoint of Madhvi Parekh, birds and animals, kitchens and nursery associations, find a counterpoint in ungendered art which bears no apparent marks of a "feminine" sensibility (figure 7). Inevitably, perhaps as a younger generation of women artists emerges, the criteria for evaluation and expression become more even-handed, even as the direction and "truth" of art are

foregrounded as concerns. For the number of artists contained in this book a much larger number creatively perished; others for reasons of space could not be included despite their remarkable personal initiative and the significance of their work. In years to come, uncertain incomes and the tensions between domesticity and profession will continue to reverberate through women's histories. It is through such tensions that the history of women's art in India will continue to be written, with all its promise, uncertainty, and visible grandeur. The artists who have been included in this book represent disparate backgrounds and some of the heterogeneity of modern India. There is no uniform voice or artistic credo, no consensual spirit of shared intent. Yet, each of these artists represents something central to developments in contemporary Indian art. Their work, poised at the edge of the new millennium, covers a spectrum of nearly six decades, from the earliest impulses of modernism to post-modern rhetoric with multifarious debates and discoveries along the way.

The art critics and art historians who have generously contributed to this volume have not only uncovered biographies and individual scales of value but also aided in the still unfolding exercise of critiquing modernism in Indian art. It has been a fascinating journey, which I, as a participant, acknowledge with a deep sense of gratitude.

Notes
1. Partha Mitter, *Art and Nationalism in Colonial India 1850-1922*, Cambridge University Press, 1994.
2. John Ruskin (1819-1900), the famous British critic referred to his favourite women painters as "pets". Even when women artists in the West led unconventional lives, they were attributed with appropriately maternal instincts. Harriet Hosmer, American neo-classical sculptor of the nineteenth century and an unmarried woman, spoke of her sculptures as her "children". Rosa Bonheur who dressed like a man and specialized in painting animals was described as painting "with the loving care of a conscientious mother" (Whitney Chadwick, *Women, Art and Society,* New York: Thames and Hudson, 1990).
3. Mitter, op. cit.
4. Ibid.
5. Ibid.
6. Tapati Guha-Thakurta, "Women as Calendar Art Icons. Emergence of pictorial stereotype in colonial India", *Economic and Political Weekly*, October 26, 1991.
7. The image of Bharat Mata/Mother India in literature and art was a compelling icon of the late nineteenth and early twentieth century. Bankim Chandra's highly emotional evocation of Mother India in *Anandamath* was followed in paintings of the same subject by Abanindranath Tagore (1905), Amrita Sher-Gil (1935), and M. V. Dhurandhar, among others.
8. See Radha Kumar, *The History of Doing,* New Delhi: Kali for Women, 1993.
9. See Susie Tharu and K. Lalitha, eds., *Women Writing in India, 600 BC to the Present.* Vol. I, New Delhi: Oxford University Press, 1993.
10. *Roop Lekha*, Vol. XX No. 2, 1948.
11. Mitter, op. cit.
12. Catalogue: Through the Looking Glass — Exhibition of Paintings by 4 Women Artists, New Delhi, 1989.
13. Adil Jussawalla, Catalogue, 1973, Pundole Art Gallery, Bombay.

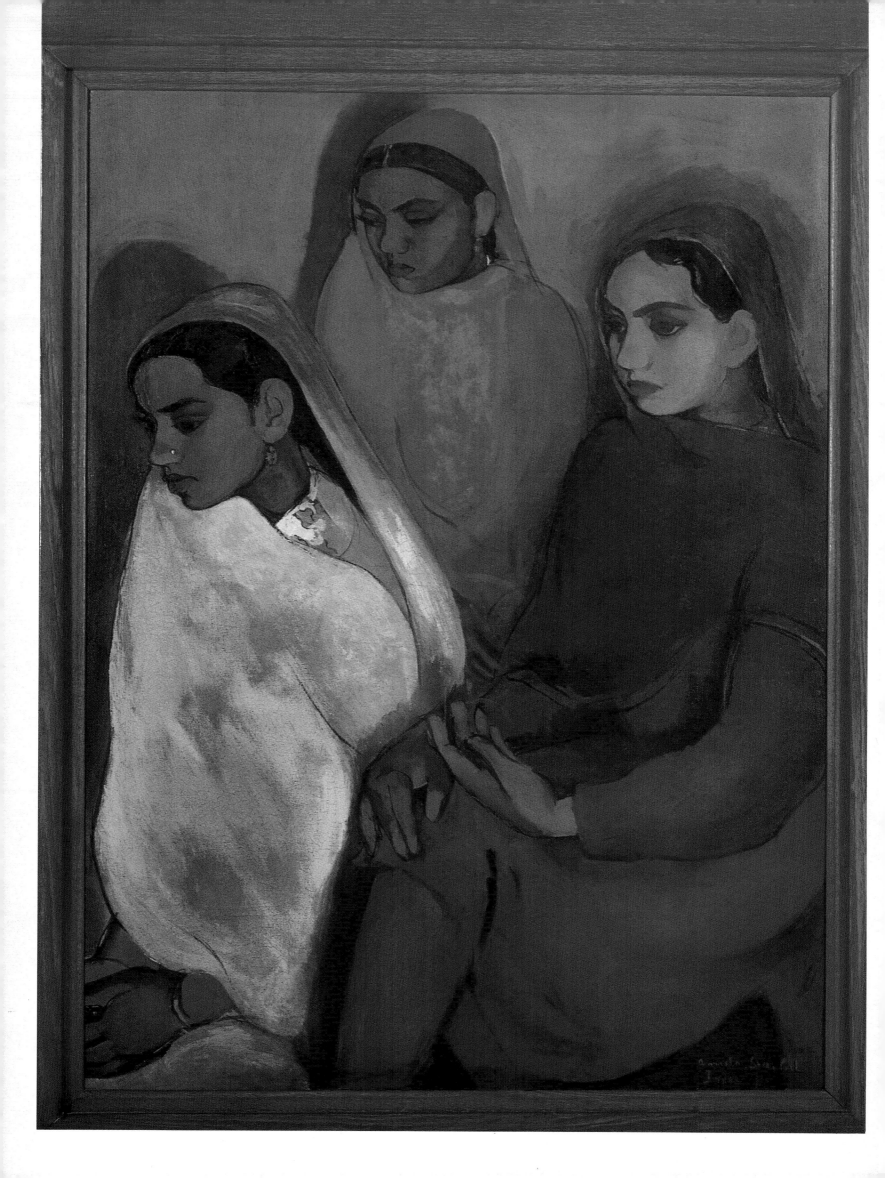

On Amrita Sher-Gil: Claiming a Radiant Legacy

Nilima Sheikh

For a woman painting in India, Amrita Sher-Gil is inheritance. No perspective on our art is complete without reference to Sher-Gil. Her commitment to her self-image as an artist, as much as her brilliance and flair, has ensured for two or three generations of women artists since, the right to be taken seriously.[1] If I have chosen to dwell on the work and ideas of Sher-Gil it is from gratitude, but inevitably through questions raised by the predispositions of my own context. The range of her complex legacy, needless to say, is larger.

Choices of Birth

Amrita Sher-Gil was born in 1913 in Budapest. Her Hungarian mother Marie Antoinette had met her father Sardar Umrao Singh Sher-Gil of Majithia while on a visit to India in 1911 in Simla. They were married soon after. Amrita and her sister Indira spent their childhood in and around Budapest, and after 1921 in Simla. At the age of five Amrita started painting and drawing. Resisting her formal convent school education in Simla, she spent most of her time painting, reading, and playing the piano. When she was fourteen, contact with her painter-turned-Indologist uncle Ervin Baktay brought some direction to her artistic passions. He encouraged her to study from life, using the families of domestic servants as models, and would then critique her drawings. This attention

from him was pivotal in resolving her ambitions as a painter: in providing the academic base to her subsequent career, as well as incising a memory of the facial and figural types which she later came to identify with the India that "haunted" her.

In 1929, the Sher-Gil family went to live in Paris where Amrita studied art, initially at the Grande Chaumiere under Pierre Vaillent and later at the Ecole des Beaux Arts under Lucien Simon. She acquired academic competence and acclaim, winning a gold medal and election as an associate of the Grand Salon. While her engagement with Parisian life was considerable, she maintained her links with Budapest and with Hungarian writers and painters. There are indications that she aligned herself with what emerged as the European alternative to the modernist movements of the "cultural capital" of the 1930s.

Yet, in 1934, barely out of art school, she opted to put Europe behind her, despite favourable working conditions and an active intellectual life, and claim India as her chosen site. She marked out her own mission: "I am an individualist, evolving a new technique, which, though not necessarily Indian in the traditional sense of the word, will yet be fundamentally Indian in spirit. With the eternal significance of form and colour."[2] And then, relying mainly on her own critical judgement, she set out to "interpret India and, principally, the life

Three Girls. 1935.

Oil on canvas;
92.80 x 66.50 centimetres.
Collection of the National
Gallery of Modern Art,
New Delhi.

Sher-Gil suspends the interactive aspect of portraiture by locking her figures in their own brooding silence in an effort to provide them their integral space.

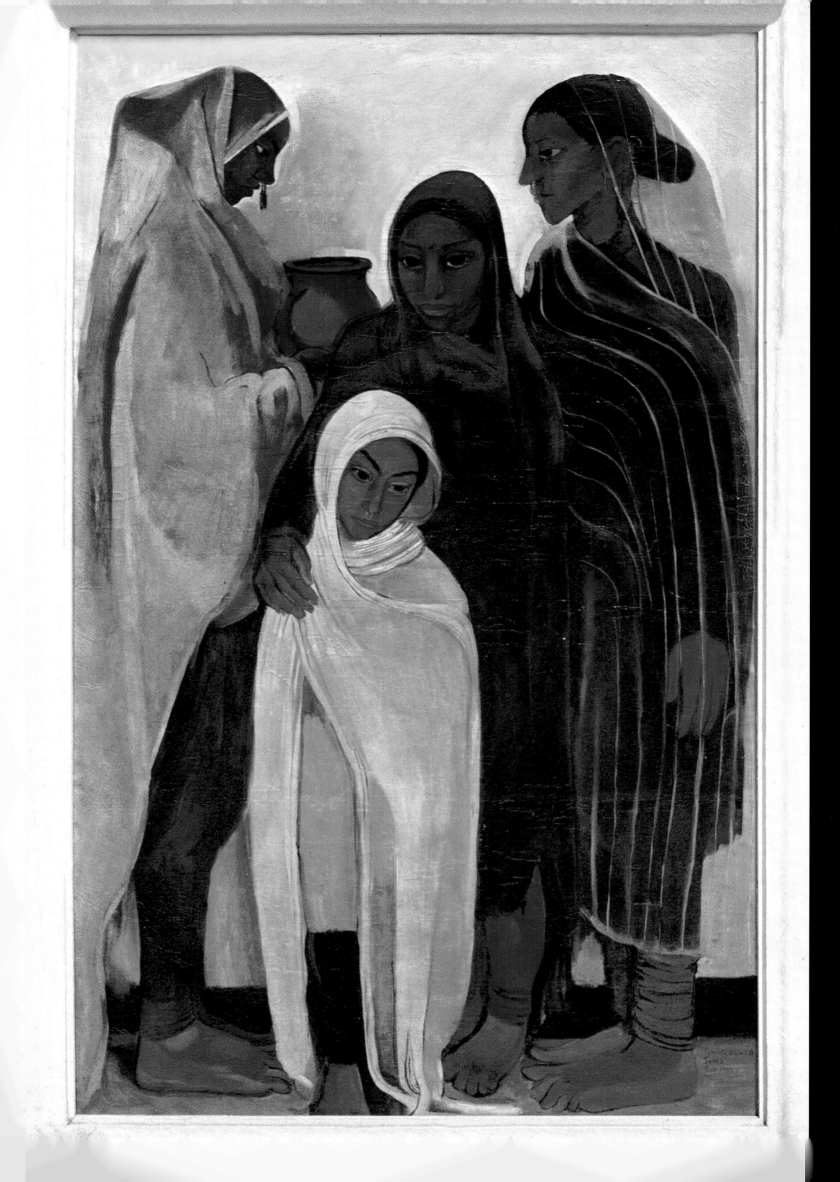

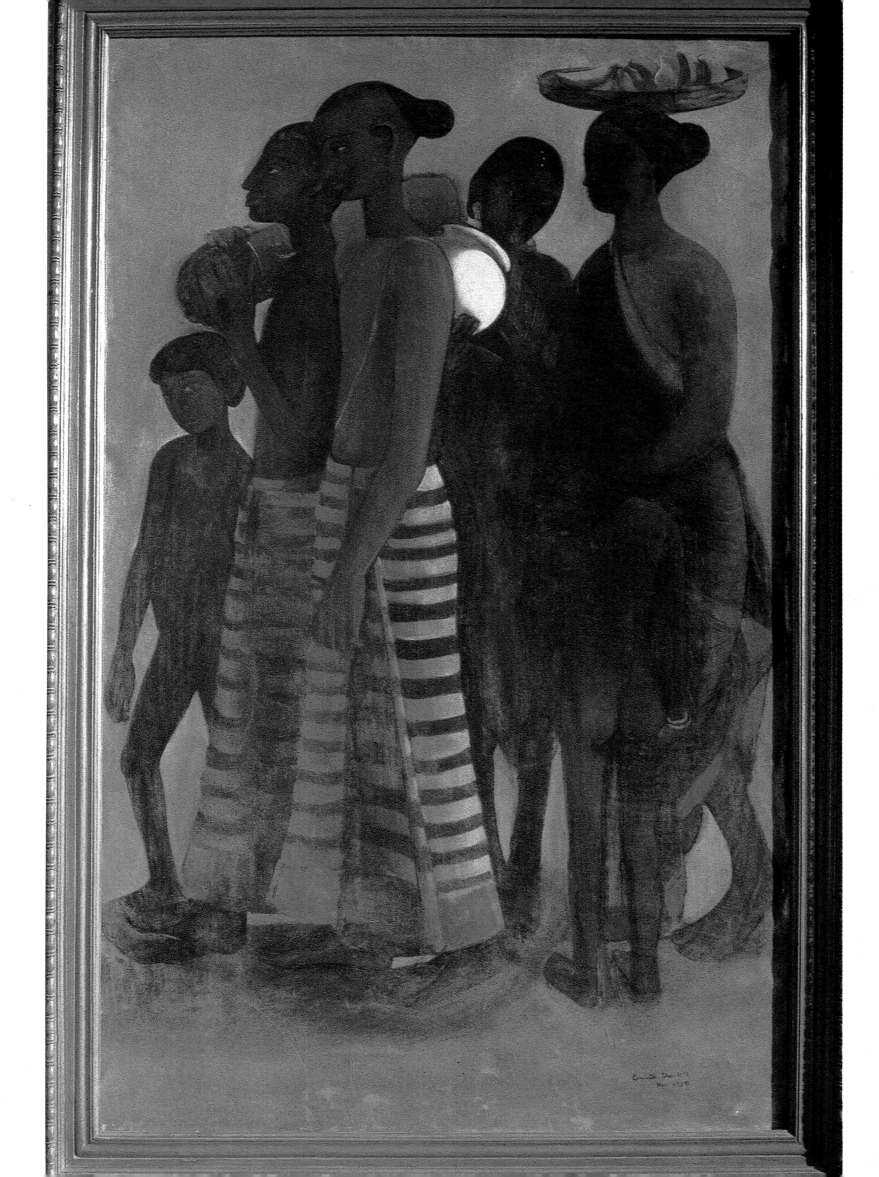

of the Indian poor on the plane that transcends the plane of mere sentimental interest".[3] En route she confronted the great Indian traditions of painting and sculpture. She was ecstatic and inspired, and pushed her language, now seemingly inadequate, with each new painting. The struggle was not only evident in her paintings but was also formulated through her writing and in correspondence with family and friends, notably connoisseur-critic Karl Khandalavala, the only "collaborator" in what was veritably a one-person art movement.

In the 1930s both Binode Behari Mukherjee and Ramkinkar Baij were coming into their own. The Bengal movement was in fact entering one of its finest phases. It is ironical that Sher-Gil, due to the insularity of her location in an upper-class social stratum in North India did not know enough about the Bengal movement to enthuse her, or even to arouse her curiosity. Sher-Gil's perception of professionalism would also have conditioned her response to the politically reactive and culturally multifaceted Bengal movement where the dominant ideal saw art as vocational choice. This in her mind may have been equated with dilettantism: her single-mindedness during working hours would brook no impingement even from her own personal life. She perceived

Hill Women. 1935.

Oil on canvas;
148 x 89 centimetres.
Collection of Vivan Sundaram.

To break free of portrait conventions Sher-Gil tries grouping her figures and uses body rhythms as compositional constructs.

South Indian Villagers going to the Market. 1937.

Oil on canvas;
148 x 90 centimetres.
Collection of Vivan Sundaram.

The use of a complex of body-stance forming a coordinated gesture often seen in the narrative traditions of paintings is devised here out of an intuitive response to Ajanta.

and projected herself as a professional artist — a celebrity almost from the time she started painting. Starved of genuine criticism and support, she valiantly battled her problems on her own. Yet, on the other hand, her beauty, youth, and social position, her glamorous and flamboyant personality and controversial lifestyle, and her easy proximity to the political centre of the country kept her upfront in the gaze of the educated milieu. At the age of twenty-four she was lionized, signing "about a hundred autograph books"[4] at the opening ceremony of her exhibition at Allahabad. She even wanted to see her "sugary" self-portrait in *The Illustrated Weekly*,[5] a paper she dismisses as "rotten", to advertise her capacities as a portrait painter — quite the prototype for today's media celebrity.

Sher-Gil lived for just seven years after graduating from art school. These years have left wealth enough for each of us to construct our own Sher-Gil. This essay is limited to her struggle with the constraints of academicism, her relationships with Indian traditions of painting, and her commitment to the beauty she recognized around her and within herself.

Algebra of Learning

Sher-Gil's academic training has eventually, over the years, been identified as a handicap by most commentators on her art. Her natural ebullience strained against it, her inspirational preferences signalled otherwise, yet something from the milieu she was brought up in and her own psycho-social make-up made the realistic academic vision natural to her. The small or big thoughts and images that make up our imagination are, after all, perceived in some convention or other. The post-Renaissance convention of painting portraits institutionalized in the courts and salons of Europe has endured the mutations of time and geography. The form is invested with the fascination of

creating a persona which shares a space with the painter: of somebody who is real, and really there, yet has to be brought to life by the limited but crucial decisions of the painter — so that the person can become his/her own legend as told by the painter. The transaction takes place in the private space between them: the artist moves away to make room for the spectator.

Sher-Gil seems to have known the rules of the game very early in her life. As a twelve-year-old, she writes in her diary about a sad little child-bride at an Indian wedding, in a descriptive mode close to the portraitist's, inducting sentiment natural to the genre.[6] For the adult Sher-Gil, interest in discovering persona through description becomes indivisible from the academic portrait convention. In her portraits of the early 1930s the space between the sitter and the painter is crucial in determining the image, rather than the pictorial space, which is thus relegated to being "background". Sher-Gil battles with the naturalistic straitjacket the convention gives the figure. Even in the paintings she regards as straightforward portraits, the figures rarely look out of the picture frame. Though the pose is frontal, the gaze remains inside. The figures are locked in their own brooding silence in an effort to provide them their integral space, pinned down to a stillness.

She tries grouping her figures, as in *Three Girls* (1935). In *Boy with Lemons* (1936) and in *Hill Men* (1935) she attenuates the forms with stylish flourish and reduces the naturalistic non-essentials in an effort to achieve "significant form".[7] It is these early paintings — portraits and those deriving from the genre of the portrait — that bequeath to the movement of modern Indian painting the conventions to depict pain. Human misery becomes stereotyped in the "soulful eyes", "melancholic faces"[8] and attenuated bodies of the protagonists, placed frontally against a "background", but (until we come to Arpana Caur) averting confrontation.

With the body-rhythms of women Sher-Gil seems to have more ease, as in paintings like *Hill Women* (1935). But it is not till 1939, when she is back in Europe for a year and paints *Two Girls*, that she really comes to reconcile her involvement in portrait painting and her interest in the "inner meaning" of her subject with the evolution of a starkly simple form. The painting is reductive in its process of stylization, but complex at the levels of interaction of painterly and psychological construct. The image is frontal, yet secret. Lessons learnt from Ajanta in the potential mobility of figure-background gestalt have been internalized. She has moved on from "the period of . . . great soulful eyes in a melancholy face, romantic, . . . I have grown out of that sort of thing."[9] And through the linguistic code of differentiated traditions of painting she has now started to search her own vision. "The Mughals have taught me a lot. Looked at rightly, the Mughal portrait can teach one everything almost that matters. Subtly yet intense, keenness of form, acute, and detached (somewhat ironical observation). All things I needed most."[10]

Sher-Gil had decided at the outset of her career to pitch her tent on her declared homeground, and wanted her inspirations to come from there.[11] And so, in 1934, when she declares with defiant foresight about Ajanta being worth more than the whole Renaissance, it is a radical consciousness that prompts it. When she really encounters Ajanta, she is ecstatic, but also relieved — that she really *does* have something to learn from. We know from Sher-Gil's letters that 1937 was a watershed year in her life. At the end of 1936, she travels to Ajanta, Ellora, and then Bombay (where she meets Karl Khandalavala), and then spends two months travelling in South India, exhibiting her work (along with Barada Ukil), looking at paintings, photographing and drawing from them whenever she can. Her letters astound one with her perceptive insight and discrimination, even when confronted

with murals with which she had no prior acquaintance, such as those at Padmanabhapuram and Mattancheri. It seems ironical that while Amrita Sher-Gil's paintings became prototypes for many later modern Indian paintings and her manner and style was often imitated, there are few artists even till today who are aware of the paintings at Mattancheri which moved her so deeply.[12]

Amrita Sher-Gil's own ability to "look at rightly" beyond physical attributes to the meaning of their coming to be, is quite special. Her natural acuteness of perception is activated by the pressing desire for extension of her own world-view. It is for this reason that for all her Clive Bell aesthetics of reductive simplicity, she has no difficulty in accepting the *alankarik* aspect of the tradition of Indian painting, of ornament as an integral part of pictorial structure.

At Cochin she paints to "assimilate" Ajanta. In *Fruit Vendors* (1937), she places the dark bodies in white against the green and red of the Kerala landscape — the only way she knew how. The figures pose against the studio device of a one-third–two-third division of background space, divided into green and red. But the moulded rhythms of Ajanta begin to find an equation, as they do in the paintings she made on her return to Simla, such as *Women in Red* (1938). In *Bride's Toilet* (1937), limbs and glances lift, turn, and extend in a new-found autonomy of space devised for the first time by action released from gesture. The ritual is self-conscious, but there is a breathing of bodies through the rhythms of feminine activity (an inheritance claimed most of all by Arpita Singh). With *South Indian Villagers going to the Market* (1937), there is for the first time a suggestion of progression of time in the undulating movement of group gesture. The device of a complex of body-stance forming a coordinated gesture is often used by narrative painters of different traditions. With this painting, to quote K. G. Subramanyan, "Amrita came closer to the

appreciation of the special character of Ajanta painting than most, its studied disposition of masses, its rich and mellow colour play. She also came nearer to seeing the sensuous humanism of Ajanta than many"[13]

Contradictions and Resolutions

The most puzzling aspect of Sher-Gil's work and aesthetic is her dependence on the model. It comes out of her academic-realist predispositions as we have seen, but even after she moves away from the logic of portrait painting to figures in interaction (after her visit to Ajanta and the South), then to figures and animals in interaction in landscape (after greater exposure to Pahari and Mughal miniatures), she continues to get her paintings posed for her. So even though she has the intuitive grasp to see "that the figurative iconography of Ajanta was not an abstract from the static realist scene, but the mobile terminology of sophisticated pictorial language",[14] it does not in effect change her dependency on painting only from a direct and static encounter with the models or scene she chooses to portray. So, a Sikh boy is made to act as a South Indian *brahmachari* or a Pahari servant woman is dressed up brightly to participate in the tableau of a bride's toilet.[15]

Sher-Gil, strangely, seems to know only two categories of painting — studio and *plein air* (a term brought into currency by the Barbizone painters and the Impressionists). For nineteenth-century painters, the excitement of moving out of grey studio interiors to the changing lights and colours of the outdoors was their involvement in precisely that: the temporal changeability of colour in light. Whereas Sher-Gil, engaging landscape for the first time in her paintings, was seeking an ideational *synthesizing* of nature. The words she uses are "stylization in the sense of nature". Yet, somehow *plein air* is the only *functional* category she understands nature with and so the need for verification with optical experience. The point that Basohli or even

Siesta. 1937.

Oil on canvas;
38 x 55 centimetres.
Collection of the National
Gallery of Modern Art,
New Delhi.

Sher-Gil often paints the
languorous repose of resting
women, inspired equally by
Pahari miniatures as by the
small town life around her.
Woman Resting on Charpoy
(1940) of the National Gallery
of Modern Art collection would
be another instance (see figure 2
in Introduction).

Ancient Story Teller. 1940.

Oil on canvas;
87 x 70 centimetres.
Collection of the National
Gallery of Modern Art,
New Delhi.

It is likely that Sher-Gil's often
dramatic but always imaginative
use of white was inspired by the
fresco and tempera traditions of
Indian painting.

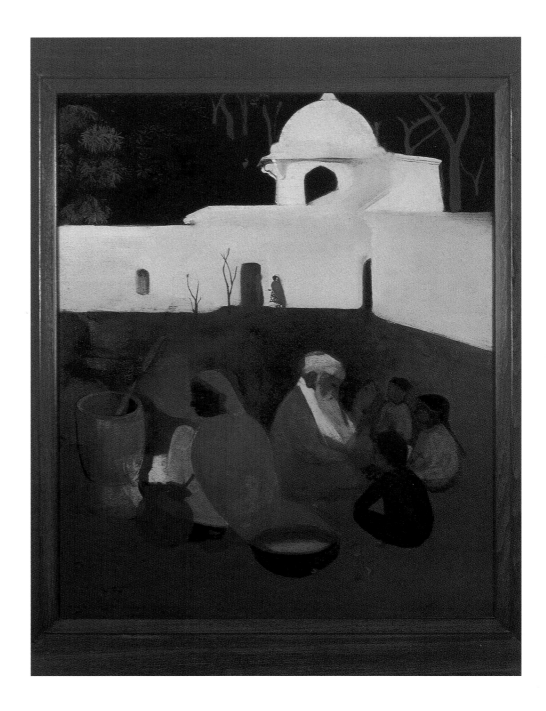

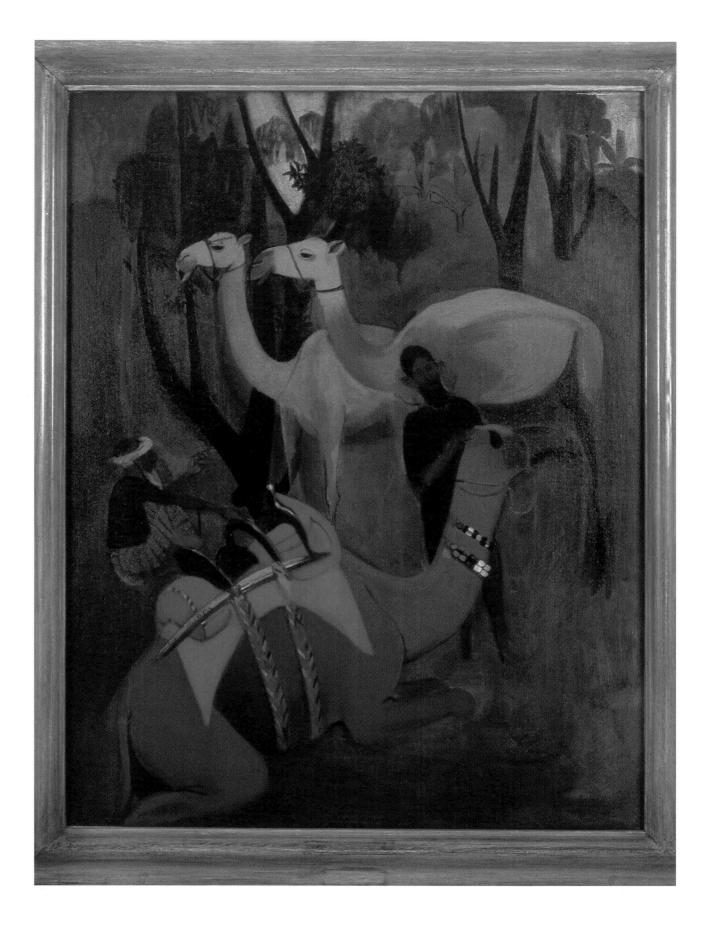

Camels. 1940.

Oil on canvas;
100 x 74.80 centimetres.
Collection of the National
Gallery of Modern Art,
New Delhi.

Sher-Gil came to India with the
avowed intention of fulfilling
herself as a colourist — under
the influence of Indian painting
and life.

Mughal painting was not *plein air* seems to elude her: it was not through depletion of the real image that the form and spatial constructs of these systems were arrived at. None the less, her intuitive and sensory responses are so integrated, that she receives the linguistic code of an aesthetic based on the intrinsic function of ornament without difficulty. She is never baffled or perplexed even in front of so highly complex a system of ornamental structure as the Ramayana mural at Mattancheri.

Sher-Gil's South Indian travels do other things to her as well. Landscape presents itself in a way it often does when one is travelling. She sees it perhaps for the first time as pictorially viable, in friezes and tableaux. But it had to await "assimilation" (Sher-Gil often asks herself for time to assimilate — it is an important notion with her). She is overcome by the beauty of South India, wants to live and paint there for longer spells, and wonders how she could ever paint in Simla again. But it is in Simla, in October 1937, that Sher-Gil paints two pictures — her first serious attempt to provide her figures with an outdoor living space. In *Siesta* (1937) Sher-Gil ventures into a new pictorial adventure. There is reference to a Rajput *nayika* surely, in the sleeping figure of the woman centrally located as the motif of sexual expectancy. The staging of the scene is a little uneasy. A shifting of spatial alignments, thus, a dislocation of relationships (even the bed the woman sleeps on does not quite seem to contain her) is perhaps due to an effort to relate to the definition of space, through configurative extensions, of a Rajput prototype. (The painting seems to prefigure, not just pictorially but also in its attitude of relating to the new input, some aspects of the paintings of Nalini Malani.) Though specially attracted to Basohli for its sensuality and colour, it is likely that Sher-Gil found the guileless naturalism of Kangra easier to relate to her own visualization of *space*. In *Story Teller* (1937) the life of people

in the Himachali village and small town finds easy compatibility with the gentle humanism of Pahari painting on the one hand and post-Impressionist figure-space gestalt on the other.

During 1938, Sher-Gil finds herself more and more engaged in the miniature tradition and refers frequently in her letters to Mughal painting. It was not just her taste that led to easier accommodation with them, she felt in fact that "the imitators of the Mughals have never erred so badly as the imitators of Ajanta . . . by the very things they stand for, they (the Mughals) bar the way to excessive degeneration of form conception".[16] I am sure there are factors of climate and ambience — of the colour, light, and land-space of Saraya (near Gorakhpur, where the Majithias had a family house) and Simla, the body use and physiognomy of people around her, too, that must have brought Mughal and Rajput painting alive for her. Paintings like *Elephants in the Green Pool, Women in Red, Red Verandah, In the Ladies Enclosure, Village Group, Resting,* and *Red Clay Elephant* (all 1938) are all of this moment of equilibrium, what she calls "expressions of my happiness".[17] Conversely, the induction of pictorial space through lessons learnt from Indian painting helps Sher-Gil find her equation with post-Impressionist spatial devices, particularly with Gauguin's.[18] This newly discovered equation prompts her to declare, "how significant of the fellowship of all great art that a mind of such completely different origin as Gauguin should have a common atavism with the Basohli miniaturist". In her enthusiasm and new access to both, she mistakes shared pictorial dispensations for common pictorial intents. But she has already, quite remarkably, grasped something of the function of stereotype in painting when she writes, "I find it difficult to express what exactly I find that Renoir and Brueghel have in common with the Mughals. Yet they possess, all of them under their seeming

conventionalism, I might almost say standardization of form, an astounding faculty of picking out of characteristic essentials of a face, a body, a hand, a foot and compressing it into the most subtly simple of moulds."[19]

Desire

I have written enough about the struggles Amrita Sher-Gil had to face in her quest for a personal idiom. Let me now mention the two aspects of her artistic make-up which stood her in good stead during the ups and downs of her short career — her skills and her lust for beauty. These should be self-evident; they are some of the first things one notices about Sher-Gil. But I find the need to reiterate them in the contemporary context, when skill is often seen either as redundant or as art's own fly-trap. Amrita Sher-Gil knew that her draughtsmanship had flair. She also recognized that it had to be tutored to serve her changing needs, but even in the recognition of the abundance of skill at Mattancheri and Ajanta and the inadequacy of hers, she is inspired, never incapacitated or embarrassed. Sher-Gil is celebrated as a colourist, but it is her use of white with which she continually surprises one. She finds basic function for it — recall the classical structuring of monumental form through white in *Brahmacharis* (1937). The evocative use of white in the mural and miniature painting in fresco and tempera stirs her to unorthodox adventures. In oil painting where the use of pure white is not very common, this intervention has radical implications which Sher-Gil exploits with verve. As a central ellipse around which there is an evolution of form, one could think of *Ancient Story Teller* (1940). Or as that final flourish out of the magician's hat — a slab of white, or a flash of lightning.

Sher-Gil's love of beauty is unabashed and unbounded. It finds partnership in the recognition of her own sexuality as well as in the primacy of the sensual in art. She says, "I think all art, not excluding religious art

has come into being because of sensuality. Sensuality so great that it overflows the boundaries of the mere physical — how can one feel the beauty of a form, the intensity or the subtlety of colour, the quality of a line, unless one is a sensualist of the eyes?"[20] She talks of an imperative need for beauty, and believes in its fundamental role in the experience of art. She has been chastised for this by commentators who read this desire for beauty as an aesthete's fastidiousness and felt that it could come in the way of a true comprehension of reality. I think this is a moral guilt and one that is born of academicism. I would stress that for Sher-Gil the driving need for beauty was intrinsic to her creativity. And in that sense she comes far closer, for all her academic-realist background, to the spirit ("feel" is the word she uses) of the traditions of Indian painting than most of us. Within the priorities mapped out by Occidental aestheticians well into the 1930s,[21] colour occupies a secondary role, equated interestingly with the feminine; of the surface, seductive, decorative, hence dispensable.

Despite her enthusiasm for the "significant form" aesthetic, Sher-Gil's exultation in colour starts rather to burst at the seams of a straitlaced aestheticism, under the influence of painting and life around her. After all, she came to India with the avowed intention of fulfilling herself as a colourist. If she still does not have the wherewithal to transport colour outside the "verifiable with optical experience" logic, she certainly has the passion to suffuse, heighten, enrich colour, till its potency loads feminine bodies with the life-endowing juices of nature. And body smells permeate living spaces and landscapes.

Her last few paintings such as *The Swing*, *Woman at Bath*, and *Woman Resting on Charpoy* (all 1940) are integrated images of the complexity of her person and of its passionate relationship with the land she chose to belong to. Colour in these paintings breaks bounds, on to the soil, its history and contemporaneity with which she had searched contact — towards new directions. The sensuous act of painting, desiring both acuity and fruit-laden abundance, is brought to tend feminine sexuality and bring it to flower. The metaphor reposes in the yearning body unlocking its confinement.

Story Teller. 1937.

Oil on canvas;
50 x 75 centimetres.
The Badruddin Tyabji family collection.

Photograph: Krishen Khanna.

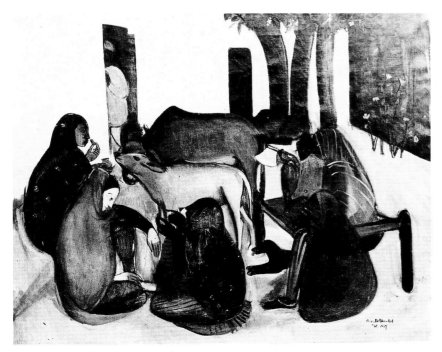

Figure Acknowledgements
All photographs, except *Hill Women, South Indian Villagers going to the Market*, and *Story Teller*, by Sunny.

Notes
1. Sher-Gil herself did not hold much brief for other women painters, and declares in a letter to Karl Khandalavala dated January 1, 1937 that "few women can paint and I think that it is because they are as a general rule not passionate souls but sentimentalists". She was also uneasy with what she calls the effeminate and quick to scoff at it. These are, however, random comments and have to be seen in the context of her time. There was a limited role for gender in the mainstream understanding of the visual arts in the first part of the century, resulting inevitably in a streamlining that left little expressive space for feminity, nor much for mobility or transgression of gender typification.
2. Amrita Sher-Gil, "Evolution of my Art". Reprinted in *Amrita Sher-Gil*, essays by Geeta Kapur, Gulammohammed Sheikh, K.G. Subramanyan, and Vivan Sundaram, Bombay: Marg Publications, Vol. XXV No. 2, 1972.
3. Ibid.
4. Letter to sister Indira from Allahabad, February 2, 1937.
5. Undated letter to Karl Khandalavala from Simla (probably in November 1937).
6. ". . . only one sat pale and silent in an out of the way corner and she was the little bride. She was very fair and there was an expression of weariness in the lovely liquid dark eyes. Her little finely curved and rose hued lips seemed like drooping rose buds and were sealed as if it were in silence eternal. She had a finely chiselled nose and was on the whole very beautiful, her black hair was open and she was wrapped in a pearly white veil . . . the young girl sat silently resting her little round chin in her slender hands and she seemed as if she guessed the cruel fate which had been meted out for her by Rani and Raja and her other rich but distant relatives in whose hands she seemed a helpless toy. Poor little bride you little know that perhaps you might live a year. You are doomed and yet you do not realize." Diary entry, Simla, August 1, 1925.
7. In an article, "Evolution of My Art", op. cit., she writes, "now I am deviating more and more from naturalism towards the evolving of new and 'significant' form, corresponding to my individual conception of the essence of the inner meaning of my subject".
8. Letter to Karl Khandalavala from Saraya, July 1, 1940.
9. Ibid.
10. Ibid.
11. In 1934, in a letter from Budapest, she explains to her parents her need to return to India in the interest of her artistic development. "Our long stay in Europe has aided me to discover, as it were, India. Modern art has led me to the comprehension and appreciation of Indian painting and sculpture. It seems paradoxical, but I know for certain, that had we not come away to Europe, I should perhaps never have realized that a fresco from Ajanta, or a small piece of sculpture in the Musee Guimet is worth more than the whole Renaissance."
12. " . . . some of the panels must have been painted by Indian Rubens, Renoirs, Douaniers, Rousseaus or Ingres (if Ingres had a million times more talent, he might have painted some of the hands and feet of the frescoes depicting erotic scenes, but he in spite of everything remains a deadly bore) whereas every bit of these paintings have an extraordinary vitality which will exercise fascination till the end of time — I am carried away". Letter to her sister Indira from Cochin, January 25, 1937.
13. K.G. Subramanyan, "Amrita Sher-Gil and the East-West Dilemma", in *Amrita Sher-Gil*, op. cit., in note 2.
14. Ibid.
15. The extent to which she carried this idiosyncratic working method was amusing, even bizarre. We have this image of Sher-Gil sitting on a stiff-backed wooden chair painting on a canvas propped up on an easel, held down from blowing away by an attendant, on uneven stands at the Cape Comorin beach. For a painting entitled *Elephant Promenade* she had an entire scenario enacted, with elephants and grooms, some wives, against the compound wall and dome of the Majithia estate at Saraya to give her what *looked* like a Mughal miniature. And then she grumbles about the hard hours of working in the heat for her *plein air* painting.
16. Letter to Karl Khandalavala from Saraya, July 1, 1940.
17. Incomplete, undated letter to Karl Khandalavala from Simla (probably in April 1938).
18. The following description in an incomplete letter (probably in 1938) to Karl Khandalavala, of one of her own paintings, could well be a breakdown of one of Gauguin's — " . . . a composition in which horizontal lines dominate. A slab of pale green sky, a horizontal coral coloured wall in the distance, a slice of flat ground dotted with tiny figures carrying pitchers; and enclosed by a low olive green hedge is a foreground of dull green grass studded with tiny pink and red birds. A row of sitting women in pungent colours, and a thin black dog accentuates the horizontal lines . . . a standing girl breaks the horizontal accent ever so slightly."
19. Undated letter to Karl Khandalavala from Saraya (probably in February or March 1938).
20. Letter to Karl Khandalavala, New Delhi, March 6, 1937.
21. "The union of design and colour is necessary to beget mankind, but design must maintain its preponderance over colour. Otherwise painting speeds to its ruin: it will fall through colour just as mankind fell through Eve." Charles Blanc, *Grammaire des arts due design*, Paris, 1870.

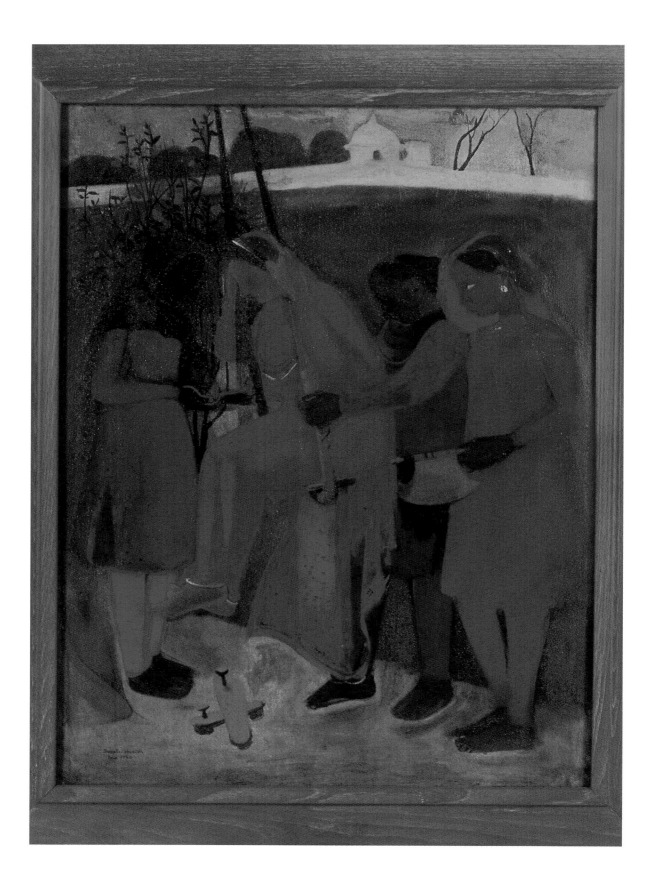

The Swing. 1940.

Oil on canvas;
91 x 70 centimetres.
Collection of the National
Gallery of Modern Art,
New Delhi.

The sensuous act of painting,
desiring both mood and acuity,
is brought to tend feminine
sexuality and bring it to flower.
The ritual is celebrated through
the traditional metaphor of the
swing.

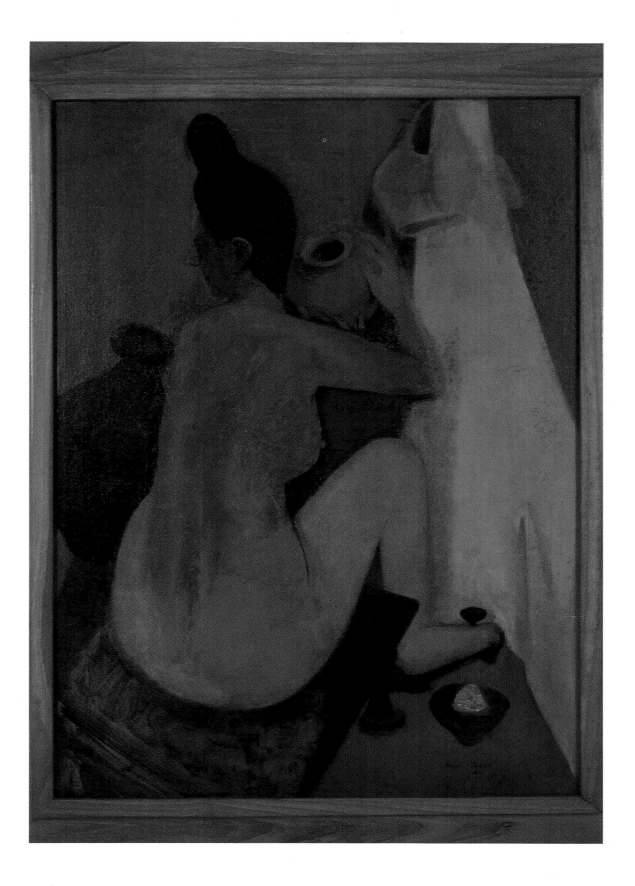

Woman at Bath. 1940.

Oil on canvas;
92 x 70 centimetres.
Collection of the National
Gallery of Modern Art,
New Delhi.

Drawing on the European genre
of painting the bathing nude,
Sher-Gil suffuses the delicately
nuanced surface of this elegant
painting with the grace of light
in colour.

Devayani Krishna: The Fire of God

Keshav Malik

Of the painters of the 1940s and 1950s, Devayani Krishna appears to have the least direct relevance to society as it is today. This may possibly owe to the fact that in her most serious work — prints and related paintings — she seems one of the few artists who speaks to one's soul. Yet, there is an abiding importance in every small detail of her prints, especially those done during the 1960s, that makes them still occupy a special position in her oeuvre.

Sacral Reality

Attempting a dispassionate assessment of her work, it must be kept in mind that art writers have not been unanimous in reaching for superlatives in praise of Devayani. However, it is far from enough to recognize her for being a woman painter or printmaker alone. Unless her insight into sacral reality is acknowledged, there is no true recognition of her rightful place in the galaxy of Indian artists, her contemporaries.

Really a special kind of artist despite her limitations, in some of her paintings Devayani often seduces the viewer with colour so ravishing, the strong pull it exerts on the senses makes analysis of the content elusive. Paintings such as *War* (oil on hard board) and others, besides being physically accessible, present a symbolism which is never too general, too personal, or too involved.

Devayani first studied art at Indore under D. D. Deolalikar, before obtaining her diploma in the fine arts from the Sir J.J. School of Art in Bombay. With her husband, the eminent artist Kanwal Krishna, she joined Delhi's Modern School in 1954, retiring from it only in 1977 as Head of the Art Department. In a career spanning four decades, she received an honorary mention at the first Triennale India in 1968. Indicative of her contribution to the world art scene are several solo shows in India, Europe, and the United States. Her significance, however, lies in her pioneering spirit, in her ability to coax out her own spaces and referral points.

Following her marriage in 1942, Devayani travelled extensively, to Sikkim, the Tibetan border, and the North-West Frontier Province, with her husband. During a four-year sojourn in Sikkim she studied Tibetan masks and Buddhist art. She has also researched Indian folk motifs and toys. All these studies may well have contributed to her own style in several ways. In addition, Devayani worked for some time in the medium of batik, along with her daughter Chitra, and over the years displayed some wonderful batik prints in exhibitions.

As a pioneering printmaker Kanwal Krishna developed the prototype for a print press which he had specially built by Masseys, an engineering firm in

Bom Bom Bole series - 1. 1974.
Collograph.
Like her *Allah* series, Krishna imbues this Shaiva symbology with the associations of an early primitive faith.

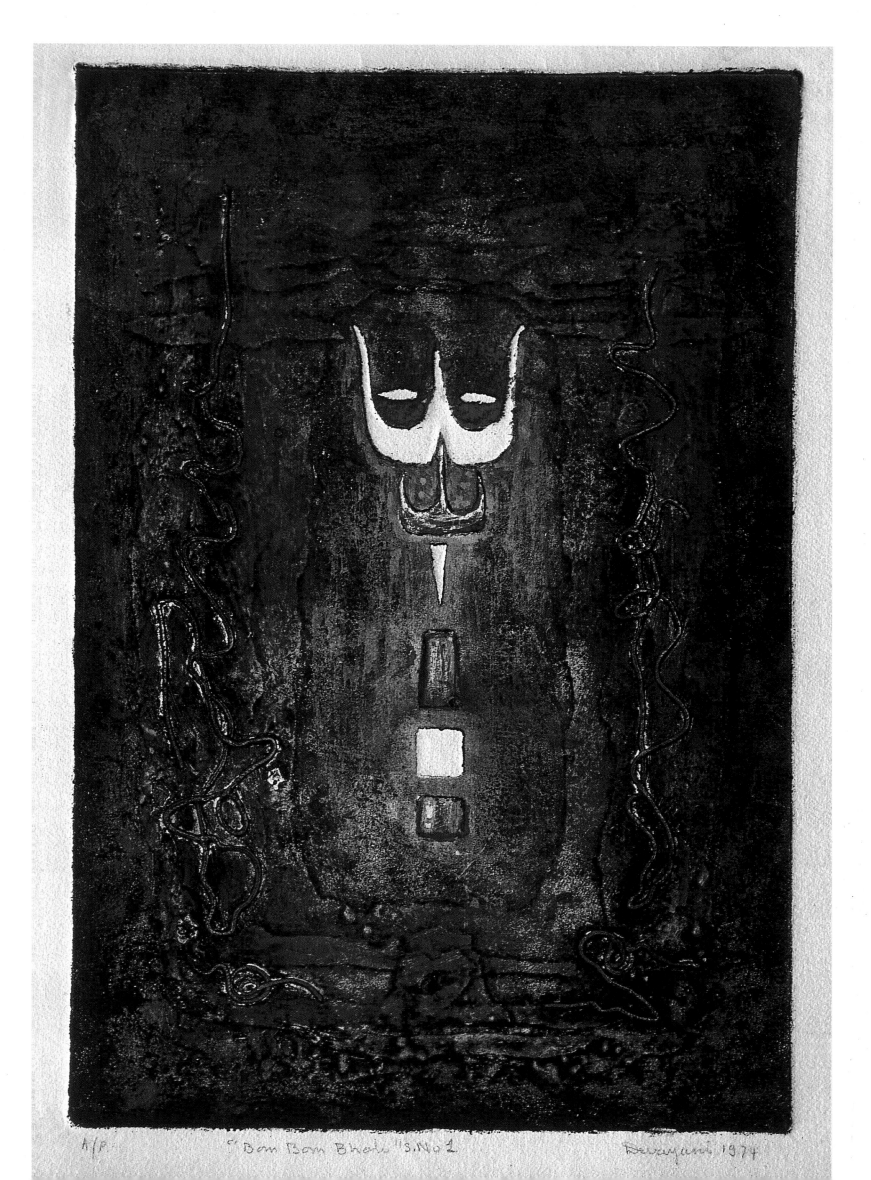

A/P. "Bon Bon Bhola" s. No 1 Devayani 1974

Madras. Watching him work, Devayani tentatively introduced her own formulations.

Peak Experiences

In 1965 I remember writing that Devayani's new work was excellent. A memorable composition of this period is *Under the Roof of God.* With its powerful cross, this work has the authentic simplicity of primitive Christianity before its adoption by imperial Rome. The deeply etched lines are simple, as though executed by someone humble with fervent faith, perhaps a fisherman. Her other works swarm with whorls of shells, segments, and prismatic light patterns. They stand up well, but only *Under the Roof of God* really sets the mind afire. All the works have cosmic or theological titles, and the high aspiration of the artist is palpable, a spirit of prayer against evil and for light.

The whole effort reached an artistic climax two years later in 1967 when Devayani's graphics made considerable impact: ". . . like the divine laws, struck out with lightning force, came to Moses on the mountain, so the name of Allah to the print making fingers of Devayani Krishna". What came to be titled the *Allah* series, in which the name of Allah appears in stylized Arabic characters, started quite spontaneously. When this happened in one print, it took the artist by surprise. She then went on to complete an entire series in the same vein in different shades, but with the same underlying inspired theme.

The work may be compared to a peep into the holy cave of Amarnath, the primordial holy symbol appealing to our subconscious. This work could hardly have surfaced without Devayani's long practice in printmaking. While working on the *Allah* series the artist also made a serious study of calligraphy in various languages.

There is nothing laboured about these outstanding works. The artist imposes her vision, manages to reconcile subject and technique, and rehabilitate the lagging emotion for the sacred. Even if we do not analyse this apparent mystery, we may at least say that such signs and symbols, as in this artist's work, present themselves to the mind in various guises, and that perhaps true vision lies deep down in a childhood experience, or a racial memory, or a Jungian archetype. Only at a subsequent stage does the craftsperson in the artist deliberately attempt to shape what she has been given into the distinct outlines of a perfected work of art.

As a printmaker Devayani worked with speed and spontaneity to capture the inspired moment. Copper, zinc, even cardboard would be pressed into service as a medium, and while printing, more than twenty such surfaces were prepared in as many days. Much of her work is conceptual — the revelatory moment of the *Allah* series, or the indefinable emotion of mother love, as in the print series *Ma*, challenged her imagination and experimental language. In the aftermath of the Chinese aggression, she painted *War*.

War tackles a public or universal issue with a profound and direct, yet subtle power. There is in it total integration of form and content, and the meaning of the work goes straight home with devastating effect. But the prints, as in the *Allah* series, are not message-oriented; they are, so to say, pure spirit in its essential form. Works like *Under the Roof of God* or the *Allah* series are peak experiences. And despite the fact that the artist supplied these prints with her own titles there has been a great deal of speculation as to what they mean and, in particular, some strenuous efforts have been made to read into them a kind of narrowly occult spiritualism. With their unconventional thematic content they are not without honourable ancestry,

though that may be of a mixed, universal kind — Arabic calligraphy, some distant metaphysical searchings *a la* William Blake, the Torah.

Devayani is never didactic either, being by nature of a retiring, reserved temperament. Her work, quite like true poetry, chooses from the world what it considers most appropriate to its ends: it combines in a single, well-tied knot a host of heavenly meanings. Her prints therefore resist temporal erosion. She reveals herself only by the deep subliminal images, even the etching into the plate goes deep, literally speaking. The printmaker in her wants to assure us of the absolute truth and authenticity of what is revealed to her. Through the *Allah* series runs the refrain that the super-real is possible. On these perhaps allegorical plates she tells us the simple truth, that truth does not die; she convinces us of the relevance of timeless things. But if the artist is reluctant to speak directly, she is also ready to plunge into ever deeper experience. This may be why her performance has not really been repeated, even by herself. Works like those mentioned above are proof of the artist's atonement to the large world, and in this she appears not as a superficially Indian artist of the mid-century, but a universal one. This may or may not be genius, but her authenticity and integrity in this period are singularly compelling in the annals of modern Indian art.

An Innocent Persona

The artist's persona is innocent of all progressive humanitarianism as is reflected in some art of the day. But it matters little whether one believes that an artist should justify the social order of today, or the social order of tomorrow. The root error in evaluating works of art springs from the judgement that the artist exists to subserve any political, religious, or ethical code. Such a presupposition breeds the false approach to art by which we

judge the standing of an artist in the light of what he or she states, instead of experiencing the total work. The point may be raised that unless we judge the work of an artist by what he proclaims, we are evacuating art of all moral or other content and reducing it to a sequence of patterned lines and arranged colours, thereby reverting to the triviality of aestheticism fashionable some hundred years ago. If the concept of good art is a valid one we must admit a scale of values by which we can distinguish the elegant minor work from any superb, consciousness awakening art. We may agree unreservedly with this argument provided we also recognize that the values inherent in a lasting art work arise from the art itself and are not imposed upon it by the didacticism of the artist.

I believe that no art can win unreserved recognition unless it expresses with complete fidelity the personal vision of the artist — and that vision Devayani Krishna certainly has in her peak work. The more coherent, exact, and piercing the vision, the greater the art, but the essence of the vision is its individuality, its undistorted reflection of the total experience of one person. The presentation of art dogmas, held even with complete sincerity, can never be a substitute for that personal experience in which belief and doubt, passion and thought, memory and desire are so closely blended that nobody can distinguish one from the other. A true art work is a whole world of order and beauty, instinct with the morality that grows from the acceptance and the understanding of experience; it is never the expression of formulae, religious or otherwise.

Privileged Moment

The best of this artist's work has a splendour which is unique, and it arises from its mingling of the divine legend with the remembered experience of the artist's own hidden life. In going over the *Allah* or the *Mask* series of prints, for instance, we are not giving intellectual assent to any theological proposition, but sharing in the revelatory vision that came to the artist in the course of a lifetime of work and suffering. Here is a perfect fusion of all the elements that make up a satisfying work — there is both artistic and moral unity in Devayani's prints, as also in some of her paintings.

"I always feel as though I stood naked for the fire of Almighty God to go through me. One has to be terribly religious to be an artist," said D. H. Lawrence in one of his letters. All artists do not experience such intensity, but when they do, they create a visionary art, and in this aspect the all-important mastery of craft is of little help. Evidently, at least for a time, Devayani adopted attitudes alien to the general current of artistic belief. Any artist at similar rare moments encompasses the enduring theme of man's spiritual destiny. She spoke out in a universal language and, if only inadvertently, made passing comments on her own times and its history. But she sees these often sorrowful and degraded realities from the point of view of imagination.

The constant question before an artist like Devayani is how to reveal the inner essence of things by painting the outer forms. The inner spirit is invisible, but the artist must render it visible. Line, colour, tone, and form are but clues to the hidden realities which s/he attempts to etch, paint, or sculpt. For instance, a subject is seen apparently painted all awry; a line goes in a particular way, leaving the other side unmarked. The shape of an object is formed by allowing space to be everywhere except where that object is.

Some artists see only with the inner eye, as Devayani did in her privileged moments. In her prints within their surrounding darkness, there is a hallowed light, and in it unity and strength — a light seen in a dream; a vivid, livid red, forming tridents and scimitars with messages of import. These things emerge from the innermost realm of the psyche, from the many varied depths of the mind. These are the myths, then, of an inner universe. In her purest work Devayani has got to the fire of the imagination, and there the images flow out like red hot lava. The symbol of the lit cave in her work stands for intensity, profundity, the power of both life and death.

Though the overall body of Devayani Krishna's work may be small, we may consider it to compare favourably with other artists', if only for it being more universal in scope and more genuine in its implicit philosophy. The most significant aspect about this artist's finest work is that it lives on, it cannot stale.

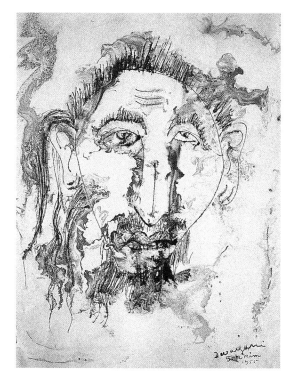

The Portrait. 1955.
Drawing in Indian ink.
Krishna's portraits occasionally had strongly expressionistic overtones.

Note
Dimensions of the works are not available.

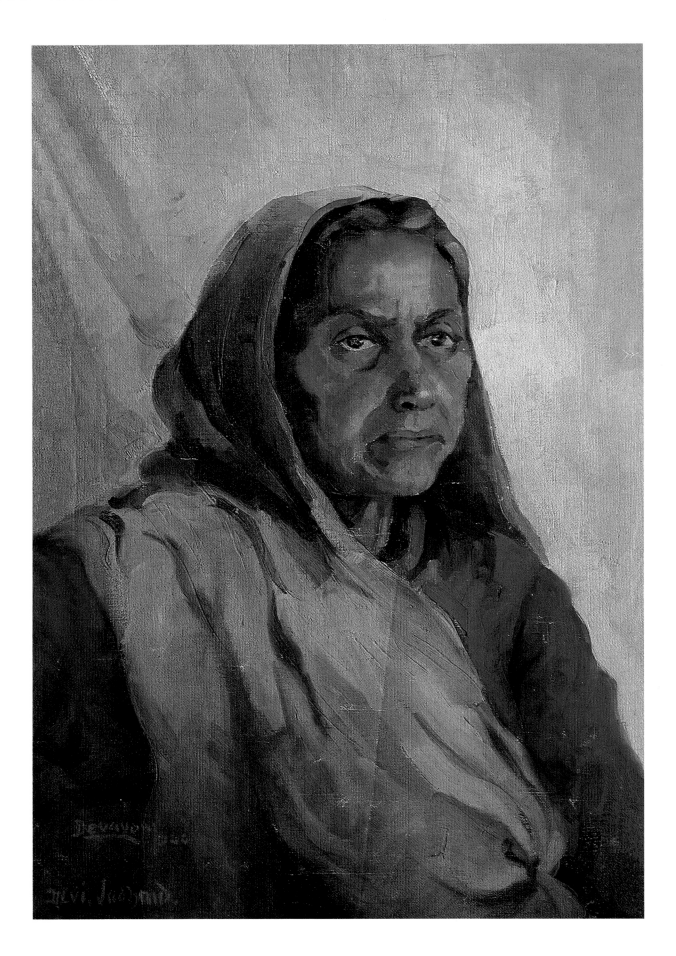

Portrait. 1940.

Oils.

Krishna's early paintings date
back to the last months of
Sher-Gil's life. Portraits were a
mainstay of her work, especially
in the 1940s, during her
travels with her husband
Kanwal Krishna.

Embrace. 1965.

Etching.

The artist veered towards giving
her forms a geomorphic
association with a central
luminous core.

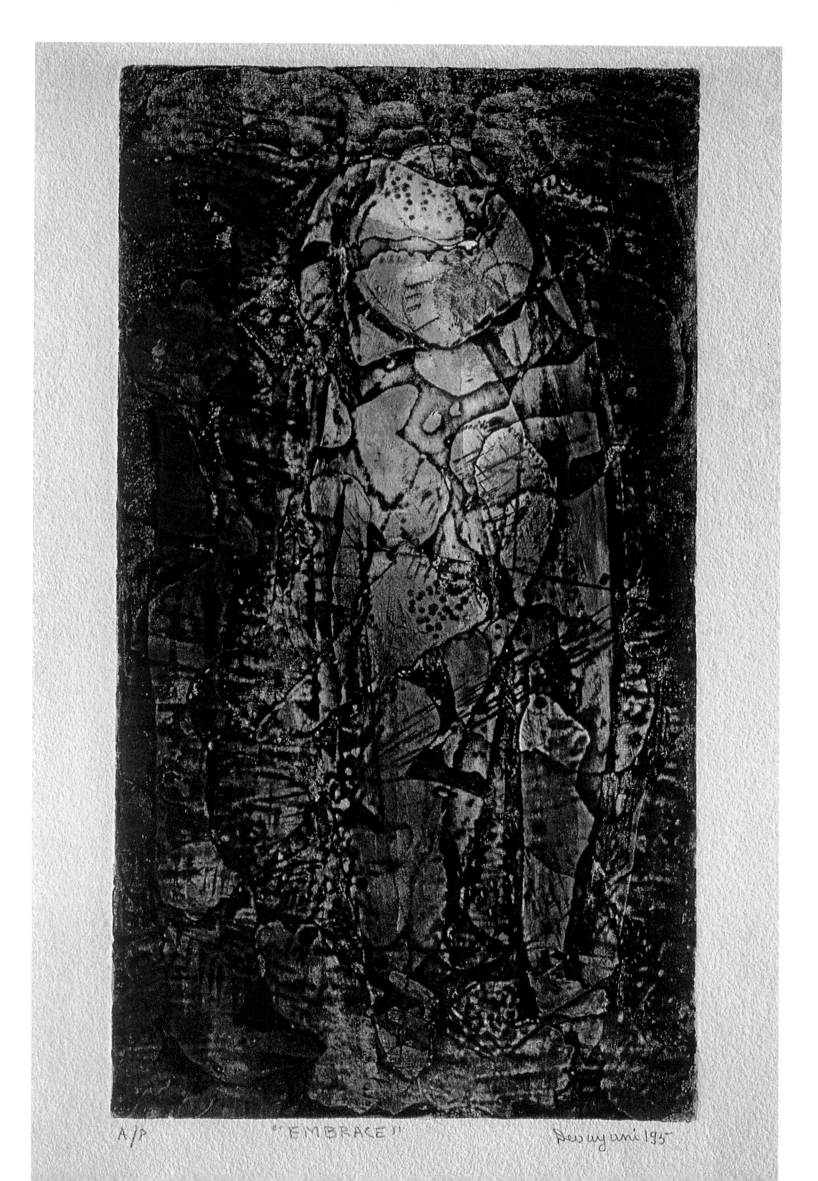

A/P "EMBRACE" Devayani '95

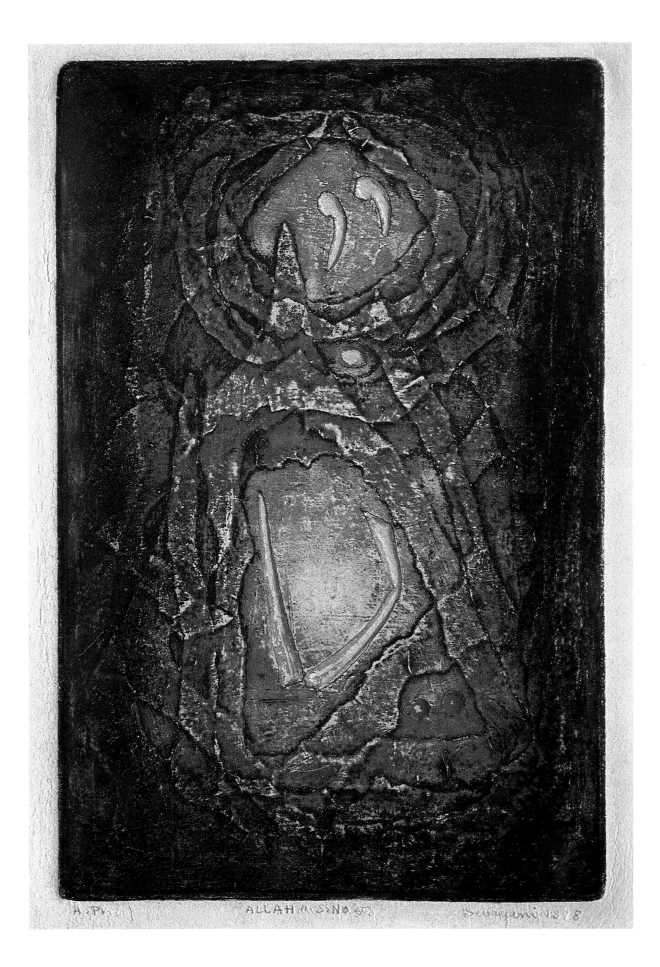

Allah series - 5. 1968.

Collograph.

The artist's approach to the spiritual was freewheeling and eclectic, even as she gave the subject a broad-based interpretation.

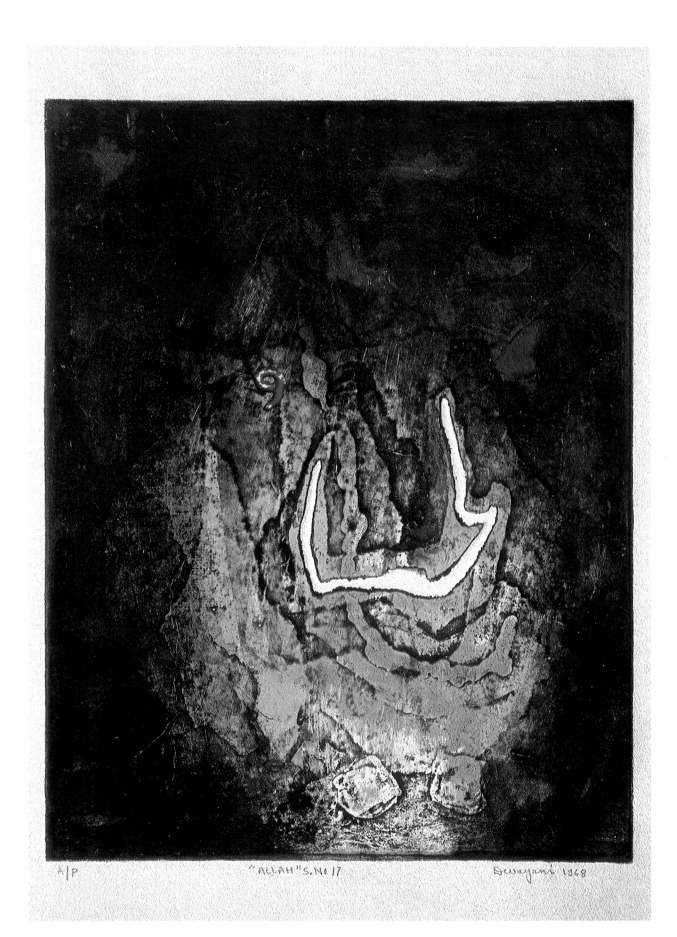

A/P "ALLAH"S. No 17 Devayani 1968

Allah series - 17. 1968.

Collograph.

In her prolific output of this
central image, Devayani Krishna
studied several Islamic
calligraphy forms.

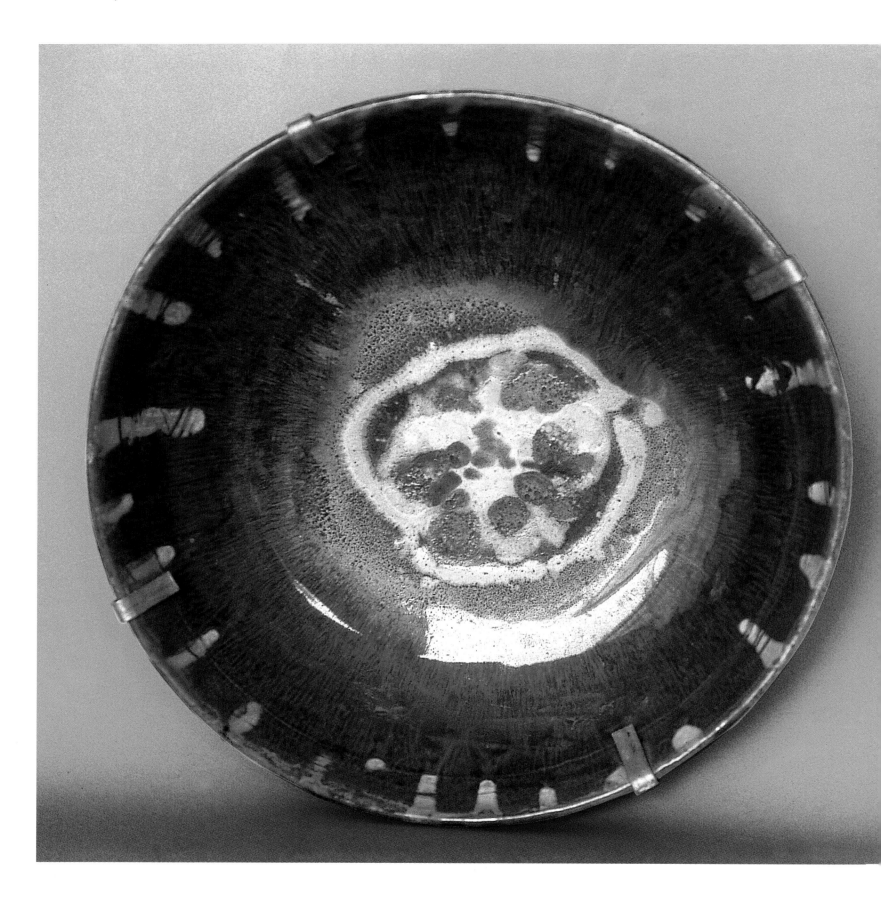

Ceramic Plate. 1970.

Besides introducing the first print
press made in India, the
Krishnas initiated ceramics at
Modern School, Delhi.

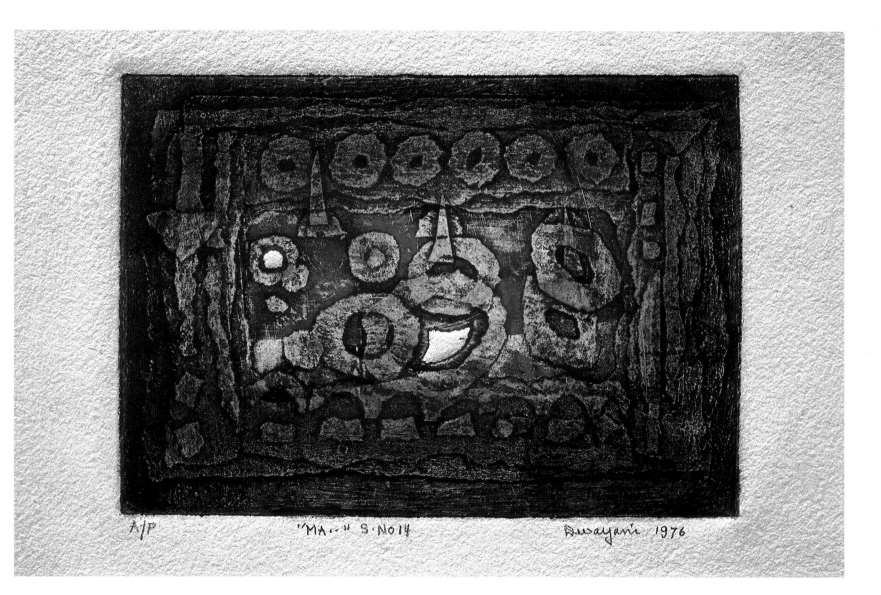

Ma series - 14. 1976.

Collograph.

Her attempt was increasingly to depict abstract themes in a conceptual form.

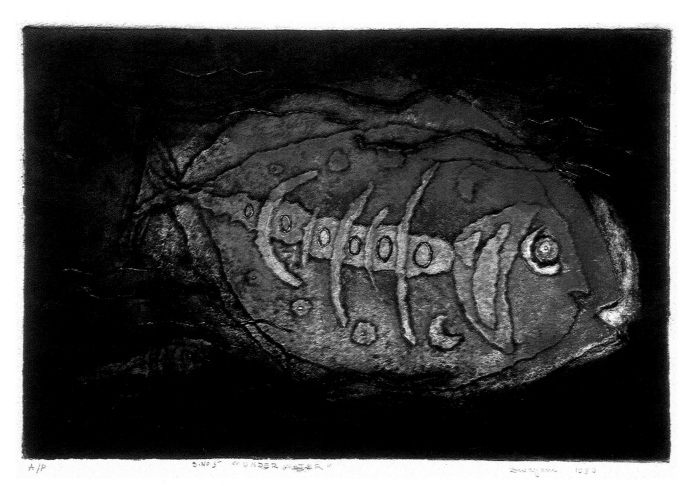

Under Water - 5. 1984.

Collograph.

An imaginative work on the life-forms of the sea-bed.

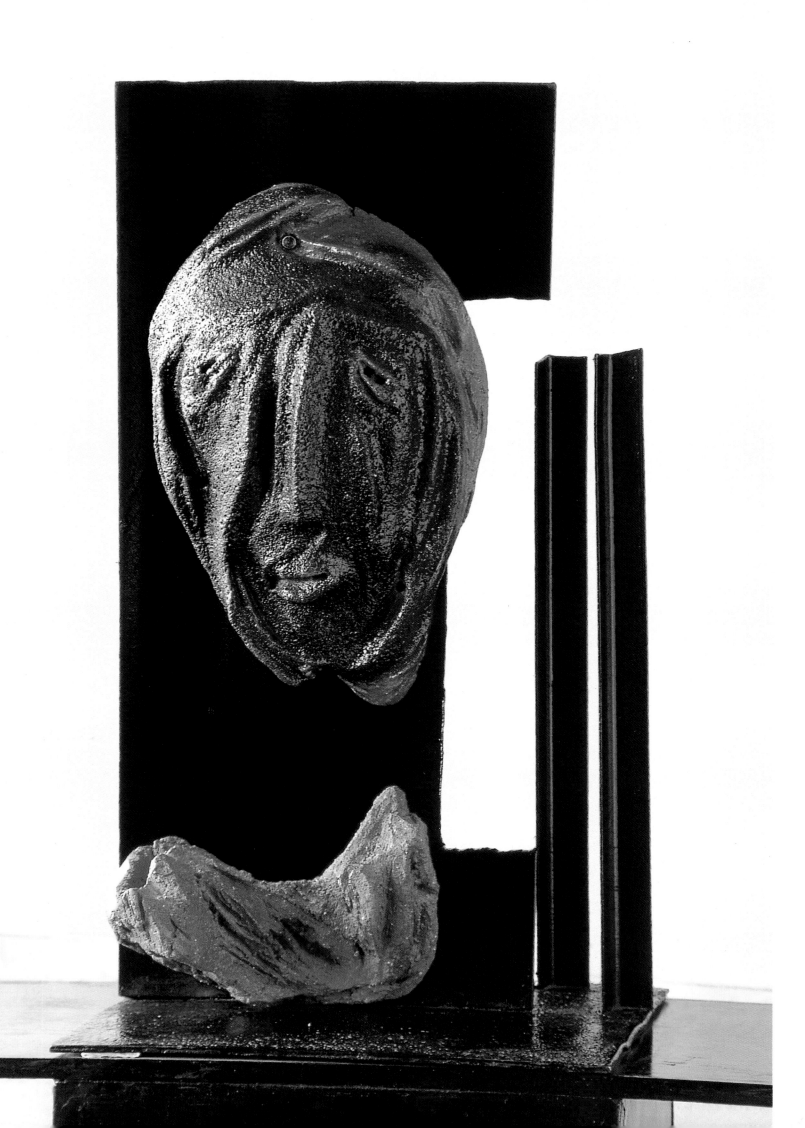

Pilloo Pochkhanawala: Disharmony and Inner Mechanics

Anahite Contractor

Between the mundane and extraordinary exists a hiatus waiting to be unveiled from its unstable, aspiring state, and to reveal to the plethora of critique a world of innovation and complexity. The work of Pilloo Pochkhanawala (1923-86) is a case in point.

Mask.

Terracotta and iron;
59 x 33 x 28 centimetres.
Private collection.

In an experimental mode Pochkhanawala sought to use varied materials, their tactile quality retained in the sharp lines and faint curves of her work.

The early part of this century was certainly not dynamic (or even aesthetically sound) for sculptors in India. By and large, the most horrendous decorative idiom prevailed in the name of art. A limp, schizophrenic language began to develop, imitating ancient temple and cave sculpture indiscriminately and devoid of any contemporaneous relevance. Added to this were the dated leftovers from British academism. Barring the genius of some scattered Bengal and Baroda school artists who were beginning to break free from conventional shackles, modern Indian sculpture was tottering and would have been more aptly termed "hybrid" Indian sculpture, at the time.

Amidst all this, in the mid-1900s, Pilloo Pochkhanawala began to emerge as a serious, complex, thinking artist. Her zest manifested itself in the entire gamut of techniques and media that are available to a sculptor. She began her journey with direct carving, cement, lead

(especially her early quasi-feminist series of women in varying moods which include works such as *Brooding, Pensive, Sari-clad,* and so on). Her nature was essentially one that respected freedom, which is why even in technical terms, she could not pursue wood carving for very long, since this medium possesses an intrinsic tempo of its own, grains which defy undoing and, after a point, choke the inventive quality of a sculptor. Pochkhanawala abandoned wood because she felt that "to impose myself on it would have been vandalism".

By 1958, Pochkhanawala began to sculpt in welded steel, combining it with other mediums and found-objects, so as to yield an effect, not so much of mixed media, but of a wonderful extension of the same basic material. For instance, her sophisticated metal casting or appendages of stone and sheet metal, and later even junk and found-forms — all merged into an amazingly filial quality.

The most radiant example of Pochkhanawala's oeuvre stood proud till recently as one of Bombay's greatest landmarks at Worli. Titled *Spark,* this enormous sculpture was representative of the artist's penchant for unshackling the orthodox rigidity of formal and spatial constraints imposed by the prevailing notions about art.

Aluminium alloy was another medium employed by Pochkhanawala to unravel the convoluted language of space and

line which had possessed her and clamoured to erupt in an individualistic, unconventional manner in her style. Besotted with nature since the very outset of her career as a sculptor, aluminium became her medium (in the early 1970s) for her series of sea and skyscapes. She began to visualize modernist sculpture with the reincarnated version of the landscape. Her narration of the sea in several works was also a passionate dam-burst from within the claustrophobic walls of her metropolis, Bombay. According to the sculptor herself, her homage to the sea was her own balmed vision aroused by the vast expanse of space, "the Indian ocean . . . the only place in Bombay where one can look out into space, not someone's living room . . . the only point of contact with nature" The versatility she rendered to an otherwise restraining medium, helped develop the stylistics of freedom and of unabated vigour, to an age of appalling conventions in art and aesthetics.

Despite Pochkhanawala's studied abandon and release of energy, aluminium did prove to be thwarting with its aloof visual quality. Besides, the sculptor faced technical snags as she did in several of her experiments. Owing to the relatively low receptivity to oxidation in aluminium, Pochkhanawala had to abandon this medium because it entailed a corresponding limpness in expression, and lacked the directness of approach which was characteristic of her style. However, the struggle did go on as the sculptor persisted with alloys of the same material, experimenting with a characteristic sense for detail with a mixture of aluminium and varying permutations of nickel, silica, and copper-bronze — until eventually a rare progeny of alloys was produced for Pochkhanawala to wield as she visualized her dynamic scapes.

It is believed that the history of articulated space has manifested itself in the most amazingly consistent and teleological pattern. The manner in which space is conceptualized within the gamut of the arts, over a period of centuries, determines, to a great extent, the very stylistics of that genre. For instance, the frontal perspective of ancient Egyptian art determined the idiom for that period, just as two-dimensional magic manifested itself in certain Malwa and Mewar schools of Indian miniature paintings, and developed a corresponding notion of space for the same.

As mentioned earlier, the dynamics of space-time were not very exciting at the time of Pilloo Pochkhanawala's advent into sculpture, especially modernist Indian sculpture. With the powerful exception of Adi Davierwala — her colleague and another modern Indian sculptor with similar searching — Pochkhanawala was almost unique in her time, mainly because of her marvellous visionary zeal for puncturing conventions.

Since these two artists shared their complex problems of form, technique and, most of all, of the said space-time angle, it seems mandatory to parallel the polemics of one against the other. Davierwala, who was influenced by Jacob Epstein, culled a specific, recognizable, geometric style for his ambiguously figurative idiom. Davierwala's was the language of the constructivist, although the thick, mechanized figures that he produced (within the same temporal framework as Pochkhanawala) often attracted the title of "mechanical artist" to himself. In actual fact, Davierwala's vision ran wonderfully parallel to that of Pochkhanawala. They were both trying to come to terms with changing ideologies, and to establish once and for all an emancipated methodology of producing as well as viewing art.

The constructivist motif became Davierwala's intrinsic idiom for expression, and for Pochkhanawala it was her dynamic foray into space. Both sculptors dipped into bazaar art, found-objects, and an assemblage of sorts, but it was the extreme sophistication of the co-mingling of these vulgar (as in "common") strategies, that defied the usage and produced a spectacular modern vision.

The seemingly spontaneous forms thrust forward from their given polite boundaries, bounding off in space with a mind of their own. These were really orchestrated with great foresight. In Pochkhanawala's sculpture one often views meditative spatial rhythms adhering to a clinical sense of order, and a futuristic confrontation with canonical problems.

Since Pochkhanawala first began to sculpt in 1951 at the relatively late age of twenty-eight, her obsession was to unscramble the tight boundaries of space which were available to her through the time she existed in. Her arrangement of motifs, the strategic use of negative space around them, the aesthetic disproportions and, occasionally, her violent distortions even within the abstract mode she chose to work with, render to Pochkhanawala's sculpture a keen dynamism even today.

The *Seascape* series (aluminium alloy, executed in 1974) derived its sources from Pochkhanawala's childhood memories of Zanzibar, where as a young girl, she occasionally saw dead bodies washed ashore. These were later reincarnated into ceramic, steel, and aluminium alloy — *Ophelia* with her gasping, desperate expression being a perfect example.

So it was established that Pochkhanawala's stylistics encompassed both poetry and technology; her sculpture speaks an ambiguous language of raw, primeval strength, even as it undulates with unmistakable fluidity, grace, and a modernist relevance. All this for a commerce graduate, self-taught sculptor is paltry euphemism.

Although it is commonly believed that in Pochkhanawala's work material and technique predominated, I strongly reject this notion as simplistic and devoid of analytical procedures.

Even though her style might seem dated today (as would that of any of her formidable Western counterparts), it cannot be denied that Pochkhanawala had a legitimate tenacity for bringing about a rare marriage between form and content. If one tends to overlook her relevance on the modern Indian artscape of the mid-1900s, it is simply because history has a ruthless way of moving onward.

When, in 1951, Pochkhanawala first visited art museums in Europe, she was struck by the freedom of space that she viewed in great Western art. She said, "The paintings did not ruffle my composure unlike the new sculpture . . . (it was) . . . like a bolt Evidently it was my sudden grasp of the third dimension that left me mortified by the sculptures I was seized by the feat of the challenge of tackling something so difficult."

However, she did take up the challenge and substantiated Henri Focillon's theoretical premise that a work of art treats space according to its own needs, defines space, and culminates in a stage whereby space is created like the plastic worth of the work itself.

Pochkhanawala was influenced by Western masters such as Brancusi, Chadwick, Calder, and the mobility and monumentality of Henry Moore's works. She often quoted Moore's famous statement and imbibed it for her own methodology: "For me, a work must have . . . pent-up energy, an intense life of its own, independent of the object it may represent. When a work has this powerful vitality we do not connect the word 'Beauty' with it. Beauty, in the late-Greek or Renaissance sense is not the aim in my sculpture." Pochkhanawala too aspired towards this philosophy and substantiated it in her work, whether she was doing a massive thirty-foot public sculpture or theatre sets in thermocole.

The mid and late 1970s (1974 onwards, to be precise) saw a spate of *Metalscapes* and the *Time Cycle* series from Pochkhanawala. The *Metalscapes* almost undertook the treatment of maquettes because after the sculptor's experiments with aluminium alloys, just before this phase, she began to wield relatively smaller pieces of metal into forms which were potentially capable of immense scale and sprawl.

It was at this juncture in her career that Pochkhanawala began to concentrate on searing the rigidity of welded scrap metal which she had been using, and formulating an idiom of liquid lines through cast aluminium. It was from this point onward that her images of the elemental forces of nature came into being, and established an enduring relationship with her oeuvre. She visualized public sculpture as a medium for interplay with the actual forces of nature. One of her works titled *Coral Reef* was executed with a kinetic dimension to it; it was meant to be installed at one of the Bombay beaches so that at high tide the waves could actually lap up a conversation with the sculpture and exist in tandem with it. Highly polished and minimalistic in essence, *Coral Reef* is truly Pochkhanawala's representation of a sophisticated economy of line along with a wealth of detail.

Pochkhanawala once stated, "There is inevitably a gap between a concept and its concrete realization. It is my problem as a sculptor to narrow the gap, to amalgamate idea with form." And this she achieved with diligence and passion, creating an interplay of semi-geometric contours with meaningful negative spaces and also by blending and contrasting textures so that a kinaesthetic quality is stimulated between points and a studied multi-dimensional quality is developed.

Between 1977 and 1979, Pochkhanawala had embarked on her major series titled *Time Cycle* which is characteristic of her metaphysical probings and of cyclical patterns inherent in nature. She used the Indian concept of preservation, destruction, and re-creation in order to celebrate life with a realistic sense. These nimble combinations of semicircular steel rods, exposed armature, and enormous sweeps of heavily textured cast aluminium, rendered to the *Time Cycle* series the circumlocution and maze-like continuum of life itself. During this period, Pochkhanawala established that, as far as her own stylistics were concerned, a time-cycle was not about rebirth, but about ". . . the continuation of the species. I, as I am, have my allotted time span, and that is all." Her concerns were not other-worldly, but of immediate accord.

Before Pochkhanawala finally succumbed to her raging cancer in 1986, she turned once again to a theme which helped her to come to terms with the situation or at least to unravel it in a private manner, as one would in one's personal diaries and journals. In 1980 she turned away from nature, but only relatively, for her concerns remained perennially earth-bound as well as probing and metaphysical. The next two years were spent manifesting her personal anguish in a series titled *Death-Mask*, whereby it was her intention to project ". . . death in human beings, animals and the landscape". These were mainly unglazed terracotta masks, morose in quality, with an abated expressionism within them and an intense preoccupation with death. These masks are mounted as on dark angular metal scaffolds — as menacing and inevitable as the theme itself.

But after a relatively brief sojourn into the personal dimension, Pochkhanawala made a return to the *Time Cycle* series, probably because it afforded her the aesthetic distance which she was curious to attain, even as she maintained a personal record. In these last few years, she resorted to the motif of the cloud, celebrating nature once again with organized principles of spatial constructions and producing even within metric patterns, a unique bulbous, elemental solidity.

It has always been an enchanting exercise to observe and analyse a sculptor's sketches. Pochkhanawala is certainly no exception. She did some detailed drawings which could, at that very stage, unravel the third dimension

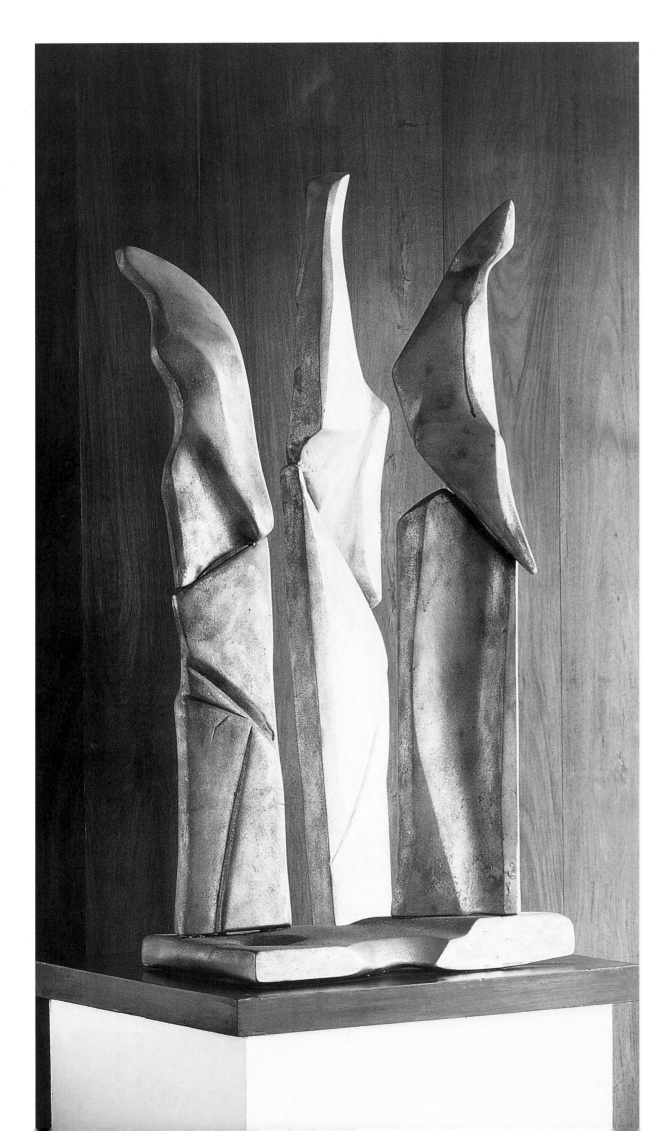

Triple Ascent.

Aluminium alloy;
108 x 48 x 40 centimetres.
Private collection.

Pochkhanawala used aluminium
alloy from the early 1970s, for
its fluid, tensile quality.

found in sculpture. Both mass and negative spaces were treated with great finesse and foresight, so that even her drawings had an amazing tactile quality about them.

The architectonics of Pochkhanawala's style and the splendid constructivism which make her sculpture easily recognizable even today, possibly sprang from her ability to visualize beyond the defeating two dimensions of paper. An integrated structure with its spirit of abandon could easily be foreseen from the flourish of the sculptor's pen, and the furious cross-hatching acts as a womb for multifarious depth dimensions.

Fragments make a form. Conversely, it could also be a solid form which is the stimulant for isolated parts. In Pochkhanawala's sculpture one views a contrapuntal force at work — a force which defies spatial dimensions to conquer the ambiguous and kaleidoscopic contour of a given form.

Like the formalists of the modern world, Pochkhanawala determined to establish through her form of art that volume is space itself. Complex geometric regulations account for spatial depth and complexity. An almost Matissean "unnaturalistic" line was employed in order to achieve that phenomenal sense of abstraction, and a topsy-turvy world of forms that precariously defied "order" as we know it.

This sculptor toppled the polite formulae of existing standards and, like Rudolf Arnheim, established that distortions create space. Both extension and infinity are intrinsic to Pochkhanawala's sculptural space, just as it holds tantalizing illusions and transient images within the sculpted juggled areas.

Pochkhanawala's sculpture constituted a spatial arena, thrusting its lines forth, or being sucked into the crevices of a form, crouching in, inviting light to play across its contour until it could spring forth in merriment, maintaining its elastic multiplicity, and defying conventional ways of viewing art.

She often wrote poetry, romantic and passionate in tone — much like her sculpture

and drawings. It is her "Courage" that acts as a befitting requiem:

To float on the wave
Of your own choice
Aware that you may drift
As flotsam on a forsaken shore.

Figure Acknowledgements
All photographs by Ravi Kashalkar, courtesy Cymroza Art Gallery, Mumbai.

Drawing.
29.50 x 52 centimetres.
Private collection.

Pochkhanawala's drawings, though infrequently seen, reflect the demands she made on resistant materials to achieve her goals.

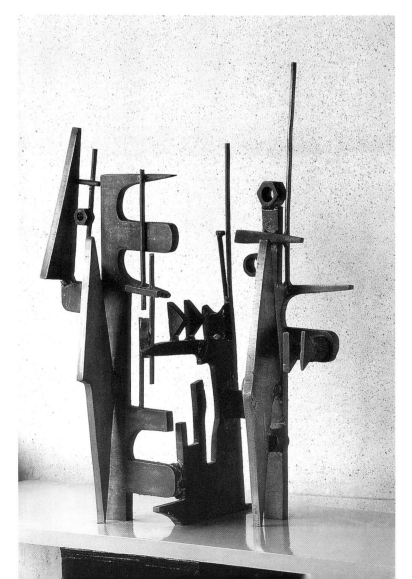

Ascent. 1970.
Scrap metal;
63.50 x 40 x 20 centimetres.
Private collection.

Scrap metal, symbolic of the industrial detritus of Bombay, was used by Pochkhanawala to break away from conventional methods of sculpting.

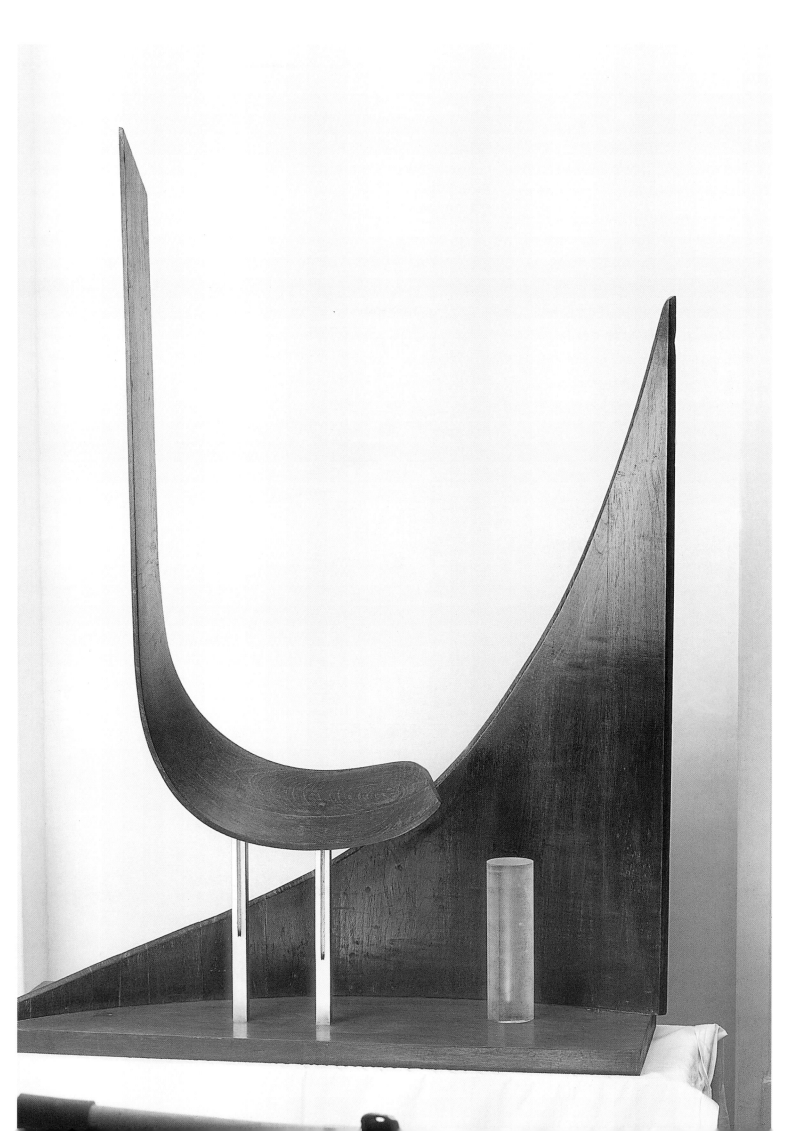

Title not known.

Wood epoxy;
124.50 x 89 x 30 centimetres.
Collection of the
Pochkhanawala family.

Pochkhanawala's experiments in
the use of geometric forms to
contain negative space were a
continuing endeavour.

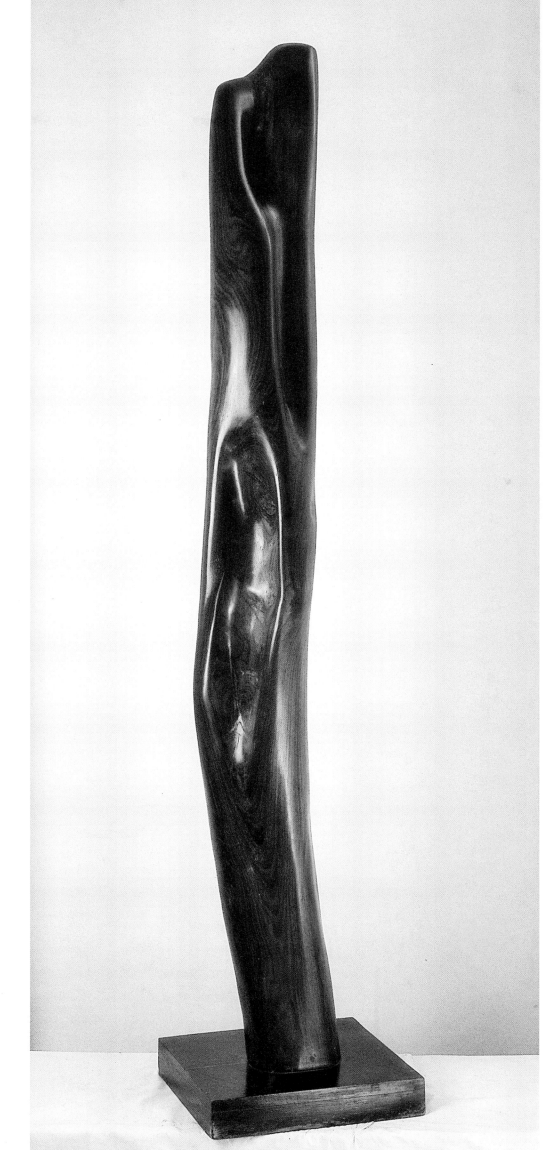

Title not known.

Wood;
178 x 21 x 21 centimetres.

Collection of the
Pochkhanawala family.

Some of Pochkhanawala's early
work was in wood, which she
gradually outgrew since wooden
grains dictate their own logic of
construction.

Meera Mukherjee: Recasting the Folk Form

Tapati Guha-Thakurta

To meet Meera Mukherjee is to encounter a wall of privacy and self-enforced solitude. To trace in her a stance that is specific to her position as a woman artist is to come up against a further wall of reticence. For there is in this septuagenarian artist, the most remarkable of sculptors on the modern Indian art scene, a resistance against placements in any school, group, or movement. Such a resistance has become constitutive of the image of the artist, as a lonely, struggling individual, immersed in work, oblivious of the demands of wealth and publicity.

The image has a long genealogy, central as it is to the modern mythology of "art" and "artists". In Meera Mukherjee that mythology is subtly subverted even as it is reproduced in other forms. Her life and work have in many ways been radically interventionist: what they threw out was a fundamental challenge to some of the key assumptions of modernity, to the distinctions and hierarchies it posed between "artist" and "artisan". The artist's special genre of metal sculptures, drawing on the forms and techniques of the Bastar and Dhokra craftsmen, has reinscribed the "folk" within the parameters of the "modern". Likewise, her life has repeatedly broken out of the mould of a comfortable middle-class existence, in pursuing her impulse to integrate her modern self with the idealized persona of the tribal craftsman.

In a career stretching from the late 1950s, the most momentous point seems to have been Meera Mukherjee's decision in 1960 to live and work with the metal craftsmen of Bastar. What followed was a fellowship from the Anthropological Survey of India to conduct an extensive survey on the metal craftsmen of India, and long sojourns in the tribal belts of West Bengal, Bihar, Orissa, Nepal, and South India. This experience has come to provide the key to her entire artistic output. It lays out the central frame for viewing the evolution of her sculptural technique and style. It is important, however, to locate this framing moment of her work and career within the broader spectrum of her personal and artistic history — to play out its significance amidst the run of other beginnings and other ends in her life.

Narrating Her Life: Beginnings and Directions

Born in 1923, Meera Mukherjee was admitted to the art classes of the Indian Society of Oriental Art at the age of fourteen. Here she was taught painting by Kalipada Ghoshal, an archetypal "Indian-style" painter of the Abanindranath school, and sculpture by Giridhari and Maheswar Mohapatra, two traditional craftsmen the Society had sought out. Now in her seventies, this is

Sitting Woman.

Bronze;
62 x 50 centimetres.
Collection of
Georg Lechner.
Photograph: Geeti Sen;
courtesy Max Mueller
Bhavan, Mumbai.

Meera Mukherjee's seminal inspiration was the "living arts" of India. Here the posture of the figure and the ribbed surface of the metal draw equally from sculptural tradition as from the artist's talent.

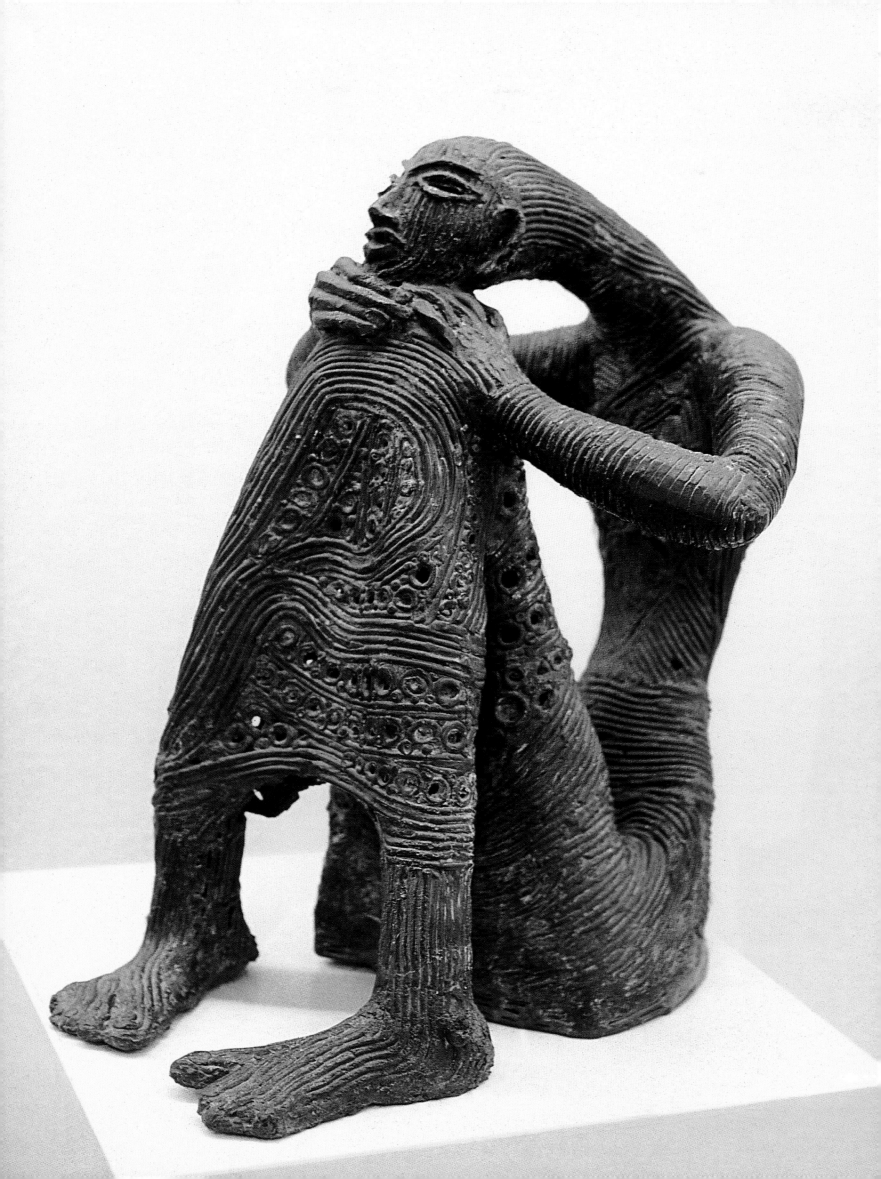

where she locates her "beginning", way back in 1937. Years later, in the course of a short-lived marriage that brought her to Delhi, she acquired another intensive five-year training and a diploma in painting, graphics, and sculpture in 1951 from the Delhi Polytechnic. The two stints of training stood at odds with each other. In Calcutta, the teaching had been entirely in the "Indian style"; in Delhi, that training was never recognized and, in fact, fully reversed by a "Western" academic rota of classroom work. Even if they together equipped her with a wide vocabulary, the artist perceives both kinds of training in terms of a major lack. In neither case did the teachers explain what lay at the roots of the styles they were imparting, what their histories and meanings were, what she was to learn to "see" through them.

It was at the Akademie der Bildenen Kunsten in Munich which she joined on a scholarship in 1953 that she became aware of this lacuna in her training. The offer also lifted her out of a major personal crisis: a broken marriage, social scandal, lack of material support, and dependence on her brother's family. Here in Munich, amidst other German students, the question of her Indianness and autonomous identity first obsessed the young artist. She seemed so exotically different in her looks, in her dress and demeanour, in her conversation and thinking; yet why was her work like that of any other good Western student? This question, once put to her by a fellow student, tormented Meera Mukherjee for months. It forced her to begin questioning the taught modes of seeing and representing. Now, she recalls, came the period of catharsis, a slow painful struggle at resolving this inadequacy. The results were elusive, hard to come by: for it was a search not just for a style but for her self. She worked tirelessly to arrive at a personal idiom that would be as strikingly indigenous as her Indian sari, and as completely individual as her own being and person.

Till then, she had been working on large life-studies in the academic convention. In her own room she began to experiment on some smaller innovative pieces in bronze. In a fortunate break, her professor introduced her to the head of the casting department who offered to cast some of these pieces for her. The whole process of casting at the Akademie was shrouded in secrecy and exclusiveness: the entire job would be handled solely by professors on models handed over by the students. It became her special privilege to be permitted to work even in the adjoining "finishing" section of the casting rooms, where she would be given her cast metal moulds in raw to work out the details, where she learnt a variety of new cutting, furrowing, and embossing techniques. At the end of her two-year term she was awarded another two-year scholarship by the Deutsche Akademie to do a Master of Arts.

However, much to the disappointment of her teachers, Meera Mukherjee gave up this opportunity and returned to Calcutta in 1956. This she marks as another critical turning point in her life. A long-nurtured dream and plan stirred in her of searching out the different metalwork traditions of her own country and working with these artisan communities. She remembers, in this context, her first spellbinding encounter with archaic Egyptian and Etruscan art in the galleries of the British Museum in London and the strong affinities she perceived between these and the folk traditions of her own country. The "dead" and long-lost art of Europe made her sharply aware of the continued living presence of similar arts in India. A sense of a living tradition now appeared to her as her special bonus as an Indian artist.

Yet, the Calcutta to which she returned offered little support for her plans; there was no money, nor any proper home to return to. She went out to teach in Dowhill School in Kurseong for a year,

then returned to Calcutta to teach at Pratt Memorial School. Finally, in 1960, throwing up her job and gathering together her meagre savings from four years of school teaching, she headed for Bastar encouraged by the anthropologist Dr Surajit Sinha, with whom she had first seen samples of Bastar metalcraft.

On the Trail of Traditional Craftsmen

This is what the artist, and all who view, collect, or study her work, would consider the true founding moment of her artistic quest. Her book *Metalcraftsmen of India* (1978), the hardworked product of the surveys she conducted under the aegis of the Anthropological Survey, provides us with a detailed itinerary of her travel, search, and encounters. In the volume of information it offers on each metalworking caste and community, and each of their lifestyles, work techniques, and equipment, also lie hidden snippets of the artist's personal history. The anthropological account comes laced with a sense of her private strife, her frustrations and successes, as she struggled to situate herself and her work within these craft traditions. This self-location was never free of tensions and contradictions. Continuously, then, and throughout her later work, the problem would remain as to whether this celebrated exchange between the modern and the folk could ever be a symmetrical one. The lines between discovering and learning on the one hand, and appropriating and transfiguring on the other, would always require to be redrawn and renegotiated.

The animosity of the craftsmen towards an intruder and potential competitor marked the beginning of her sojourn. Landing in Bastar in the middle of much political turmoil in the region, she found the artisans unwilling to impart their work techniques beyond a point. Once again, she was not allowed to participate in the casting process. It is no wonder, then, that to Meera Mukherjee the experience of

casting is still wrapped in mystery and wonder. What was once kept from her as a jealously guarded technique would soon be hers, but it would continue to invoke in her the same mystical resonance.

The process she perfected from these craftsmen was one she already partially knew and one she still practises. It is known as the lost wax or *cire perdue* method, and is common to various folk metalwork traditions across the globe. Its fundamental principle revolves around the building of an initial wax model (moulded solid if the pieces are small, or left hollow inside in the larger pieces), which is encased in clay and baked. Through an opening in the clay cast, then, a mix of liquid metals heated over many hours in a furnace is poured in, letting the initial wax model melt away and be replaced and replicated by a solidified metal mould. With the mould fully formed, the outer clay cast is broken open. The finishing task is to work out the surface details on the metal figure, and to improvise with the invariable gaps and flaws.

The resistance of the craftsmen to fully share their work methods with her, she later felt, was a blessing in disguise. For it forced her to experiment and innovate on the basis of the little she knew and observed. It also left the artist free, for instance, to try her hand at a completely new range of forms and at an enlarged scale of sculpting. Whatever the initial hostilities and hardships, Bastar was for her a uniquely rewarding experience.

It set her off on a long trail in search of her "living tradition". In March 1961, Kamaladevi Chattopadhyaya of the All India Handicrafts Board arranged a stipend for Meera Mukherjee to study bronze casting at a bronze production centre at Bangalore. This was her first encounter with craftsmen working in the classical sculpting tradition: an acquaintance she would later enrich in the course of her more extensive tour of the South Indian temple towns. Immediately after, followed another course in Calcutta in bronze casting with

Prabhas Sen at the Regional Design Centre. Here she had the opportunity to see the work of various other folk craftsmen — the Dhokra artisans from West Bengal and Bihar, the Khoruras and Ghantrars from Orissa, and a group of Nepalese Sakya craftsmen from Bhaktapur — all of whose work would fascinate her as deeply as that of the Bastar Gharuas with whom she had first worked. Then, in April 1953, the intervention of Professor Nirmal Kumar Bose obtained for her a Senior Research Fellowship from the Anthropological Survey to investigate the state of the indigenous metalcrafts of India.

Metalcraftsmen of India stands as a record of three years of work and travel. Later writings in Bengali would touch on the more personal romanticized undercurrents of these tours, staging them as a voyage into the innermost recesses of tradition, creativity, and the self. There are recollections of great physical toil and financial hardship — cold nights of lying awake; working at furnaces, waiting for the metal to heat or for the cast to cool and harden; long delays and bottlenecks in the stipend coming through to her, in distant parts, where she would be as down and out as the artisans, with little to sustain her except the joys of work. Coupled with these accounts is the idealization of the timelessness and humbleness of the folk traditions, the wonder of the discovery of each village and craft community, and the unravelling of their lineages to distant, historic pasts. Throughout, however, the artist's own work stands foregrounded as the most powerful testimony of the experience of these years.

From the Folk to Her Own Art

Meera Mukherjee had been exhibiting her work since her student days at the Society of Oriental Art, but it was these years spent in close observation and participation in folk art methods which would be the most influential

and formative for her work. They laid at her disposal a fund of images, conventions, and techniques, which she could embellish with her own expertise and imagination. In her hands, a recognizably folk art idiom, one she had closely internalized, was transformed into a sculptural style that bore her inimitable stamp. Similar techniques of preparing moulds and casts, similar ridged and embossed patterns were made to produce a range and type of sculptures whose pedigree was clearly individualist, modern, and urbane. Throughout, her style has retained its folk lineage, but it has thrived on introducing into the folk form a scale, volume, and versatility that is her unique artistic trademark.

The artist's images have taken shape as much from myth and folklore as from everyday rural and urban life. Traditional icons, so far as they find a place in her repertoire, assume a radically transformed, individualized presence. So, her dancing Behula emerges dancing and tilting from the edge of a floating raft, and Nataraj takes on a third leg and a frenzied ebullience in *Cosmic Dancer*. From myth and legend, we are taken swiftly into the realm of the everyday and the contemporary. Even as the artist underlines the physical labour of each production, one of the main themes that runs through her sculptures is that of work, toil, and daily activity. The images range from the purity and earthiness of village life to the dehumanization of urban existence. We meet fishermen throwing nets, women pounding rice, weaving baskets, stitching *kantha*s, or carrying pitchers on their heads: equally we have male and female labourers passing loads, workers laying cables, the bustle around a slum, minuscule bodies pouring out of a bus, or faceless figures hanging on to bus rods. The crowning image of this genre is her monumental piece *The Spirit of Work*, now in the National Gallery of Modern Art, New Delhi.

The theme of work finds one kind of contrast in the artist's equally arresting images of fun, play, and leisure — of a game of *Ekka*

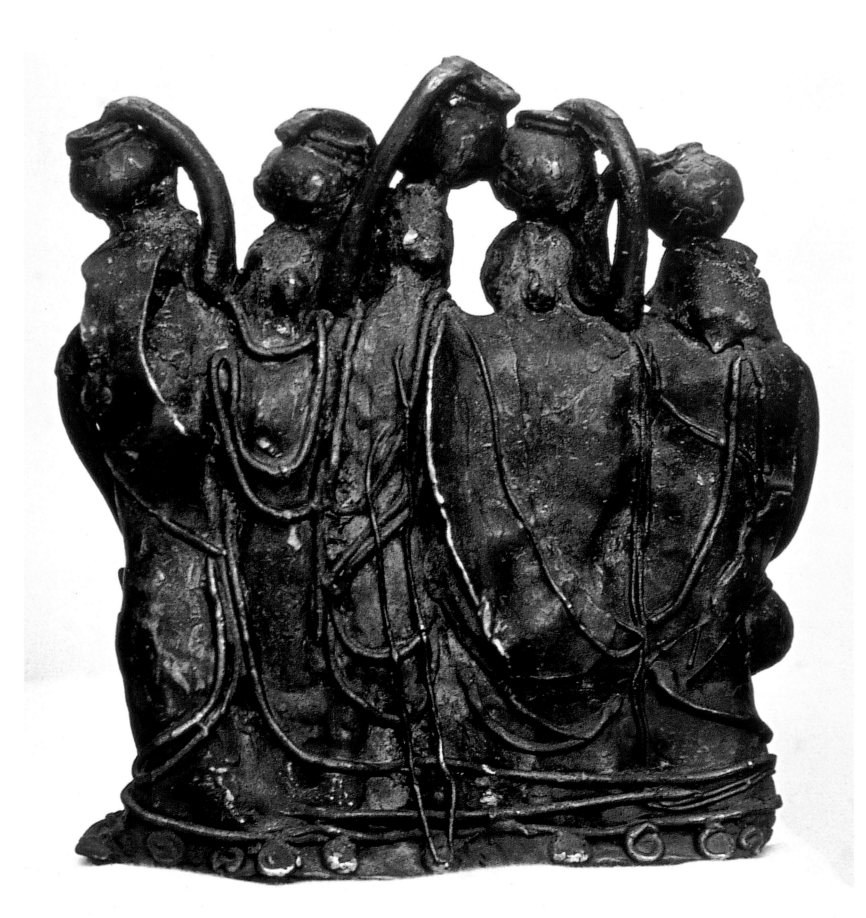

Panghat
(Water bearers).

Bronze;
30 x 26 centimetres. Collection
of Srila Mookerjee. Photograph:
Abhijit Basu.

A continual refrain in Meera
Mukherjee's work is the image
of daily toil and activity.

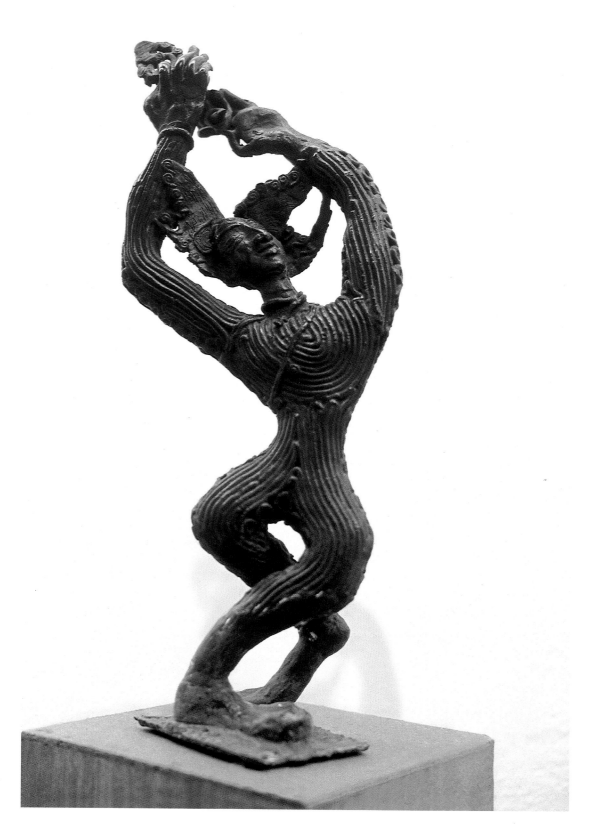

Baul.

Bronze;
47 x 18 centimetres.
Artist's collection.
Photograph: Geeti Sen;
courtesy Max Mueller Bhavan,
Mumbai.

The wandering mystic of Bengal,
the Baul, sings and dances in
inspired rapture.

Dokka (hopscotch), of straggly boys hanging *Topsy-Turvy* from a tree, of dogs and cats, of hordes of buffaloes and elephants, of a grandmother narrating stories and mothers caressing children. While they shed all sentimentality, these small pieces instil amazing qualities of delicacy and tenderness into the hardness and angularities of metal. Work, movement, or activity find another powerful counter in Mukherjee's output of contemplative images, wrapped in moods of lyricism and quietude. A favourite subject here is music. A large body of sculptures of singers and musicians opens up a lesser known side of the artist: her parallel life-long passion for music and her training as a classical vocalist. There is also in her a strong streak of pacifism and a Buddhist faith, which has found expression over the years in some large serene figures — of the sage Balmiki, of a seated Buddha, of statuesque female figures in *Thought* and *Repose*, or her most memorable towering image of Emperor Ashoka laying down his sword at Kalinga.

The small and the monumental, the mobile and the still, dense narratives and single, massed figures — together map the spectrum of the artist's oeuvre. Meera Mukherjee's ingenuity lies in her transfiguration of the folk art form into an entirely different creative idiom, realizing in it a set of novel possibilities. We see this, for instance, in the way she has elaborated the wax moulding and metalcasting technique to create highly intricate and complex tableaux, with webs of figures and shapes, with tiny forms worming out of crags of metal scrap, or with a flourish of etchings on metal relief. We find the artist, here, revelling in the sheer materiality of her medium, making the most of each irregularity in the mould, letting forms grow out of every dent, lump, or jagged edge. A tree swept by a storm, a "kite house", the crowded scene of a Benares ghat, the figures and shanties of a *Basti-Bari*, boats and boatmen swirling around a spherical *River*

of Life; these form some of the most evocative images of this genre.

The artist's innovations on the folk medium are even more dramatically evident in the enlarged scale of her sculptures, where she holds the viewer in awe not just by the magnitude of the figures but also by the sheer labour that has gone into their casting. Sometime in the mid-1960s, Mukherjee became preoccupied with volume and size. She began to experiment with massive pieces which required to be cast separately in several parts over long periods — the challenge was to conceive of each part to fit the other and the full structure, without the facilities of a prior trial. The first, most majestic product of these experiments is her *Ashoka at Kalinga*, nearly eight feet tall, as powerful as it is poignant. It was the artist's statement against the Naxalite violence that gripped Calcutta in the late 1960s. For a long time, *Ashoka* stood in the small grounds of the artist's Paddapukur residence. Cast in twenty-six parts over two years, the artist's reflections on the making of this sculpture provide it with its critical annotations. They highlight all the elements of trial and error, anguish and ecstasy that have been integral to the artist's sense of the production process. To her, it was the ultimate of wonders when *Ashoka*, never checked before for balance or stability, managed to stand on its own feet.

In recent times, advancing years and failing health have prevented her from sculpting very large pieces. Her exhibition of 1993 brought on view one new large sculpture. With a reddish tarnish that makes it appear like a terracotta piece, it takes up her favourite form of a large-eyed, large-limbed female figure seated at a loom which frames the whole sculpture. The rise and fall of her massive hands as she weaves, the artist explains, symbolizes the ebb and flow of life. Called *Ihokal*, it brings to the fore the increasing metaphysical,

idealistic slant in the artist's work.

Another exhibition of her recent sculptures from the winter of 1994-95 offered another large spectacular female figure — a centrepiece surrounded by some smaller, intricate pieces. A series of her musicians, a pirouetting Birju Maharaj and an enrapt Amjad Ali join several others playing the flute, veena, mridanga, or the pakhawaj. Two delightfully inventive images — *Belpata Gatha* and *Barboti Khet* — emerge from the artist's favourite repertoire of motifs of village women at work, ensconced in the intimacy of the local rural milieu she knows so closely. Her flair for dense narrative compositions, working out animated details from a jagged mass of metal, reaches a new pitch in a piece where a foliated tree grows out of the rear of a multi-tiered hutment. Finally, as a *tour de force* stands her gigantic female figure, in shining bronze, her two outsized arms raised at the shutters of a window from which she gazes out. Titled *Akash* (Sky), it seems to evolve from a smaller image of *Kal Baisakhi*, where a woman opens a window into the impending storm.

The Artist as Craftsman

In many ways, Mukherjee has been living the life of the village artisans with whom she identifies. Her work follows their seasonal routine; all her casting is stored for the winter and carried out with them in village furnaces. Like them, she also resorts to distress sales of her sculptures. She is well known in Calcutta's art-collecting circuit for seldom quoting a price for her works. The sale of her masterpiece, *Ashoka*, stands as a telling example; in 1977 it was purchased by a hotel chain for only Rs. 75,000: an amount that would hardly cover the cost of its metal today. Meera Mukherjee's naivete in financial matters and her failure to keep a record of where her sculptures go have become legendary: while they feed on a common image of the other-worldly artist, they

go in tandem with a life that has long been lived alone, in austerity and hardship, outside the limelight of the elite art world. Spectres of bereavement and grief seem to have a constant presence. Her diaries of her casting seasons are filled with episodes of illness and death — of friends and family in Calcutta, of village children and co-workers — underlining the odds that each piece of her art has had to contend with.

The President's Award she won in 1968 for Master Craftsman in metalwork summed up the obvious paradox of Meera Mukherjee's identity. The "master craftsman" here was already an established modern artist in her own right. Yet, even as exhibitions, awards, and sales marked her growing status, the artist was acutely uncomfortable at the privileging of her position vis-a-vis the craftsmen. It had never been her intention to displace the folk artists by the implicit publicity that was given to them in her own art. Resisting this effect, she has laboured to support and protect the Gharua and Dhokra craftsmen in whatever ways possible. She has tried to draw them out of their obscurity, help them with sales and orders, create a taste and awareness of their art in urban middle-class circles.

Today, after years of effort and frustration, the artist clings to her utopian vision of the self-survival of the folk arts in an uncommercialized, pre-modern rural milieu. Moving away from the racket of promotions, exhibitions, and orders for mass production, Meera Mukherjee has removed her commitment to these craftsmen to a personal creative plane. These folk artists, their work and lives, have come to fill her entire world. They spring out of all her writings and images, her pastel sketches and paintings, or her self-illustrated children's tales about Santhal boys and girls — four of these children's books were published by Seagull Books, Calcutta in 1992. The "folk" has become so deeply ingrained in all work that it serves as her sole distinctive symbol.

For a long time, Mukherjee has been convinced of a continuing strand of Buddhist faith and practice among the metal craftsmen she met, scattered from Nepal to South India. For her it has been the pursuit of an enigmatic spiritual trail, unearthing hidden Buddhist traces and links, constructing her own civilizational view of her art tradition. Her book *Vishvakarmar Sandhane* (In Search of Vishvakarma), is given over more fully to this trail. Here, more than ever before, we find the artist withdrawn from reality into a world of myth and fantasy. In it, all the legends and iconographies she recounts keep dissolving into the recurring myth of the original creator. The very artist who had always prioritized the elements of labour and toil in her work now returns the whole process of creativity to a meditational force: to *dhyana* and an inner intangible inspiration. On this count, a work like *Ihokal* or *Akash* and a book like *Vishvakarmar Sandhane* stand together. In them, we see the artist in the twilight of her life, locating herself within what she has imagined and enacted as her "living tradition", sliding into the reification of "art" even as her sculptures in all their magnitude turn more lyrical and contemplative.

An illustration from the artist's book of children's stories, *Kalo o Kokeel/Chhobi Anka* (1992).

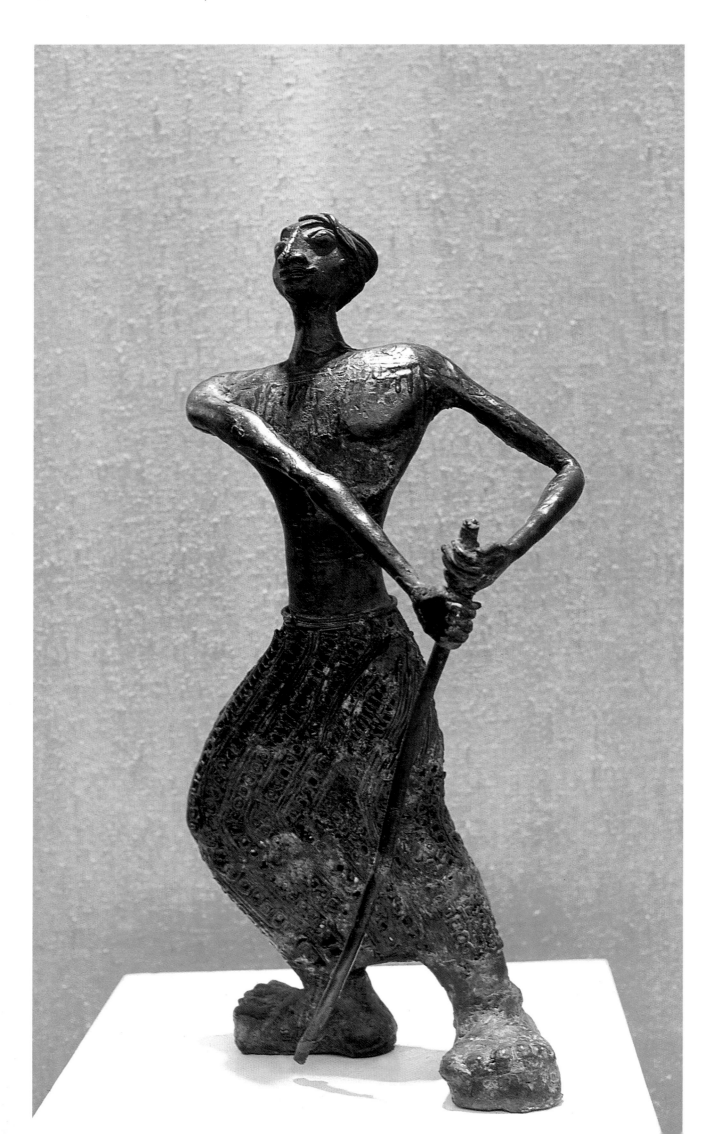

Boatman.

Bronze;
78 x 26 centimetres.
Collection of Surogit Banerjee.
Photograph: Geeti Sen;
courtesy Max Mueller Bhavan,
Mumbai.

Romance and power are evoked
in the figure of the ordinary,
anonymous worker.

Cosmic Dance.

Bronze;
46 x 35 centimetres.
Collection of Rubi Pal
Chowdhuri.
Photograph: Geeti Sen;
courtesy Max Mueller Bhavan,
Mumbai.

Meera Mukherjee's Shiva as the
divine dancer marks a rhythm of
"frenzied ebullience".

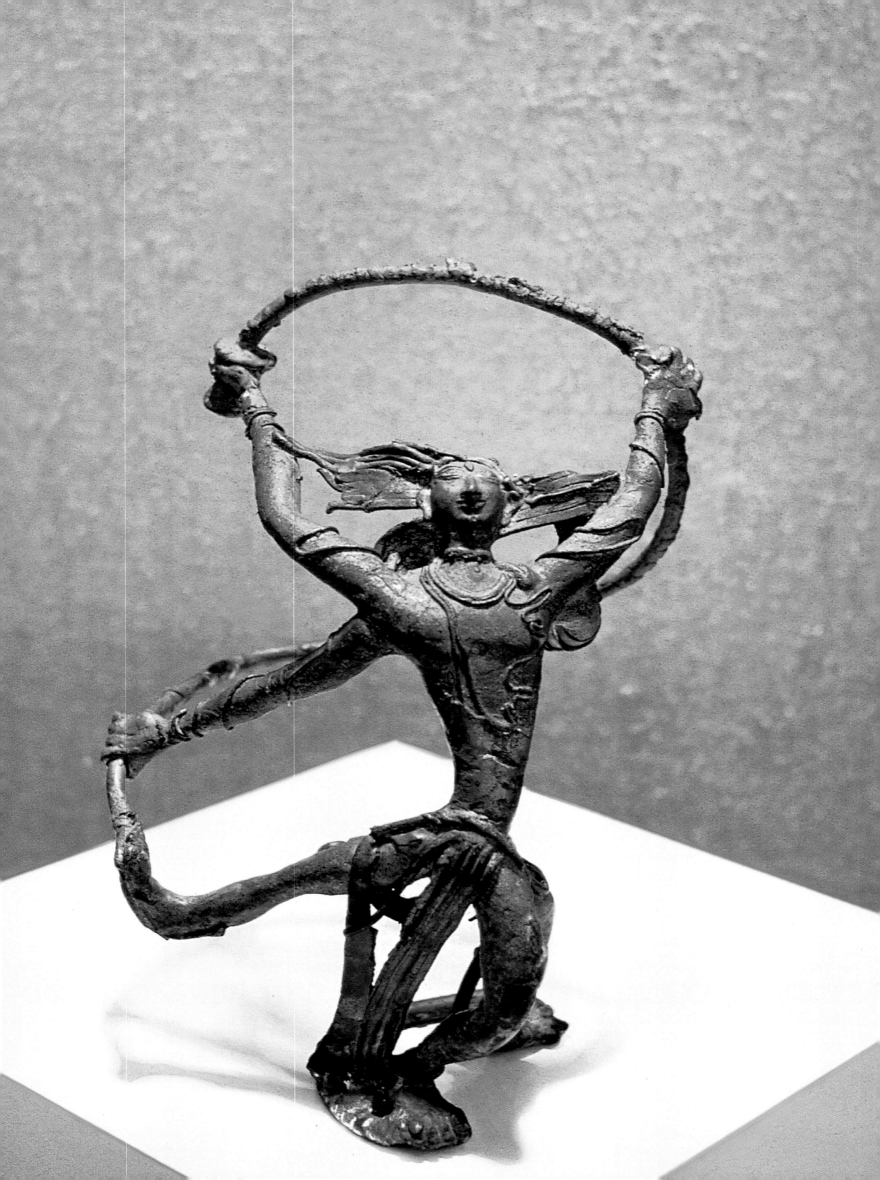

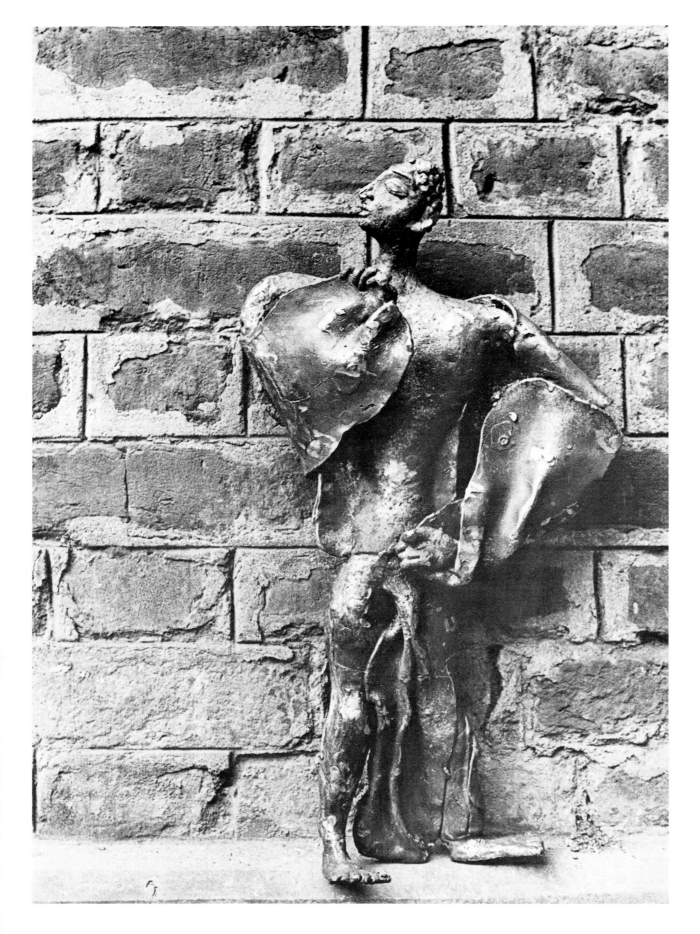

Man with Shawl.

Brass and bronze;
56 x 32 centimetres.
Artist's collection.
Photograph: Mahendra Sinh;
courtesy Max Mueller Bhavan,
Mumbai.

This image reflects the artist's
ability to invest the ordinary
stance and gesture with a poetic
lyricism.

Ashoka at Kalinga.
Now standing on the lawns of
the Maurya Sheraton,
New Delhi.

Bronze;
250 x 125 x 60 centimetres.
Collection of Welcomgroup,
Maurya Sheraton, New Delhi.
Photograph: Abhijit Basu.

A moving, powerful comment on
war which emerged from Meera
Mukherjee's first and most
successful experiment with
volume and scale.

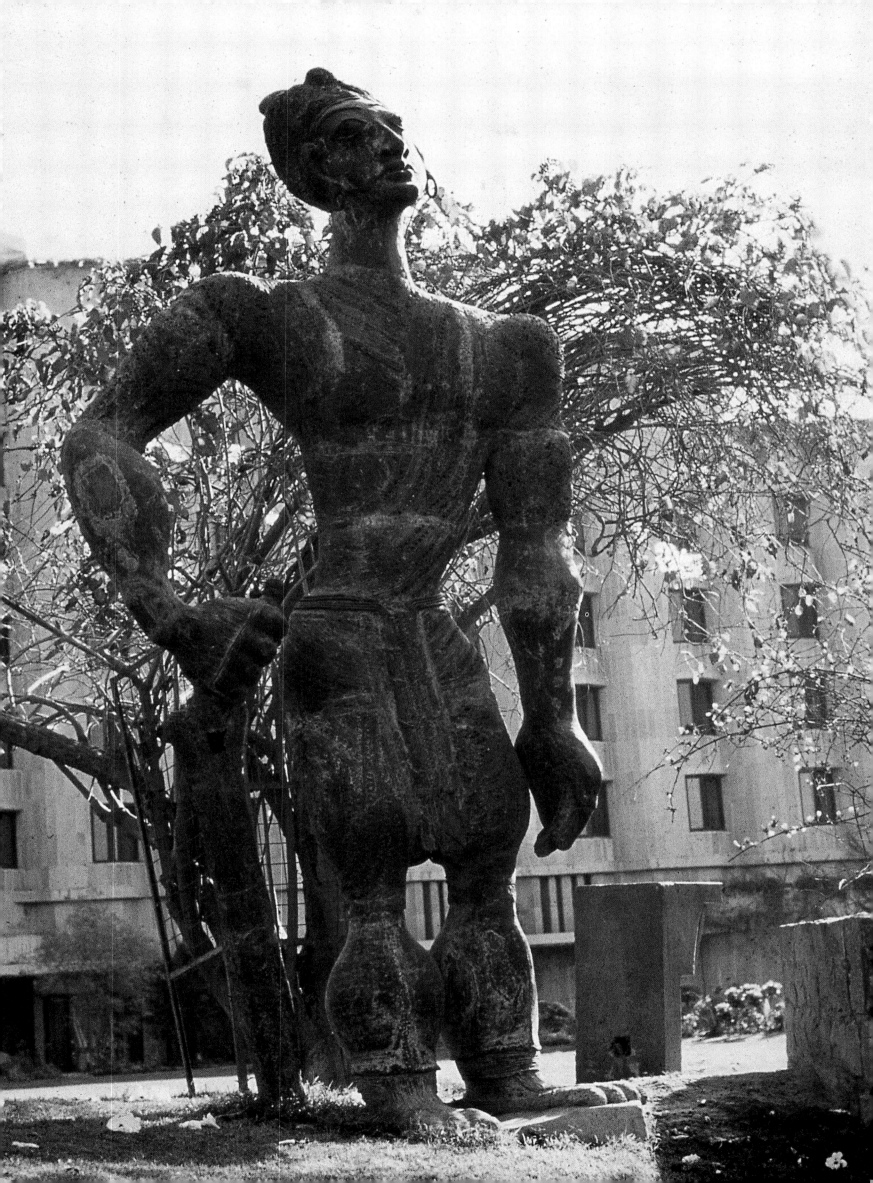

Nasreen Mohamedi: Dimensions out of Solitude[1]

Geeta Kapur

A Curved Line Across the Page

So much of Indian art is based on anthropomorphic intent, on metaphoric allusions, on deep morphologies. On the great temptations of the imagination to privilege condensation where icons are provocatively enshrined and symbols give over to a voluptuous afterlife of pain and profanation. The overweening romanticism of Indian art, in the way of trapped subjectivities and in the form of those seductive fruit of metaphysical paradoxes, was evacuated by Nasreen Mohamedi (1937-90) alone among her Indian contemporaries. Think of her immediate and illustrious contemporaries — Bhupen Khakhar, Gulammohammed Sheikh, and Arpita Singh. She simply circumvented their aesthetic.

Untitled. Mid 1980s.
Pencil on paper;
18.75 x 18.75
centimetres. Collection of
XAL Praxis, Mumbai.
"Nature is so true.
Such truth in her silence.
If only we would listen to
her intricacies.
Then there is no
difference in sound and
vision."
— 1980, *Nasreen's Diary*.

Nasreen's aim was to disengage representational ethics derived from the artist's committed gaze. She deliberately cancelled or defied the regime of the gaze, being sceptical of the appropriative/exploitative aspects of it. And she took up the conventions of the glance as in Eastern aesthetics — fleeting, evanescent, always at the point of vanishing, and taking the view with it.[2] Further, she worked with a sense of shadow: recalling as if Christ's imprint on his mantle; the shadow of the Hiroshima victim on the rock. She replaced the icon with the indexical sign that is always determinedly against the symbol as well.

It is not that she had no antecedents in contemporary Indian art. Bombay her city, has had an honourable record of both sumptuous and spare abstraction. Gaitonde, much senior to Nasreen, acted as her Indian mentor in the early 1960s. The Bombay legacy also included her long-term friend and colleague, Jeram Patel, who settled down to teach in Baroda, where Nasreen too gravitated in 1972, becoming a unique presence for successive batches of students. If in the Indian situation we want to find a single complementary (also, contradictory) artist vis-a-vis Nasreen, it should finally be Jeram Patel. Because of his passionate excavation of the negative image which signals a new direction in Indian abstraction beginning with the Group 1890 exhibition in 1963. Because he turned the materiality of the object inside out, literally, by the use of blowtorch on wood. Because he worked out this controlled transaction between the erotic and the macabre in his ink drawings, setting up an explosion in the prehistoric assembly of bone and tool conducted through a single devolving morphology — even as Nasreen, also working with ink on paper, was engaged in clearing the great debris.

Nasreen sought in her work to coalesce phenomenal encounter and formal trace; to at least raise the question, what makes Kazimir Malevich's white on white a mystical diagram and also something of an objective fact?

Deep Independence/Primeval Order

Nasreen made a firsthand acquaintance with European art at the age of seventeen; she studied in London's St Martin's School of Art during 1954-57, and in Paris during 1961-63. She continued to travel through most of her life; she lived for periods in the desert cities of the Gulf, she visited Turkey, Europe, Japan, and North America.

A definite set of art historical trajectories comes to mind in Nasreen's work. First, the lyric mode in modern art exemplified by Kandinsky and Paul Klee — who we know have been dear to many Indian artists including Nasreen. In 1970, at a point of transition in her work, she made a noting in her diary: "Again I am reassured by Kandinsky — the need to take from an outer environment and bring it an inner necessity."[3] Thereon she worked out on an image abstracted from nature on the metaphoric principle and transmuted it in the manner of the postwar abstractionists, especially French tachistes like Mathieu and Michaux. She followed the tachiste trail in the bold swatches of her oil paintings until the middle 1960s. Nature served as a referent, becoming an optical/tactile play of biomorphic forms. Nasreen's more classical work beginning in the mid-1970s evolved gradually, from this material substratum into a linguistic mode, as in the case of veteran artist Agnes Martin (b. 1912) with reference to whom her work acquires a distinct resonance.

Agnes Martin, coming from the milieu of an original version of abstract expressionism in North America, spoke in her prose poems[4] about Platonic notions of beauty and form, taking an egalitarian point of view — the mystical point of view. Hers was the space of the sublime, a form of prayer, utterances in an open space, lake, field, or desert. She would quote from a biblical passage: " . . . make level in the desert a highway for our God".[5] And she would complement it with a Tao thought: "If water is so clear, so level/How much more the spirit of man?"[6] Martin would take us from Judaic thought to Greek to Asian thought, especially Zen and Tao, and then return to contemporaries like John Cage, Ad Reinhardt, Barnett Newman, and Mark Rothko.

As she went on, Martin painted dots of atmospheric colour; she drew people, grass, as little rectangles; she worked out spaces between drops of rain. She made an airy matrix where the parallel lines were undulating, following a pencil along a string or measuring tape; and they were nearly invisible: "luminous containers for the shimmer of line".[7] And when, after a period of oblivion, Martin returned to painting pale hard paintings, it is as if she further accepted impotence, humility, silence, and blankness. Thence she made a bridge to the minimal/conceptual aesthetic and came to be included in art shows privileging systemic painting based particularly on the grid. Her work was placed, among other minimalists, with Frank Stella, Robert Ryman, and Carl Andre.

Consider Nasreen's trajectory. As early as the mid-late 1960s she had written: " . . . The new image for pure rationalism. Pure intellect which has to be separated from emotion A state beyond pain and pleasure." Adding, as she so often did, a self-instruction — "Again a difficult task begins."[8] In continuation with that aside she might have added further that in the solitude of such sentience you gain a mystical penetration of the world so that you need never be found wanting in an egalitarian world-view. Also that an artist may simultaneously seek compassion and rational poise in a choice of structures, which is to say in her formal aesthetic.

In 1971 we find Nasreen dedicating herself "To grasp one's entire heritage with intuition, vision and wisdom — with a total understanding of the present."[9] She began to move beyond her virtuosity in the manner of tachisme, beyond also the painterly variants in India, to a state of frugality as in the modal form of the grid that marked an advanced aesthetic.

The grid proper, made so prominent by the minimalists, had of course a connection with signal moments in modernism — with Mondrian, who derived a logic from nature but took it over into a hypothesis about the universe as conceived of, or rather conflated with, the structure of the mind. Since then the non-representational image, with nature as ultimate referent, is seen to gain intelligible coherence by acknowledging that the eye is part of the mind; that phenomenological experience is translated into a linguistic idea before it becomes visually manifest as perceptual epiphany or empirical presence, within painting, sculpture, or installed object.

Working out her own lyricism Nasreen realized that a natural phenomenon may be opened out to reveal its inner matrix; that the subtle sensation which the very dismantling of the great visible structures of nature creates, would then surface; and that the inflected face of water or invisible wind currents from the desert plains as these are computed on to a notationally marked graph, could become pure thought.

Rosalind Krauss says, " . . . the grid announces among other things, modern art's will to silence, its hostility to literature, to narrative, to discourse."[10]

At the intersection of late modernist and minimalist art, artists attempted to resolve the language in favour of structures in which all compositional units are equal and inseparable from the whole and the surface is in perfect unity. Nasreen took a firm step towards this formal move and then as determinedly undid it in the 1980s with an *aspiring* mode, a mode that broke with the ethics of the grid. If Martin

would say that in the diagonal the ends hang loose, or that the circle expands too much,[11] Nasreen, on the other hand, would use precisely those forms.

" . . . My lines speak of troubled destinies/ Of death/ . . . Talk that I am struck/By lightning or fire "[12]

"Circular depths/Texture of edges/To study circular depths and depression."[13]

In the aspiring mode, as I call it, Nasreen preferred movement — lightning, or a superb ascent from the ground of an elliptical desire. Finally, then, Nasreen was quite like Martin and not so too. She aspired to a detachment that could be called Nasreen's classicism, but included therein was Oriental aesthetics and especially her love of the great singing voice in Indian classical music (such as Amir Khan, Gangubai Hangal, and Bhimsen Joshi). Here you have in the very forms of sublimation the vibrations of the shuddering soul and its vastly spiralling melancholy.

She would, in her gentler way, insist on transmuting formal rigour into an ordered immanence into romance, articulating the successive moves in her staccato notes:

"Economy and structure and intuition. Overlapping forms . . . The intense sensitivity of the moon — at each phase retaining its perfect form."[14] And thus extending the transfiguration of nature's graceful changeling, she delivered it to an expanding order of phenomena. We find scattered across her diaries these instructions to herself which I draw out and align in a fresh poetic order:[15]

Work in horizontals and work in varying proportions.
Dots circles arrows leading up and across.
Verticals in gradations by studying edges intensely.
Curve
Curve slowly to O
At the edge of the void/Extension from + and −
To a drama between + and −
Balance/Touching/Loss of balance

Touch air
2½ 3 3½ 4 4 5 5 6 6 7 7
4½ 5 5½ 6 6 7 7 8 8 9 9

From the start of the 1970s Nasreen's drawings, etched with precision instruments, came to be strictly ruled. They sometimes formed a black mass with diamonds cut into them; they were shot through with shafts of light. The steeply positioned and delicately webbed wing was tuned to a set of notes that splintered into echoes and traversed the elements in a series of repetitive sounds displaced in time. She had anticipated her project already in 1969: "Examine and re-examine each contour, each dot where rhythm meets in space and continuous charges occur."[16] Charged thus, the drawings successively became complex graphic conjunctions, penetrative, flying into the constellation. Yet, for all the quality of sound and speed and light, they retained an optical perfection — the artist was as if seeing through the telescope into stellar space and then reflecting back the cosmos like a mini-matrix in the lucid orb, the eye.

"Break/Rest/Break the cycle of seeing/ Magic and awareness arrives," she wrote in her diary in 1973.[17]

The perceptual basis of consciousness, phenomenological knowledge and its mysterious perspicacity — this is expressed in the Sufi tradition by the great Jalaludin Rumi in an aphorism titled "Those Who Know, Cannot Tell", where he says: "Whenever the Secrets of Perception are taught to anyone His lips are sewn against speaking of the Consciousness."[18] With sealed lips Nasreen mapped out the terrain in a transparent interface of land, water, air, measuring on the sheet of her paper the great distances from the ground above to the sky below.

Thus perceptually acute, Nasreen's drawings raised the question of perspective in several different ways. Perspective as a ubiquitous premise of thought; perspective as verso logic

of imagist art that is representational and blocks the horizon by foregrounded bodies. In Nasreen's drawings all was distance. There was nothing waiting at the front of the perspectival trajectory, no encounter at the vanishing point. Displaced through percussive shifts of the receding target, the vanishing point stretched the terrain and deepened memory.

Maximum out of the Minimum

Beyond the humility of the plainly mystical, Nasreen should be seen as aligned to the utopian dimension in the twentieth century: its metaphysics as well as its substantive manifestations within modernism. We know that she admired Kazimir Malevich positioned at the head of suprematism where, not nature, but human destiny was once posited through geometrical propositions. The flat picture plane, a cubist injunction, developed thereon the diagonal as a preferred form; and a chevron, a cross, a triangle, came to dominate the visual vocabulary in the art of the newly formed Soviet socialism. There was, further, an interest in primary colour, light and dark, a clash of elements, thesis/anti-thesis, and a synthetic order of reason and the world. Forms in nature were regarded as merely contingent and thus dispensable before such higher purposes as the human mind's own transcendent aims. Correspondingly, the realm of representational images was displaced in favour of a self-conceptualizing formalism that would lead the way to an uncharted future. In 1921 Malevich had written:

"This is what Suprematism means to me — the dawn of an era in which the nucleus will move as a single force of atomized energy and will expand within new, orbiting, spatial systems Today we have advanced into a new fourth dimension of motion. We have pulled up our consciousness by its roots from the Earth. It is free now to revolve in the infinity of space "[19]

In the decade of the 1920s, the

Untitled. *Circa* 1988.

Ink and pencil on paper;
26.25 x 33.75 centimetres.
Collection of Rukaya Dossal,
Mumbai.

"Black, strong, gliding wires
creating drama
As one moves along
Patterns of grey
Drops intersecting."
— July 18, 1966, Deolali,
Nasreen's Diary.

Untitled. *Circa* 1985.

Ink and pencil on paper;
27.50 x 35 centimetres.
Private collection.

"One day all will become
functional and hence good
design. Then there will be no
waste. We will then understand
basics."
— 1980, *Nasreen's Diary.*

Untitled. *Circa* 1985.

Ink and pencil on paper;
27.50 x 35 centimetres.
Private collection.

"Observe some object in
Different light
A cosmic rhythm with
Each stroke."
— July 18, 1969, London,
Nasreen's Diary.

Untitled. *Circa* 1985.

Ink and pencil on paper;
57.50 x 72.50 centimetres.
Collection of Altaf and Navjot,
Mumbai.

"In the midst of these arid
silences one picks up a few
threads of texture and form."
— March 12, 1971, Baroda,
Nasreen's Diary.

constructivists in the Soviet Union used similar geometrical means to celebrate not the victory of the autonomous mental realm but of a futurist plan of the world. Concrete elements from hypothetical forms of architecture were floated and positioned to give a new sense of a dynamic order in the world, one of the famous examples being of course the 1919 design and model by Vladimir Tatlin of the Monument to the Third International. Here then was a utopian demand for perfection that was material and dialectical.

Nasreen did not come from a dialectically thought out interest in the utopian, nor from some ordering system or futurist blueprint of the world. But there were certain odd connections. She was, strangely enough, interested in technology: in cars, in industrial monuments, in water storage tanks, in the street, telegraph wires, airport runways, cameras, and precision instruments. She was interested in architectural drawings and architectural spaces like the paved courtyard at Fatehpur Sikri, but also the concrete sidewalks of Bombay and the asphalt highways in Europe. She was not looking for an arcadia; she was a metropolitan person, she had travelled worldwide. What was being projected futuristically in the 1920s was already, when she first travelled abroad in the 1950s as a teenage student of art, a given state of technology. The experience of speed and light, transmission and tension, that comes from technological extension of the senses was by then common experience.

Therefore what she did with the utopian language of abstraction subliminally figuring in her imagination, was to give it over to a pure sense of design. In 1980 she wrote in her diary: "One day all will become functional and hence good design. Then there will be no waste. We will then understand basics. It will take time. But then we get the opportunity for pure patience."[20]

It is in the scores of black and white photographs she took and kept away that we discover her basic formalism; a sense of "absolute" design. Through the physical experience of walking, encountering, stopping, positioning, turning 180 degrees on one's heels to view a mere object at ground level, they record plain views of the street, beach, kerb, sidewalk. The mobile body seeks to comprehend the urban environment. With the gaze embedded in the traversed ground there is, moreover, a possible critique of immanent subjectivity via the presence, ironically pristine, of everyday objects that spell out, quite simply, a poetics of space. There was a minimalist concern with real spaces and the phenomenological presence of the viewer's/walker's body therein.

Nasreen's photographs provide a material basis for her formal code and therein the odd encounter between Nasreen and Carl Andre is wedged. In 1971, when Andre came to India to participate in the second Indian Triennale, Nasreen was in an anomalous position within a voluble art scene doing very spare work that belonged nowhere. Although in Andre's conceptualism the metaphysical and the physical link in a very different way, both he and Nasreen could be said to be interested in the equanimity of non-reference, in the plane without any fixed vista, and in the infinite point of view of the *exemplary road*.[21] On that note we can begin to conclude Nasreen's art historical detours. Working through the 1980s she was taking off from several antecedents. From a sublimating, nature-based abstraction, treating nature as metaphor in the expanded field of the lyric image; from the conjunctural aesthetics of Russian abstraction in the 1920s; and from the minimalists, who take the object-world of the constructivists and their orientation towards a formal proposition that signals a utopian image, the minimalists return to a grounding

experience. With them Nasreen shared her astute concern for the spatial dimension where all encounters are privileged, where you walk in the shape of your body and measure the paces as a kind of a neutral act that is also, in an experiential sense, replete. In the manner of a monk's pragmatics there is nothing more to see than there is to do: and here I think not only of Andre but also Richard Long who turns bodily navigation into a meditative act.

Perhaps we can end with reminding ourselves of Nasreen's love of Tao and Zen on the one hand and of Islamic art on the other. The phenomenology of the object world and the positioning of the body within that is a Zen instruction; as is the choosing of a target of absolute attention. In Mughal and Turkish architecture, the geometry on the ground and the stellar light paths in space are the trajectories of those *farishta*s (angels) of Islamic lore that crisscross the skies in eternal flight Nasreen's references are metaphysical, mystical, mathematical; her sympathies are serenely secular.

Desert Birth

"And then there are those who received the desert in the cradle . . . the terrible gift granted to some, a sort of curse that is a blessing, a natal desertion, and that condemns and brings them up to poetry. The desert is a lack of origin, a lack of engendering It is the primal scene in which the infant wakes to perfect absence; to the absence of milk, which is light."

— Helene Cixous[22]

Nasreen was not born in the desert but she knew and loved the deserts of Arabia. The desert is a lack of origin, a lack of engendering, a natal desertion, Cixous says. The infant awakens to perfect absence Nasreen had herself written, ". . . the strong aridity of the desert. It makes one detached in a tiny way, in a clear and vital way. . . . "[23]

I want to make the proposition that Nasreen's work is about the self and body through a series of displacements, and that those insistently eluded questions offer the meaning of her work. That she is therefore within a great lineage of abstraction in a way that no other Indian artist is and also that she is without the tradition, being a woman artist working in India at a time when there were few others of her kind.

That the self should be hidden, denied, evacuated, is especially true of women saints, in particular saints whose persona is disembodied even when the desire is embodied in poetry, praise, labour, and self-instruction. A diary entry of Nasreen's says: "The empty mind/Receives/ Drain it/Squeeze the dirt/Hard/So that it receives the sun/With a flash."[24]

I am not speaking contrarily if I say that Nasreen's work is about the self, except that it is indeed about self-naughting as well, for every passionate negation is a mystical triumph in the way of becoming. Conducted at the edge of desire, the suffering caused by absence persists, where the body persists. Nasreen's work, speaking contrarily this time, is about the body . . . the mystical body, the female body, the body in art, the broken body.

Time and again Nasreen identified with the body of the beloved evacuated of every symbolic truth except a deeply embedded narcissism, the last bet on the imaginary and the more lustrous for it. She was Echo to a Narcissus; both were in her. The drawings reflected the visage in the sky and caught the echo on the ground below.

Nasreen conceptualized the body hovering and possessed of a view from nowhere, which is a view from everywhere, which is a kind of phenomenological plenitude. But that the body should be invisibly present in a map of a few lines is a virtuoso feat. We know the biographical fact that it was a body becoming gradually dysfunctional, losing its motor functions. I am perhaps too tempted to take Nasreen's physical affliction that made her limbs

jerk disobediently as some kind of a destinal sign, a fatal sign. Was it not like mortality in cruel play that this elegant woman should be led to an inadvertent dance of the body-soul?

Maintaining under the greatest stress a control of the hand, and brushing off the matrices of the self like so much scum on the face of light which was her white sheet of paper, she drew with her steel instruments, with pencil, ink and brush . . . like the angel who lifts off time but then reinscribes it as a day by day calendar for the future. She wrote in her diary when she was not yet thirty, "Each day is carved out and stands obliquely The cord is stretched to the end to the limit of pain — no more — if this is a truth. Beyond that a nothingness takes place."[25] And it is not a wonder that almost till the end she could arch the bow so that the arrowhead would go through the strait gate of heaven like a mystical alphabet.

Nasreen's self-image was of one always in preparation, gathering attention. One morning of May she was sitting in her shack at Kihim near Bombay, a still vacant sand beach on the Arabian Sea, when she passed on suddenly, without a sound.

Figure Acknowledgements
All transparencies courtesy Altaf and Navjot, Mumbai.

Notes
Nasreen did not date her works and we can only arrive at the closest possible approximation. Hence the use of *circa* in some of the captions.
1. The title and subheadings in this article (except the last, "Desert Birth"), are phrases taken from Nasreen Mohamedi's diaries published in *Nasreen in Retrospect*, ed. Altaf, Bombay: Ashraf Mohamedi Trust, 1995, pp. 83-97. I have quoted from the diaries, referencing them according to the chronology Yashodhara Dalmia, with the help of Nasreen Mohamedi's family, has established; a chronology based on firm dates, and where entries are not precisely dated by matching them with Nasreen's known journeys, places of residence, states of mind. See Yashodhara Dalmia, "Nasreen's Diaries: An Introduction", ibid., pp. 83-84. This book also contains my title essay, "Elegy for an Unclaimed Beloved: Nasreen Mohamedi (1937-1990)", as well as other texts, life chronology, photographs, and, above all, a large number of colour illustrations of her work, from her student days until her death.
2. See Norman Bryson, *Vision and Painting: The Logic of the Gaze*, London: Macmillan, 1983, pp. 87-131.
3. Diary entry on September 30, 1970, *Nasreen in Retrospect*, op.cit., p. 93.
4. All statements by Agnes Martin about life, thought, and art, and some part of the analysis about her work, are taken from *Agnes Martin*, ed. Barbara Haskell (with essays by Barbara Haskell, Anna C. Chave, and Rosalind Krauss), New York: Whitney Museum of American Art/Harry N. Abrams, 1992.
5. Biblical reference (Isaiah 40) by Agnes Martin quoted by Anna C. Chave, "Agnes Martin: 'Humility, the Beautiful Daughter... All Her Ways Are Empty'", ibid., p. 144.
6. Anna C. Chave quoting Taoist sage, Chuang Tzu (from Thomas Merton, *The Way of Chuang Tzu*, New York: New Directions, 1965/1969, p. 80), ibid., p. 145.
7. Anna C. Chave quoting Rosalind Krauss and Marcia Tucker (from "Perceptual Field", in *Critical Perspectives in American Art*, exh. cat., Amherst, Fine Arts Centre Gallery, Univ. of Massachusetts, 1976, p. 15), ibid., p. 106.
8. Diary entry on May 22, 1964(?), *Nasreen in Retrospect*, op. cit., p. 85.
9. Diary entry on March 3, 1971, ibid., p. 93.
10. Rosalind Krauss, "Grids", *Originality of the Avant-Garde and Other Modernist Myths*, Cambridge, Mass: MIT Press, 1986, pp. 9-10.
11. Agnes Martin, "The Untroubled Mind", *Agnes Martin*, op. cit., p. 14.
12. Diary entry on June 3, 1968, *Nasreen in Retrospect*, op. cit., p. 88.
13. Diary entry on May 10, 1971, ibid., p. 94.
14. Diary entry on November 25, 1971, ibid., p. 95.
15. Phrases from diary entries, ibid., pp. 85-97.
16. Diary entry on July 21, 1969, London, ibid., p. 91.
17. Diary entry on July 17, 1973, ibid., p. 96.
18. Jalaludin Rumi, quoted by Idries Shah in *The Way of the Sufi*, Harmondsworth: Penguin, 1968/rpt. 1979, p. 114.
19. Kazimir Malevich, "Futurism-Suprematism, 1921: An Extract", from *Kazimir Malevich 1878-1935*, The Armand Hammer Museum of Art and Culture Center, Los Angeles, 1990, p. 177.
20. Diary entry in 1980 (date uncertain), *Nasreen in Retrospect*, op. cit., p. 97.
21. See Anna C. Chave for a discussion of the commonalty between Agnes Martin and Carl Andre (from which I develop this tripartite relationship with Nasreen), in *Agnes Martin*, op. cit., p. 143.
22. Helene Cixous, "We who are Free, Are we Free", *Critical Inquiry*, vol. 19, no. 2, Winter 1993, p. 209.
23. Diary entry on March 12, 1971, *Nasreen in Retrospect*, p. 93.
24. Diary entry on November 15, 1968 (?), ibid., p. 90.
25. Diary entry on October 13, 1964, ibid., p. 85.

Untitled. Late 1980s.

Ink and pencil on paper;
47.50 x 47.50 centimetres.
Collection of XAL Praxis,
Mumbai.

"A sensitive — very intense line.
The intense sensitivity of the
moon — at each phase
retaining its perfect form."
— November 25, 1971, Delhi,
Nasreen's Diary.

Untitled. *Circa* 1976.

Ink on paper;
18.75 x 18.75 centimetres.
Private collection.

"Each particle in me becomes
alive. Yes these deserts are
necessary to growth.
The full moon — a perfect circle
— complete serenity."
— July 10, 1971, Delhi,
Nasreen's Diary.

Untitled. *Circa* 1978.

Pencil on paper;
18.75 x 18.75 centimetres.
Collection of XAL Praxis,
Mumbai.

"A spider can only make a web
but it makes it to perfection."
— March 13, 1970, Delhi,
Nasreen's Diary.

Arpita Singh: Of Mother Goddesses and Women

Yashodhara Dalmia

The arduous task of devising language in paint has marked Arpita Singh's work from the early years. That could explain her shifts from figurative work in the 1960s to abstracts and figuratives again in the 1980s. In the process she has, almost inadvertently, highlighted the loneliness and forlornness of being a woman in India and the country itself with its seeping violence as it brings itself to a state of chaos.

The throbbing multiplicity of life in its myriad hues is manifest in the large body of Singh's figurative works. At first it seems like an enchanted world where objects, humans, and vegetation are all imbued with a magical life. We have *Apples and Chair*, *White Boat*, or *Figures and Flowers* where there is a lucid flowing lyricism. Fruits, flowers, boats, and figures all achieve an equal significance in animated manifestations. They dissolve into one another, life metamorphosing into life, creating a magical symbiosis.

In the 1980s Singh's work becomes even more lucid, bringing to the fore many contradictions of life in India. White ducks invade her pictures, squatting on a chequered tablecloth creating an uneasiness. There is a *Car in a Rose Garden* disturbing the peace and quiet, and in a somewhat sombre picture titled *The Evening Tree* the still, sad twilight envelops the evening. The

uneasiness and distance is created between humans by invading objects almost as if they have a life of their own. The stillness of her humans is contrasted by the highly animated space surrounding them consisting of ordinary day-to-day objects. In many ways her flying figures are reminiscent of Chagall with whom the artist claims to have an affinity. "He (Marc Chagall) also drew heavily from Russian folklore, specifically Jewish myths, yet what he was celebrating was not a ritualistic approach to religion. It was an earthy, optimistic peasant's eye view of reality, which could accommodate fantasy as well as hard fact."[1]

It is this ability to incorporate ordinary day-to-day events with a magical life, letting the imagination soar, which lends that inexplicable meaning to Singh's works. As Ebrahim Alkazi puts it succinctly, "Are these a child's muted recollections of past experiences, or are they representations of the immediate present? Aspects of time, past and present, of dream and reality, of here and there, of presence and absence — all partake of the same ambiguity as the characters themselves. The future is now even as we speak, yet in a trice this 'now' has already receded into the past. The fascination of Arpita's works lies in the fact that they, in their laughing way, evoke the riddle of human existence, its concrete reality and at the same time its intangibility; its clarity and its

Woman with a Girl Child III. 1994.

Oil on canvas; 117.50 x 87.50 centimetres.

Symbolic of strength, the near iconic primordial mother passes on traditional wisdom to her daughter. The violence of our times is marked by the presence of the revolver.

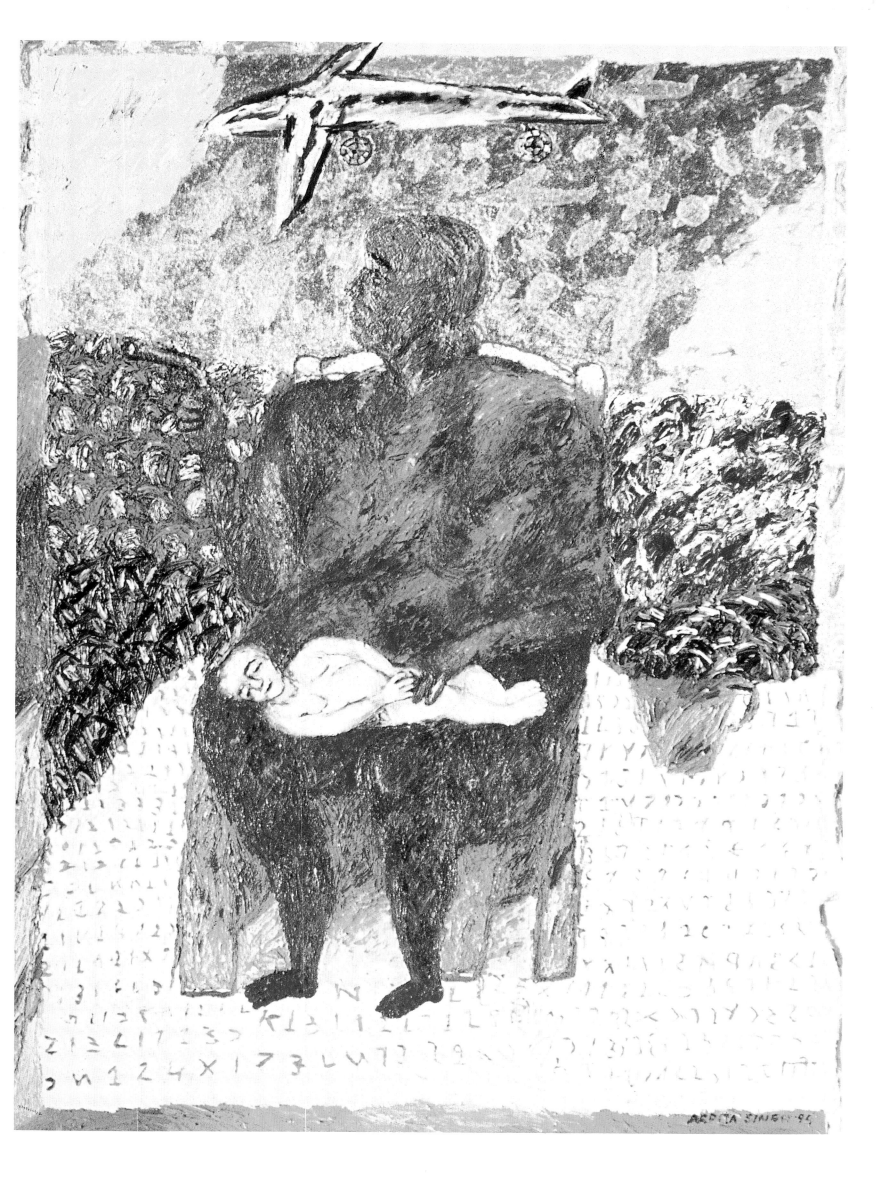

meaninglessness; its certainty and its baffling precariousness."[2]

Images that are familiar to us are shown afresh in a context which gives them a new meaning. Her *Child Bride with Swan* for instance, stands forlorn, a dazzling streak of yellow in a crowded landscape of cars, people, and aeroplanes swirling around her in a sea of blue and red. Her *Woman Sitting on a Tin Trunk* is a desolate study of a woman dressed in bright orange and holding a bouquet of flowers, her flamboyant appearance contrasting with her own vulnerability. A subterranean kind of wit surfaces in *Girl Smoking a Cigarette* where a girl smokes innocuously while all kinds of ominous mythological figures hover around her. *Women Watching a Plane* is a poignant portrayal of middle-aged women watching planes flying where there is a strong suggestion of sexual gratification. In *Woman in Floral Dress* there is a disturbing vulnerability in the woman who sits still and iconic, staring at the viewer, while the flowers and stripes on her dress take on an ominous life, almost overwhelming the wearer. Sometimes the textures and patterns of the surrounding space take on a threatening quality isolating the figure, as in *A Man in the Room.*

It seems pertinent to ask at this juncture whether Singh views herself as a woman painter. For her the term itself is one which makes no difference to her work. She says, "I am a painter. To call me a woman painter does not have a special meaning. Whatever I do is as a woman because I am a woman. My whole development has been as a woman in a specific society during a specific period. I do not know what it is like to paint as a man. Therefore, it seems strange to even say that I am a woman painter. I would just like to establish myself as a painter."[3] By implication the empathic closeness she feels to women makes her often draw upon them as the subject of her study.

We are often reminded of folk forms while looking at Singh's work, in the brilliance of her colour, in the simple, almost naive configuration, and not the least because of the wit and humour. There are important differences, however, in that her forms do not have a ritualistic, repetitive pattern where the role of the figure can be predicted in advance. In the narrative folk tradition of India no story ever ends, for that would mean death. Each character unfolds his own tale and that in turn another tale, till the whole seems a complex web of events. And that is what happens to Singh's work when she unfolds the story of the Kidwai family.

The family is organically united through a web of lines around the death of Ayesha Kidwai's grandmother. The serrated lines unite and separate each member. At the corner looms the portrait of the patriarch, the missing member who is still present. If the death of the oldest member brings the family together, the youngest in the family, Ayesha, is the subject of acute observation. Her persona with its shadows and reflections forms a whole community around her, perhaps her internal family. According to Singh, "I chose this family because I know all its members very well and can articulate whatever I want to express through them. In a way this family is a microcosm of contemporary India for me."[4] Ayesha, a Muslim, married out of the community introducing into her life the conflict between religions, between diverse cultures, generations and the sexes which in one way or the other is the life saga of most families in India.

Much like women all over India who embroider their lives making decorative, patterned surfaces, Singh makes marks all over her paintings. Every inch of space is articulated with signs which are expressive of a feeling or an inclination. Often, these counteract with dissimilar marks which

introduce a tension. Singh uses these signs to negotiate the surface, often surprising herself by what gets articulated as she wends her way from one end to the other. But the apparent text of her paintings is provided with many sub-texts, as the rational, the irrational, and the unknown make interventions. If the boundlessness of this space can be considered feminine then Singh's sensibility as a woman expresses this.

The artist Nilima Sheikh points out, "For her the pleasure and ploy of ornamentation is both celebration and disguise. Along with modernist techniques of painting she foregrounds other devices to celebrate the surface: the use of decorative motifs, patterning and what I would like to call illuminating, inexorably bringing to life, tending a surface she fears might dull. Or if it is not offered life through touch or sign, even die. Yet more often than not the motifs offered are funerary, about mourning the dead and celebrating dying. About living in spite of dying. About enacting death. In Arpita's paintings is that different from enacting living?"[5] In recent years death has entered Singh's protected world.

The violent events that have shaken India in the last few years have made Singh step out of her closely observed interiors and look at the world outside. Now Ayesha Kidwai appears boxed in between *Mourners and Soldiers*, and people once so inert in her pictures turn assertive in tens of thousands, spilling out of tenement housing, peering out of window frames, crowding the bazaars, hypertense, active, and aggressive. A woman sits multi-armed, flailing the air, while two men are lined up against the wall as if before a firing squad. In the true tradition of narrative painters, Singh has always been sensitive to events around her, and in India today, as conflicts in the neighbourhood extend and grow to envelop entire cities, her paintings have now begun to also explore the connection between personal and public tragedy.

The militiamen can be seen in plenty almost

running amuck over the canvas. They could be armed or in plainclothes or just goons pointing their guns in all directions. The multiple, simultaneous registers now include these gun-toting men always as an aside or a counterpoint to life. As Nilima Sheikh puts it, "After the Gulf War, militiamen formed phalanxes, tumbled around and pointed guns, their manoeuvres learnt from picture books tend to get obstructed by reclining multi-armed beauties doing proxy for city monuments. In Arpita's maze-cities of the last four years a great deal of men in their uniforms of conformity rush around sometimes as lawyers in a comic book Camus, sometimes in mufti, as plainclothesmen or as goons. But now they sometimes take off their costume or put on other's: the pensive gold-ochre man wearing a Baconesque nakedness watches two pink-brown men grappling in slow motion combat, and the men regarding the death on the street wear little frocks."[6] The figures have gone awry and sensibilities are thrown aside as men engage in wordless, frenzied combat. If this seems a little like pantomime it must be remembered that Singh having stepped out of her world has to cope with the lashed fury outside. Her militiamen appear like a grotesque mimicry of themselves and thereby lighten their own weight, appearing like protoplasmic blurbs on the surface. And if the humour lacks conviction it has yet to find its bearing outside the cloistered space.

A gun-toting Durga made in October 1993 raised an unseemly controversy, all the more ironic because this was one of her less successful images. When asked by the Calcutta magazine *Desh* to make an image for their Durga Puja annual, Singh in the aftermath of communal riots which had swept the country, made a Durga holding a pistol in one hand. This created a whiplash of fury among a certain section of believers who felt that the iconic image had been vandalized. When called upon to make a statement by the editor of the weekly, Singh wondered what the

fuss was about as she had painted the way she usually did.[7] The gun-toting Durga clad in a white sari in combat with a man in dark glasses was, if anything, a literal statement and one which strained her painterly strength. The multiple registers had been oversimplified and Singh seemed to be crossing that thin wedge between making a statement and painterly linguistics.

In a series of works exhibited in 1994, Singh had recovered her composure and juxtaposed her encounter with violence with beauty and humour which made it all the more poignant. In a large oil, *Woman Plucking Flowers*, a woman bends to pluck flowers in the far end of the lake-like garden. The shimmering blue metamorphoses into lotus shapes edged with a red glaze. The aquamarine surface is broken by brown triangles which intersperse the blue like sexual symbols. Slowly the realization dawns that at the far edge stands a man pointing his pistol at the woman. The distilled, flickering blue evenly matches the beauty of the moment with the brutality of life.

If the preciousness of life is juxtaposed by its ugliness, the painter chooses the monumental scale of the canvas to bring this about. Her dexterous use of watercolour when translated into oil has not always been successful and she confesses to not being able to use the medium with the same facility as her watercolours. In oils Singh negotiates the surface with colour rather than with signs and in this series the colour blue lends her the facility she is searching for. The varied textures and tones in *A Dead Man on the Street: Is It You Krishna?* form an equal counterpoint between levels of reality paralleling her watercolours. A man stretches dead across the surface, his body rippling with blue. Could it be that he is not dead but dreaming? An electric blue glides over the surface uniting the space between dream and wakefulness. Four figures stand gazing over the body and also at themselves. Singh points out that the blue god Krishna, for all his awesome feats, died an

ordinary death. The dream or reality is a truism for everyone; for all the remarkable events in a man's life, when he dies the end is ordinary, even unimportant.

A heightened sense of violence pervades her paintings. The artist finds that the private, the personal space has now been violated, destroying the one thing each human being possesses unquestioningly, the self. "The apparent comfort and safety of home can be shattered in a single moment and yet to whom can we turn? Is there any recourse to justice or peace really?" she asks.[8] This sense of violation is articulated vividly in a striking watercolour, *Afternoon*, where a middle-aged couple stands together, fingers interlocked over softly folding flesh. In the sultry afternoon they seem to be sharing a moment of intimacy in the assured space of their home. As Nilima Sheikh puts it, "The conjugal bodies are painted in relentless pale daubs of Indian red and terreverte — colours of the earth — touched with blue — grey shadows that both make and dissolve luminous body mass, the repeated sensory stimulation stimulating the pulsation of desire. This is the very private moment, not only of desire but for vulnerable incompleteness."[9] At the edge of the canvas stand ten men, one of them with a drawn pistol, sentinel to their pleasure. Could this be the nightmare which the psyche unfolds laced as it is with grim, wakeful reality?

The protagonist of many of her paintings, however, is an older woman who lends both wisdom and experience to the state of destruction around her. In a large oil titled *My Mother*, an old woman steps out of the safety of her home perhaps to complete a chore. Across the street which runs diagonally over the canvas, violence runs amuck — a veritable inferno of dead bodies, soldiers, prostitutes, broken chairs, and upturned cars. Singh explains that she had started by painting a portrait of her mother when the Bombay riots erupted and the two elements spilled into one another. But her mother also symbolizes an

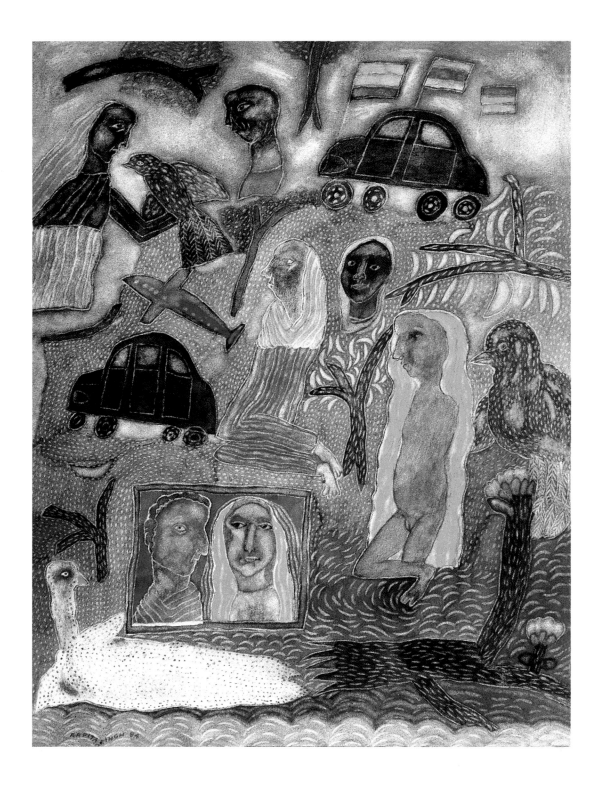

Women Watching a Plane. 1989.

Watercolour on paper;
42 x 29 centimetres.

The middle-aged woman faced with a rapidly changing urban milieu is a frequent figure in Singh's work.

Kidwai Family. 1987.

Watercolour;
49 x 29 centimetres.

Much of the artist's narrative in recent years has been through three generations of the Kidwai family, who become identifiable characters.

Child Bride with Swan. 1985.

Watercolour;
60 x 45 centimetres.
Herwitz Collection.
Photograph: courtesy
Chester Herwitz.

Through the juxtaposition of disparities, Singh's paintings create an unresolved tension. Here, this tension is marked in the ominous presence of city traffic and aeroplanes.

Apples and Chair. 1971.

Watercolour on paper;
dimensions not known.

Inanimate objects, people, fruit, and flowers are all rendered with the same degree of attention.

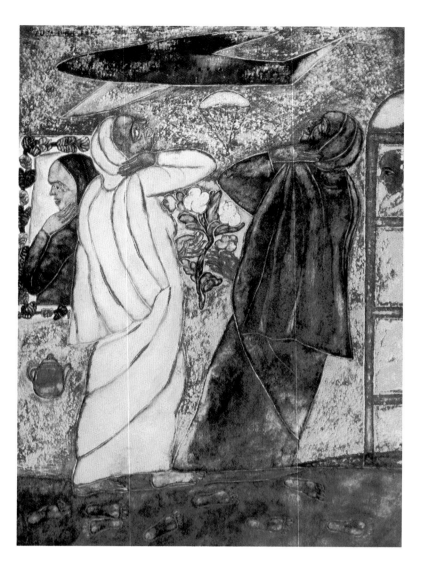

My Mother. 1993.

Oil on canvas;
135 x 180 centimetres.

The onslaught of the outside world, inspired by the Bombay riots of 1992-93, is shown in sharp contrast to the fragile presence of the elderly widowed woman.

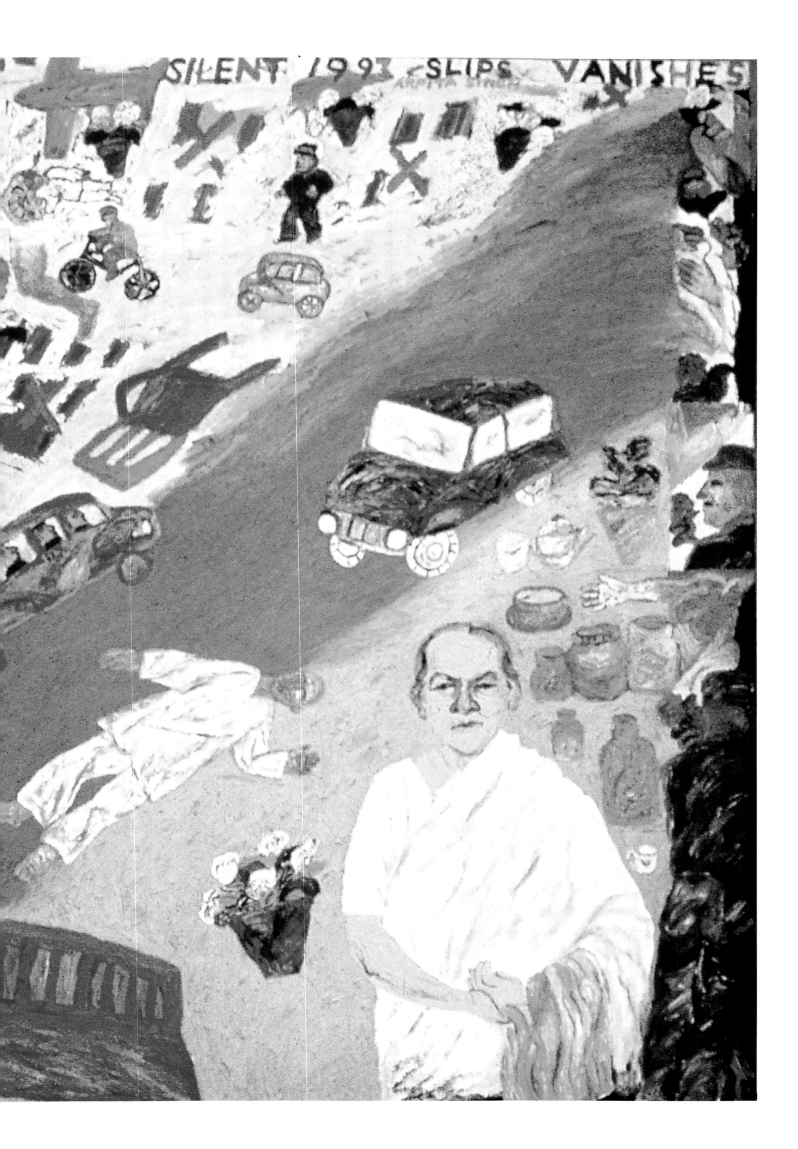

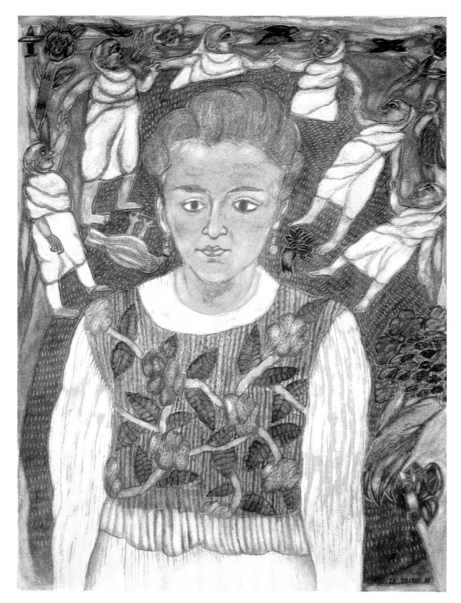

Half Ring of Protection. 1988.

Watercolour;
48 x 36 centimetres.
Collection of Victoria and Albert
Museum, London.

The feminine figure as a girl or
middle-aged woman is a
vulnerable subject.

Afternoon. 1994.

Watercolour and
acrylic on paper;
50 x 35 centimetres.

The sense of invasion is
unabated even in the personal,
intimate moment.

Men on the Street. 1992.

Watercolour and acrylic;
60 x 45 centimetres.

The heightened violence in
Indian life is marked by the
invasive presence of soldiers,
goons, and plainclothesmen.

area of confidence and strength for her, lending with her presence the possibility of rejuvenation.

The talk between us steers its course to her childhood in the 1940s, and Singh speaks of the "strange satisfaction" of having been brought up by her father who used to play with her on returning from work. "I never felt the need for toys or gifts because the relationship gave so much. I do not think one should send the child out to play till he has established a relationship at home and to do that takes time. Once that relationship is formed then outside it is easy for him to form it with others."[10]

Her mother had entered the house from an orthodox Vaishnav background and recoiled at the liberated Brahmo Samaj atmosphere. She could not adjust to the "Muslim cook, the chicken and eating on the table". Later she was even to learn cooking from him and when an English lady was commissioned to teach her English she learned western cooking from her as well. When Singh was eight years old her father died. The family used to live separately from the main house and, when urged to join them, the mother lived there for precisely three months — the time it took her to learn shorthand and typing. After that she got a government job and lived independently, supporting the young daughter and son. A self-made woman, she was transferred from Calcutta to Delhi where she set herself up with her children. "Women are very courageous. Now of course communications have advanced but in those days they used to go to far off places after marriage and it was not necessary that they would be seen again."[11]

The monumental woman who is strong though no longer iconic emerges in her paintings. Her looming presence is a reminder of the archaic mother goddess who with her ancient wisdom ruled the world. The ancient woman is recalled by Singh, for only she with

her feminine multiplicity can counter the aggression of the present. She stands for an essential creative principle which has to be safeguarded and preserved. She holds the golden girl-child in her lap, successor to her wisdom. For according to Singh, "It is the girl who inherits the tradition with all its wisdom. I have seen this with cats because we have always had a lot of cats. Male cats die after six months or they fight with other cats and leave the area. Their population dwindles very fast. Female cats know how to preserve themselves."[12]

In a watercolour Singh subverts the goddess, mocking her monumentality as it were. *Devi's Journey* is a painting of male relationships, interlocked as they are with each other while travelling in a bus. Sitting inside the rickety bus which is taking them on a pilgrimage they seem almost organically united, exuding a strong sense of male well-being. On top of the bus, both as a presence and as "the other" sits the many-armed goddess, her lightness counteracting the heavy muscularity of men.

While the concept of the mother goddess has yet to be fleshed out, assuming its full proportions, Singh sometimes manages to evoke both the reality and the myth of an older, more wizened presence. *Seated Woman with a Shawl* has an old woman in white seated with a shawl on her lap. Below her lies the prostrate figure of a man possibly killed in a riot. She could be in mourning for a dead husband. At the same time the fissured image evokes the medieval feminine figure in combat with evil. She could be an even more ancient mother goddess surrounded by trees emanating a life force amidst the destruction.

The overlapping images of the monumental woman have come a long distance from the still iconic figure threatened by her surroundings. Perhaps the girl who grew up

with Kali images instinctively grasped the meaning of the feminine principle. As she posits the self into the surroundings, the space of their canvas becomes more and more fecund. The new birth could well be towards a larger, more abstract space.

To locate Arpita Singh in the artistic consciousness of the present would be to see her not just as a woman painter but one who is at the forefront of the figurative painters of today. She could be considered a modernist in that she grapples with her medium and her images are derived from the medium. In the process she has also formed an equation with Indian aesthetics, specifically the miniaturists and the folk painters. Inasmuch as she attempts to evoke the present with its web of events she could be considered one of the most contemporary of painters.

Notes
1. Prema Viswanathan, "A brush with fantasy", *The Independent*, February 25, 1990.
2. Ebrahim Alkazi, "Fluidity of Being", Art Heritage Catalogue, 1991.
3. Interview with the author, March 1995.
4. Viswanathan, op. cit.
5. Arpita Singh, Paintings 1992-94, Vadehra Art Gallery, New Delhi, Catalogue by Nilima Sheikh.
6. Ibid.
7. Payal Singh, "A Gun-toting Durga", *The Illustrated Weekly of India*, October 23-29, 1993.
8. Interview with the author, March 1995.
9. Ibid.
10. Ibid.
11. Ibid.
12. Ibid.

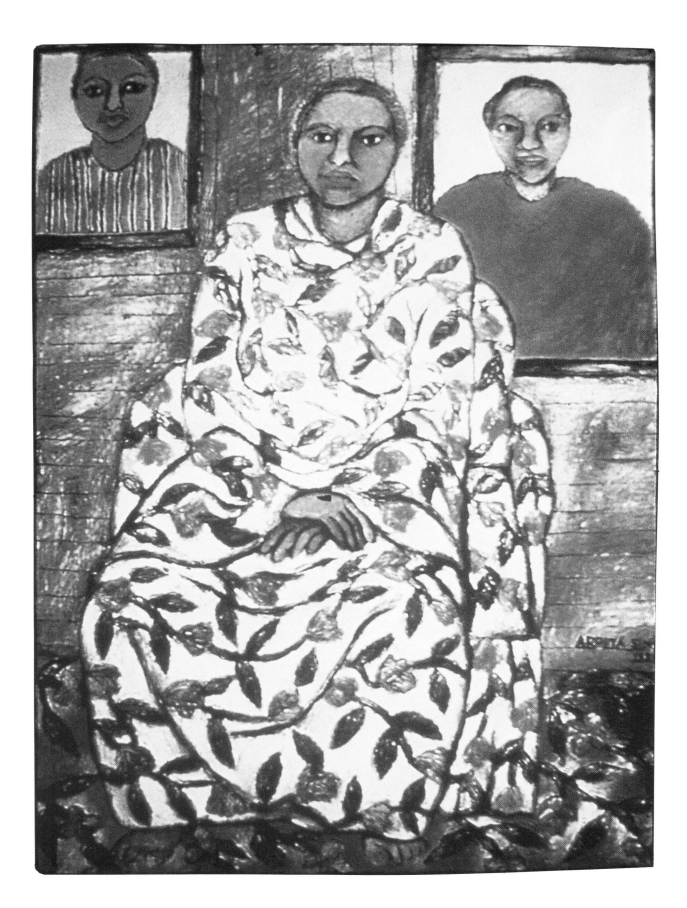

Seated Woman with Other Faces. 1986.

Oil on canvas;
90 x 75 centimetres.

Elements of floral decoration and embroidery mark the feminine space of isolation and confrontation.

Anjolie Ela Menon: Images and Techniques

Rupika Chawla

The choice of objects and images in the paintings of Anjolie Ela Menon (b. 1940) constitutes much of the humdrum and the prosaic that exists in everyday life. Their transformation into symbols of poignancy and evocation is through the manner in which they are wrapped up in mystery and an archaic beauty; the ordinary acquires a powerful visual vocabulary. While objects leap from the prosaic to the poetic, personal links to people, emotions, moods, and locations also get transformed into the general, even while they retain some of the original quality.

Themes and motifs that often appear in Menon's works are never the result of that ephemeral spontaneity that dies out once a certain state of mind or mood disappears. Her use of themes and motifs has sprung from their lasting attraction and their visual potential as seen through shape, significance, and impact. These concepts require the capacity to be transferred from an emotional or subconscious reference to a creative reality. Such a reality in Anjolie's case is spontaneously evoked — not the spontaneity which evaporates like a passing breeze but the inspiration which is based on certain basic truths important to her and therefore vital.

Intuitive responses that come into play during the shaping of an image or the execution of a methodology of painting differ from painter to painter. Nalini Malani allows a loaded paintbrush to dictate to an emerging form; Arpita Singh's photographic memory receives impressions from her environment and transfers them on to her canvas — some soaked with experience, others purely visual; Rini Dhumal's impulses are generally subservient to the laborious techniques that she uses; M. F. Husain finishes with a series of paintings the moment he feels that his reactions are becoming cerebral, turning him away, he believes, from the true beginning of creativity which lies in the emotional; Tyeb Mehta reacts impulsively to both image and technique, unwilling to be guided by thought or by rules; A. Ramachandran's oil paintings undergo the careful scrutiny of reflection, through the stages of sketches and watercolour drawings.

Both image and technique in Anjolie's case have undergone a long and purposeful journey. During her student years prior to her departure for Paris in 1960, her paintings (mainly portraits) were dominated by flat areas of thick bright colour with sharp outlines painted "with all the vigour and brashness of extreme youth", showing diversely the influence of Van Gogh, the expressionists, Modigliani, Amrita Sher-Gil, and Husain. There was as yet no manifestation of the subtle gradations of tone and texture which personified

Bhuleshwar. 1978.
Mixed media;
100 x 75 centimetres.
Collection of
Pankaja Shah.
The first work in the
Window series, which
demonstrates the dictum
of the artist to Retrieve &
Resurrect and make art
out of junk.

her later paintings. While in Paris she met Francesco Toledo, a Mexican painter who introduced her to the concept of fine layered surfaces and the textures possible therein. It is exactly this method of application which was to gradually become responsible for the surface quality of her paintings.

Travels through Europe on her way home introduced her to early Christian and medieval art, to bearded figures set amidst an architectural framework that personified this style. It also included the frontal iconic figure, the averted head, and the slight body elongation. (The early Modigliani influence had found a corroboration from an earlier date wherein the contemporary is perhaps a redefinement of the classical.) All these elements together with the deep colours of such paintings and the mellow patina of icons give to Anjolie's own works the quality of an earlier "classical" period, regardless of whether the subject is religious, as in *Prophet* (1976), or secular, *Bhaskar* (1978) or *Pyotr* (1972). Most paintings of the medieval period in Europe were either painted on walls or wood panels, and where the surfaces had a soft, gentle sheen. Anjolie's itinerant married life, and the inconvenience of acquiring canvases and stretchers in remote places, had resulted in her using hardboard instead of canvases. What originated as a practical solution resulted in a technical triumph when she realized that her surfaces could be burnished gently with a soft dry brush to acquire the same glow of medieval paintings. This technique was introduced to her by the Russian artist Viktor Fyodorov during her stay in the former USSR in 1979.

The iconic mould also bore effect with the Madonna and Child theme which was explored extensively. The nude made her appearance as well, gathering momentum after Anjolie's marriage in 1961 and the novelty of her ensuing pregnancy. The nude in her works has always vibrated with experiences that are

intensely personal to women who can also be "trapped in situations not often of their making". Her nude figures also incorporate the female principle on various levels of suggestion — the madonna (purity), the maternal (familial, the mother and child theme explored differently), and the sexual (erotica explored in its many hues). There is almost something ritualistic in the oft repeated ideal female form — full-breasted, voluptuous, and innocent looking. Art seeks to perfect the imperfections of reality; Anjolie's painted women therefore continuously flaunt their desirability while seeking to be desired in turn. The women, like the men, are normally presented frontally, large eyes averted, head turned at an angle like a lot of Romanesque sculpture. They are almost iconic in their stillness, or perhaps the static quality of arms and legs is an indication of a certain weakness of the basic drawing in her paintings — a deficiency compensated by colour, composition, and texture.

There is a warm intimacy between woman, animal, and nature in the artist's works. There can be an emotional dependence on a domesticated animal (*Girl with a Monkey,* 1972; *November-II,* 1979; *Girl with Cats,* 1978) or a sexual association (*Dream,* 1977). A link in this regard can be made with Frida Kahlo (1907-54) the Mexican painter whose traumatic personal life provided much to the vitality of her paintings and whose dependence on certain relationships was profound. Kahlo's reasons for depicting gentle animals are very different from Anjolie's whose warm nature, easy interaction with people, and the loss of a young mother would find her own validity for the subject and quality of her images. Again, Kahlo's use of a double image in *Self-Portrait as a Tehuana* and *Thinking about Death*, reflects her preoccupation with the two things that obsessed her the most in life — Diego Rivera

and the inevitability of death. In *Kalpana* (1985), *Devyani* (1986), *Mariam* (1983), and *Love Letter II* (1992) Anjolie uses the double image — the loved one obsessing the subject, through a portrait or a photograph.

The sleek black crow entered Anjolie's paintings during the 1970s. It is not imbued with the conventional connotations of doom and death but with her own interpretation of its signification. Life in a small flat in Bombay during that period with its environment stripped of flower and foliage made the ubiquitous crow a symbol of nature, a friendly surrogate. The same benign quality is reflected in other creatures that domesticate themselves — lizards, dogs, and goats. The lizard is visually effective because of its reptilian slimness and the curve of its long tail. In the painter's works it acquires the male gender, the voyeur gazing from unseen corners. When placed in conjunction with the high-breasted women that populate her canvases, the lizard's impact is never placid. Through this and other combinations Anjolie's references move from the display of innocence to unrequited desire or to the invasion of privacy and space. Dogs and puppies conjure up the frolic and play of childhood, an innocence not yet ruptured by life's realities. Empty chairs and charpoys speak of exactly these realities, of an adolescent's loss of her mother and of her father in later years. She continues to paint the unattainable or the intangible which is lost for ever, symbolized through skies or distant sails, balloons, and kites.

The *Window* series of paintings which was started in the late 1970s signified a link between empty lives shrivelling up in lonely rooms and the active world outside. During the early stages of the series the windows were painted, leading gradually to the use of actual windows salvaged from junk shops. Windows formed a grid in the later stages of this series, where images could be cut and reassembled in a non-realistic manner within wooden frames (*Chair*, 1981) or where a painted grid could

determine the composition of a painting which had not been turned upside down. The window, as a barrier, is in the foreground behind which much of the action and the emotion takes place: respite and diversion, nostalgia and pain, or the hardness and vulnerability of prostitutes as seen in the *Kamatipura* series. The theme of observing without being observed, with its occasional inflexion of voyeurism, as seen in the *Window* series, is exploited by Anjolie in various ways. It is seen through the device of a veiled woman (*Mothers*, 1987), the use of a mask (*Girl with Masks*, 1988), the sideward glance at untouched innocence (*The Acolyte*, 1994), the slit in a curtain, or the figure standing in the shadows of one or perhaps behind a wall or window — and always the eye(s) that watch. Curtains are ambivalent devices in Anjolie's paintings. Apart from hiding the gaze, they structure the background (as does architecture) and the foreground, evoking nostalgia derived from old photographs, and a great deal of pattern, colours, and design.

Intrinsic to the delight and excitement of making a painting is the challenge of an accidental happening that occasionally presents itself to a painter. While in the process of wiping the head of a figure she was dissatisfied with, she paused. It had, through the process of being partially erased, acquired a quality that satisfied her and was titled *Unsuccessful Portrait*. Accidents have also inspired textural effects on the paint surface. Shoe marks left on a wet painting by a child resulted subsequently in materials like plastic lace being pressed into other wet paint layers. Textural devices which are used impulsively function differently from images which rise from the deep recesses of the memory and the subconscious.

The vitality of an image or of an entire system and composition of a painting for that matter, cannot be sustained beyond a certain period of time. "When repeated often enough, a motif becomes a symbol which in turn becomes a cliche; a cliche becomes an absurdity, a cartoon," states Anjolie, who has for a while felt that certain elements in her work have lost their visual and emotional tautness, and hence, their validity as images. She is of the opinion that the creative rise emanating from an internal impulse (on which she places a premium) is unable to sustain certain iconographies when used too often. This is perhaps a problem being faced by almost every important painter in India today.

In terms of time, a considerable period has to be traversed from a representation exhausting itself out to a painter's recognition of it, and finally to a movement towards new directions. A change takes time but becomes inevitable. It is easy to continue painting with facile ability even when the act of painting no longer provides the same pleasure as it once did — a problem that most artists confront at various periods of their creative lives. The prolific Picasso faced similar problems and it would "have been extremely tempting to remain in the same style, to cultivate a following, to ride the wheels of success in the direction that they were already spinning. But there was something in Picasso that prevented him from ever resting on his laurels." ("Creating Minds" by Howard Gardner in *Pablo Picasso, Prodigiousness and Beyond*, New York, 1993, p. 154).

It is certainly tempting for Anjolie to rest on her laurels and paint established images since few apart from her seem to desire a change. "My worst enemies are my admirers — trapping me within the now recognizable style of my own making." Even while windows and lace curtains, sitting crows, empty chairs, and distant kites have lost the immediacy of their emotional content and hence their justification as symbols, she continues to paint them, seeking time and reflection to pull her out of her deadlock.

The first stirrings of protest towards what she herself had created came in 1992 when she exhibited furniture and *objets trouves* painted with some of her favourite images which were fast becoming "cliches". Her choice of household chairs, trunks, and cupboards painted in her own style mocked at her original paintings and constituted her statement of "removing art from its pedestal".

Cliches, whether in the form of composition, structure, or technique prove to be the enemies of many painters. J. Swaminathan's variations of bird and mountain in yellow, red, and orange required the catalyst of a new environment to bring out a highly individualized genre of indigenized abstraction; Ambadas' fluid quivering lines, valid at the time when they were first painted, lost their artistic grip when they failed to evolve; Manjit Bawa's Krishna/Ranjha theme escapes getting stereotyped because of the subtle changes of paint application, form, and colour that Bawa brings to the image; Paramjit Singh's trees, grass, and sky, though recurrent for years, are not yet beset by fatigue perhaps because of his exuberance and the painterly quality of his work.

In the case of Anjolie too, her superb technique and paint application bring much to the haunting quality of her canvases. This is a fact which most viewers take for granted since their interest lies more in the finished painting than in the process. But it is precisely those delicate layers of colour — transparent brown, olive green or Indian yellow, Prussian blue, indigo or terre-verte used in a specific manner, which lend the mystery or brooding quality to her images. Levels of memory and the subconscious achieve their visual success because of the harmony brought to them through technique. Wrapped up as they are in mists of translucency (fine glazes of paint), Anjolie's images and motifs establish themselves first through bright opaque paint which later gets altered through the ambivalence of transparent glazes which cover the painting and provide the surface effects. The clarity and assertion of bright opaque paint is very

different from the dark transparency that engulfs them. For Anjolie, an overall bright palette would signify the ordinariness of the present, stripped of mystery and the creative imagination and therefore of no interest to her. But the fresh green of *Malabar,* and other paintings of the 1980s, can evoke a bright palette. She is, above all, a colourist.

For about two years now, the artist has been struggling for a change in her visual vocabulary, a change that would take her away from the cliches that have become a cause of concern. Various external forces from the prosaic to the disagreeable have consistently intervened, making the shift difficult. The desire for change and a search for new things carries on unabated even while the demand for her paintings continues unrelentingly. Recently, Anjolie moved away from the deeply intense palette to experiment with lighter, brighter shades, even though the images have yet to make a transition. More recently, making a complete change of medium, she has created *Mutations* (1996), a series of computer-aided images which draw on the vast body of her paintings to create permutations of images that are known and yet new.

Acknowledgements
Photographs of *Bhuleshwar, Mataji, Midday II, Jhunjhunu Revisited, Atelier, Namboodri,* and *Love Letter II* courtesy Anjolie Ela Menon.

Shankaran Kutty's Birthday. 1987.

Oil on masonite; 120 x 60 centimetres. Private collection.

A portrait that goes beyond the realistic. Huge dark eyes and a wistful expression are typical of Anjolie's work.

Malabar. 1978.

Oil on masonite; 90 x 60 centimetres. Private collection.

The rich hues of the Malabar coast and conventional figures from Malayali culture recur in her work.

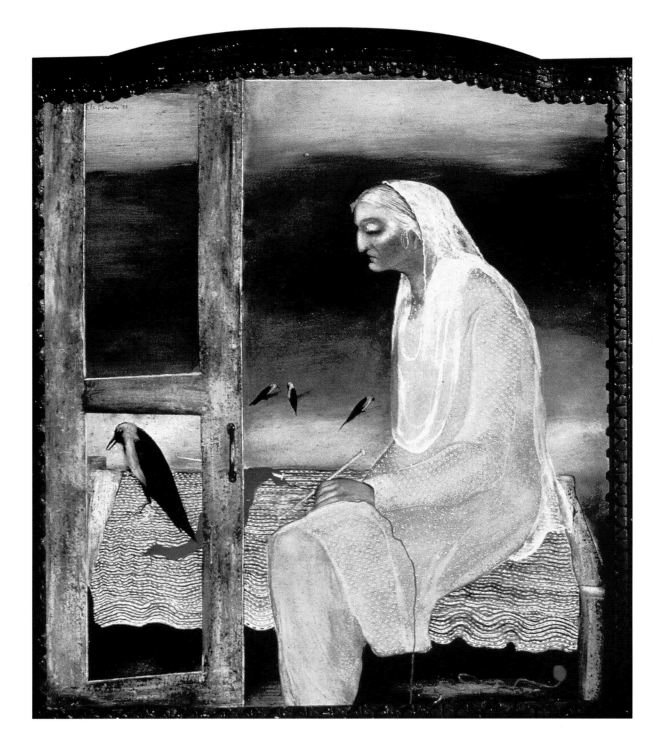

Mataji. 1982.

Oil on masonite;
90 x 75 centimetres.
Collection of the National
Gallery of Modern Art,
New Delhi.

She sits knitting in the sun,
dreaming of Lahore in the days
before Partition.

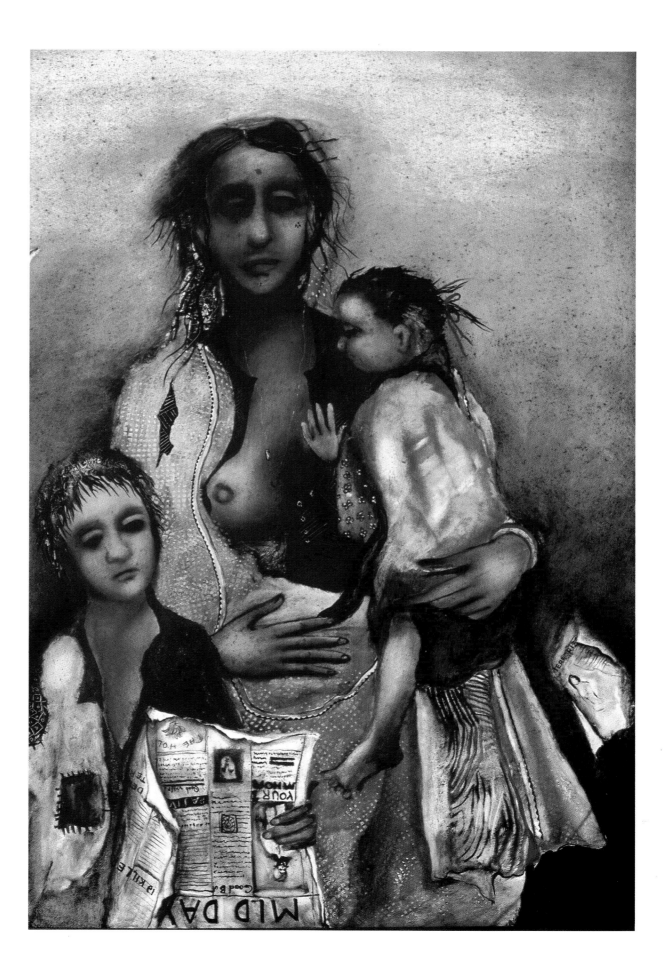

Midday II. 1987.

Oil on masonite;
120 x 90 centimetres.
Collection of Dinesh Jhaveri.

Not even the rags and grime
can hide her beauty as she
works the bus intersections at
rush hour.

Jhunjhunu Revisited. 1987.

Oil on masonite;
100 x 162.50 centimetres.
Collection of Harsh Goenka.

Strange tales from other days,
objects frozen in a time warp,
gathering dust.

Atelier. 1988.
Oil on masonite;
40 x 25 centimetres.
Private collection.

Coming Home. 1992.

Objets trouves,
painted on wood;
60 x 40 x 30 centimetres.

With such painted objects
Anjolie sought to remove
successful art from its pedestal.

Namboodri. 1992.

Oil on masonite;
120 x 90 centimetres.
Collection of Kavita Singh.

Leaning against the door, after
his ritual bath.

Love Letter II. 1992.

Oil on masonite;
120 x 90 centimetres.
Collection of Arvind Jolly.

The image of transience, paper
boats on the sea flank this
picture of melancholic reverie.

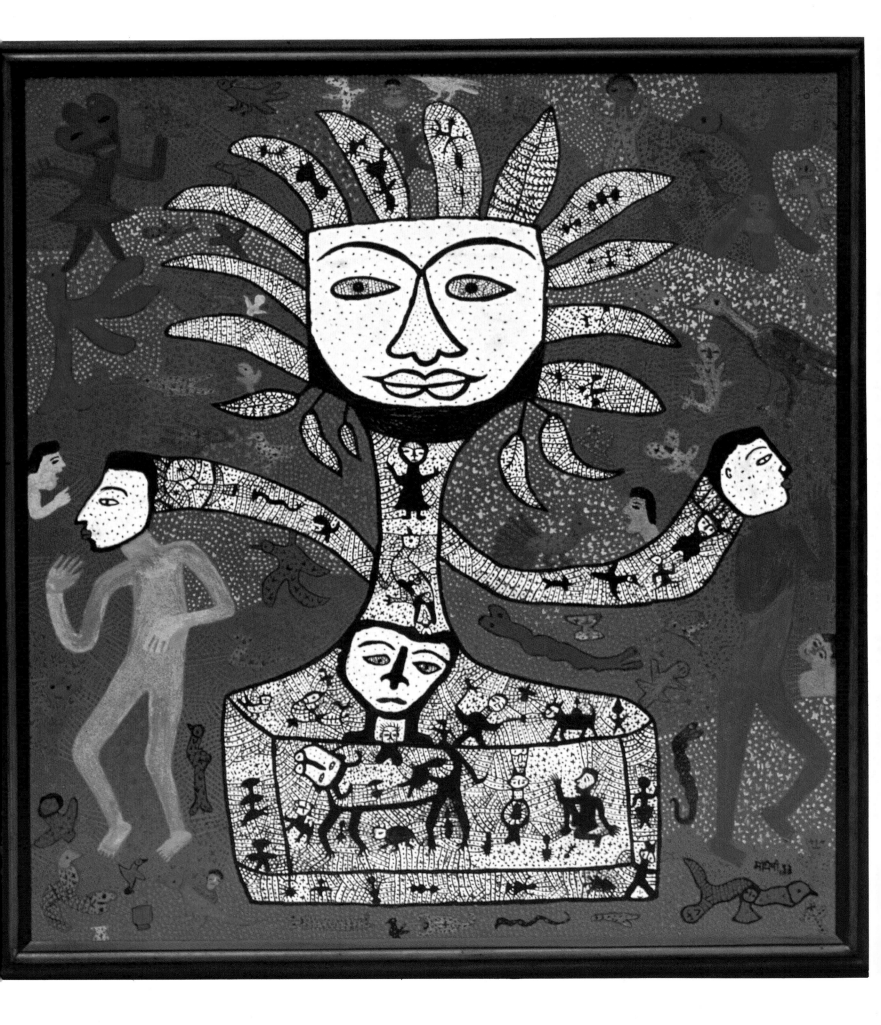

Madhvi Parekh: Child's World, Mother's Fantasy

Pranabranjan Ray

On the shores of world's sea
Children make merry
The child's ears make
Lilting legend of
Deafening roar of mighty wave
As mother pushes the swing with song.
— Rabindranath Tagore (*Sisu*, 1893)

I

One of the methods of arriving at truth through a discourse, followed by the *Navya-nyaya* school of logic, is by negation of negative propositions. In our discourse on the significant artistry of Madhvi Parekh I propose to follow this method.

II

In an autobiographical piece entitled "How Green was My Valley"[1] Madhvi has narrated the story of her birth (in 1942) in the village of Sanjaya, near Ahmedabad, and her growing up as one of six brothers and sisters, all children of a staunch Gandhian father who was a primary school teacher and a mother with no formal education who would not treat her male and female offspring differently. She remembered how as a quiet child she would give her boisterous playmates the slip and sit quietly in a field watching the cattle graze or stand by the village well, unobtrusively, gazing at the slow procession of village life. She has spoken of how fond she was of the spectacle of village festivities. A wedding or Holi or Diwali celebration would make her joyous.

All these facts are undoubtedly important, for they have entered Madhvi's work as vital inputs. One is apt to find reverberations of the child's wide-eyed visual recordings surfacing in the mature painter's work. Parallels between the observed events and memory-images can be discovered. But as critic Mala Marwah, in her introduction to the catalogue of Madhvi's exhibition in 1978 in New Delhi[2] perceptively observed, "the strength of artistic memory lies in its power to transform the subject of inspiration . . . with fresh significance". It is the manner in which she transforms her childhood memories, endowing significance to them in visual terms, that is of greater importance towards a general appreciation of her work as a painter. After all, the peaceful coexistence of diverse species of identifiable and unidentifiable animals, birds, aquatic life, plants, and people of various ages, gender, and ethnic beliefs, so evident in Madhvi's paintings, cannot be taken as observed facts. Wish-fulfilling imagination must have played its part in such depictions. More than

Sun. 1993.

Oil on canvas;
100 x 100 centimetres.

Here, the artist renders the sun, both as symbol and icon, as a figure teeming with its own life forms and activity.

that, an exclusive emphasis on the memory factor as causative of the imagery of her paintings is likely to desubstantiate the symbolic significance of the motifs, like small figures within larger enveloping figures, birds carrying the embryo of fish within their wombs, animals pregnant with birds and, of course, the preponderance of pregnant *homo sapiens.*

It is assumed that memory of a different kind is to be taken into account for an assessment of her creativity. The general assumption is that the memory of Gujarat's folk arts and crafts have played a vital role in the making of this painter and the content of her paintings. Some reviewers of her early exhibitions had even gone to the extent of suggesting that she is a continuer of the tradition of the folk arts and crafts of her state. A surface similarity between Madhvi's flat, linear, and almost geometrical mode of rendering human and animal figures, decorative stylization of birds, fishes, reptiles, and flora, the decorative use of the primary components of vegetal motifs, decorative and linear rendering of the sky, sun, moon, stars, clouds, land surface, water bodies, and waves have led many to believe that hers is a folksy art. To buttress their assesssment of her affinities with folk art they point a finger at her chromatic preferences. The textural embellishments of her drawings and paintings would suggest to them their kinship with the texture of woven and embroidered designs on traditional Gujarat textiles. In her autobiographical piece of writing, on the other hand, Madhvi has not uttered a word about her fascination for the folk arts and crafts of Gujarat, not to speak of actively pursuing them at any stage of her life. Even then, one might concede the suggestion that she might unconsciously have nurtured a particularly deep impression that the traditional craft designs had left on her mind in her formative years. However, it is certain that in her work she only creates an ambience of the

visual folklore of Gujarat, without falling in the ambit of any particular tradition of folk art or craft. This evocation is intended to make the memory of childhood in the rural Gujarat of yesteryear palpable. Too great an emphasis on the craft root of her painting would rob her work of its rich imaginative content.

In continuation of the preceding discussion, a preliminary review of the notion that Parekh's paintings are like children's art should be made. Her lack of formal education at a modern urban institution for art education is cited as a reason for the resemblance of her paintings with those done by children. Advocates of the unilinear development of art do find a parallel between the art of non-professional rural folk and children, wherever they are, albeit without much justification. No wonder, then, that some of them would find a concurrence of the folkish and the "child art" elements in Madhvi's work. A preponderance of imaginary creatures, conglomeration of multiple points of viewing a single event in a composition, resulting in a multiplicity of representation of the three-dimensional worldly space on the two-dimensional picture surface, rendering of motifs as compounds of simple geometric shapes and elements, and an inclination towards assembling of primary and secondary colours in colour complementaries, are pointed out as elements of child art in her work. What, however, the critics overlook is the fact that she employs elements of this kind of art intentionally. Her creative goal is construction of an adult surrogate of the child's world. The remembrance of things past — of her own childhood — in her painting can, therefore, be seen as a strategy she actually adopts.

Madhvi herself has contributed to the notion that her entry into the field of art has been without a passport of formal education from an art institution. When as the secondary school educated bride of a child marriage (she was

married when she was fifteen and her husband Manu was eighteen) she came of age and started living with her struggling artist husband in Bombay, the only pastime the cash-short couple developed was visiting museums, galleries, and exhibitions. During these visits Manu would make every effort to interest his wife in the world of painting and sculpture. The interest that he kindled led to her desire to learn to draw and paint during her pregnancy-related confinement in 1963. It should be noted that her preference at that point included none of the useful traditional crafts which pregnant women take up in preparing themselves for maternity and childcare. Instead, she decided to learn to draw and paint.

Manu, then a down-and-out young painter and textile designer, enthusiastically started initiating his young wife into the intricacies of drawing and painting, following meticulously the programme of training drawn by Paul Klee, in his *Pedagogical Notebooks.* Manu would teach Madhvi the mode of composing pictures on a two-dimensional surface by conceiving motifs and images as compounds of simple geometric entities and shapes like lines, dots, dashes, crosses, circles, semi-circles, triangles, squares, and rectangles and realizing them in black and white or in primary colours. On each day of her confinement, Manu would provide her with a supply of paper and the wherewithal to do exercises along the lines chalked out by Klee. He would patiently explain things very simply and lucidly. A number of these exercises and drawings were exhibited by Navin Kishore in the retrospective exhibition of Madhvi's work held by the Seagull Foundation in Calcutta, New Delhi, and in Bombay in 1992.

What is noteworthy here is the fact that the art education Madhvi received from her painter husband was non-traditional and of a most advanced kind, being the one developed at the Bauhaus school. Her interest in the non-performing visual arts grew while in Bombay and later through her association with a set of

artists during the couple's stay in Calcutta from 1965 to 1974. Thus, the myth of Madhvi's being an untrained amateur cannot be cited as reason for the childlike look of her paintings. In fact, the technical mastery with which she has been handling various media for well over two decades, and the manner in which she has been constructing earth, sky, and water imagery through rich textural weaves are enough to demolish that belief. Madhvi learnt whatever she wanted to from the direct informal education she had, and then steered clear of influence for the sake of self-objectification. In a similar way she has been seeing and learning indirectly from the work of her contemporaries, including her husband, without getting influenced. The painter is untrained only in the sense of remaining unspoilt by training. Her strength to remain an individual, transcending training and influence, comes from her wish to objectify her vision. And it is in her vision that we have to look for the apparent childlike appearance and ambience of the visual folklore of Gujarat.

III

From Madhvi's own account we know that her first encounter with young artists took place when she was training to be a teacher in a Montessori school. Interacting with children there she realized that, in representing the phenomenal world in constructs, children follow a very imaginative kind of logic, peculiar to them. Her training was interrupted by her pregnancy but continued all through the period she was bringing up her child in their tiny apartment in Calcutta. To compensate for the lack of space and nature in reality, she would trigger the imagination of her young daughter by telling her stories about her own free childhood amidst nature. The second spurt of the painter's prolific creativity came during her second confinement when once again she had to play the role of child-rearer.

These facts, among a plethora of information the artist has provided in her autobiographical piece, are of cardinal significance towards a rounded appreciation of her work. She invokes the memory of her own childhood, sans phenomenal positional details, to reconstruct the locales where the pictorial events happen. She follows that up with a child's logic of representation, of the appearance of the phenomenal space on a two-dimensional picture surface, and of phenomenal objects, through linear drawing. As the child undertakes a similar project to tell his imaginary tale, or better indicate his storyline, Madhvi configurates her imagery on represented pictorial planes, to half tell and half suggest her fables.

As the invocation of the child's imaginary world could not have been possible if Madhvi had resorted to a particularist recollection of descriptive details of locales enshrined in her memory, she reconstructs the locales according to the child's logic of representation; recollecting at the same time how as a child her own faculties of imagination would be triggered by the sights.

Following Klee's prescription she could easily have gone along with formal representation of the phenomenal reality in geometrical signs and marks on consistent two-dimensional pictorial space, to readily conform to the tenets of supposedly universalistic modern art. However, she would not be distanced either from the world of her experience or from the objective world that triggers a child's imagination. Nowhere is her differential preference further from Klee's logic, as in her representation of the phenomenal space in painting. Madhvi appears to treat her picture surface as a flat two-dimensional space, all of which does not recede or project in the same manner. Motifs and images get configured on space in a variety of ways in a single picture, suggesting different approaches to picture space. Relative sizes of motifs on

picture surface are neither determined by the notion of distance-size relationship nor by relative proportions of the object images. This mode of encapsulation of a multiplicity of spatial representation, as well as this total disregard of phenomenologically conceived relative proportioning of images, are part of the package of many narrational folk art traditions found all over the country. Madhvi can be presumed to have learnt her lesson from these sources, but unlike these folk traditions she does not make her pictorial space a mute receptacle for decorative motifs. Further, although she uses a profusion of abstract decorative marks, these in no case reduce the paintings to decorative designs. Even though her sense of the decorative can be traced back to folk sources, as critic Geeta Kapur has observed, her sense of the decorative is modern and non-traditional.

Madhvi's invocation of affinity to folk art and her refusal to carry the mantle of any particular tradition of folk art and craft, like her invocation of the logic of child art, seems to have been a creative strategy. To create the aura of recollection of a childhood happily spent in rural areas, she possibly conceives of some kind of convergence of the child's logic of visualization, the ambience of folk art, and the teachings of Paul Klee. However, an alchemy of this kind does not sufficiently account for the significance of her paintings.

Although apparently Madhvi objectifies the world of the child's imagination, aspiration, and logic, closer analyses of her imagery and constructed pictorial events would reveal that she has always been concerned with the objectification of the child's world. Madhvi the adult woman plays the role of the child, and yet not to objectify the interdependent childhood-motherhood syndrome. The x-ray imagery of wombs carrying embryos in her paintings not only makes personal reference to her own pregnancies, but also to the silent desire of millions of women to provide for their

children a protective motherhood, an extension of the womb.

An almost instinctive motherly desire to provide protection does not stop at physical protection. Following Madhvi's summons, when the beholder gazes at the characters of her paintings, they almost intuitively feel the presence of anxiety, apprehension, and pathos alongside the more palpable, even funny gestures of the limbs. All these do not exhaust her expressions of motherly concern in her paintings. The peaceful coexistence of diverse kinds of fauna and flora can be regarded as a wish-fulfilling vision the artist inherited from her Gandhian father (she has recently illustrated a book for children, for the organization Sahmat, on the subject of Gandhiji and children, entitled *Bapu*). But preservation of a peaceful milieu for the happy growth of children is a motherly concern, irrespective of whether the mother is a votary of *ahimsa* or not. All these aspects give Madhvi's work a feminine quality. Hers, however, is not a feminism of the radical variety, locating the feminine in terms of contradiction with a male-dominated society.

The manner in which Madhvi deals with the mythic and the iconic in her work clearly underscores the stand she takes against the conservative notion of tradition as something sacrosanct. A myth, like a fable, is a constructed narration with phenomenally disparate elements and make-believe events, to posit certain values and norms. But the myth, unlike the fable, makes the values and norms sacred. In her painting Madhvi not only depicts children, birds, reptiles, and animals at play, but creates an overall ambience of playfulness and adopts a playful mode of working out her visual fables. Even in those paintings where she has introduced known Puranic and brahmanical divinities like Kali and Durga, she brings them down from their iconic pedestals and engages them in worldly play. It must, however, be added that she has never critiqued the divinities the way an iconoclast does; she has, however, refused to be subjected to the authority of the sacred. The fables the painter constructs with characters in absurd juxtapositions often tend towards fantasy. Happily, her fantasies are not of a macabre kind.

IV

Madhvi Parekh's refusal to let her conception and skill be subjected to the authority of particular techniques, forms, notions, and ideas, irrespective of the stamp of tradition, modernity, and contemporaneity, and a supreme confidence in her own ability to perceive, conceptualize, and objectify those even as she uses her own acquired skill, makes her an individualistic artist. Yet, she does not reject or negate anything confrontationally. We have seen that she appropriates, transforms, and integrates any element from anywhere that she finds appropriate for her self-expression. We see an aspect of her modernity in her rejection of the authority of tradition, in her playfulness with the mythical, and in the desanctification of the iconic. Yet, she finds reference to all these important to objectify her experience and desires. The problem, however, is whether the doctrinaire kind of modernism would accept the forward and backward linkages of Madhvi's art with the phenomenal world, on the one hand, and the traditions of the land on the other. Post-modernist understandings seem to be more accommodative of such plurality.

Identifying labels, however, are neither relevant nor sufficient for appreciating the significance of this artist's very individual art. She orders her signifiers in such a playful manner as they appear under a seemingly decorative veil, only to reveal the different stratum of significance, at an extremely slow pace. The pace of revelations suits the almost time-defying nature of some of Madhvi's concerns. In this respect also, her mind beats in rhythm with that of rural India. Her intuitive oneness with this rhythm establishes her as an authentic modern artist who can transform the most vulnerable aspect of womanhood into a source of strength and power.

Notes
1. *The Illustrated Weekly of India*, Bombay, March 18, 1990.
2. Dhoomi Mal Gallery, New Delhi.

The Head. 1993.

Oil on canvas;
90 x 90 centimetres.

Wilful distortion of size and
perspective recurs in the artist's
paintings.

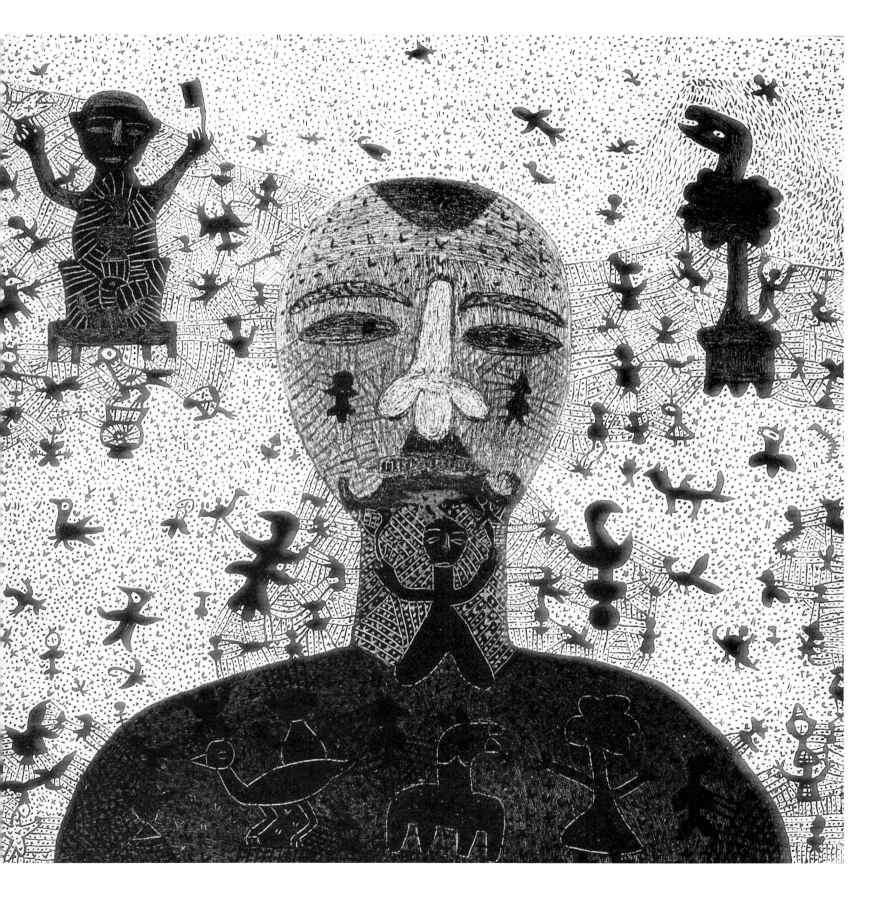

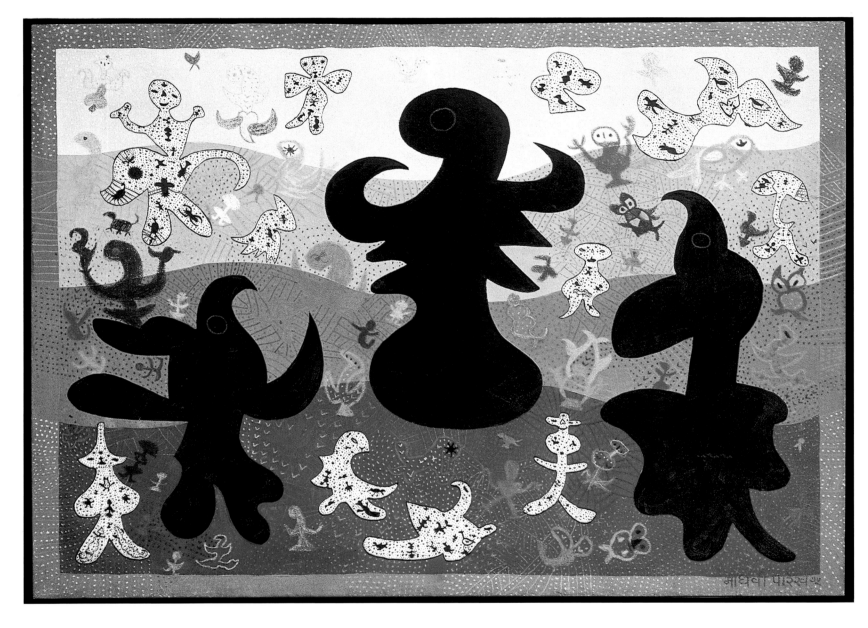

Village Opera. 1975.

Oil on canvas;
100 x 150 centimetres.

Parekh's world draws upon
reminiscences of her life till the
age of thirteen in the village of
Sanjaya in Gujarat.

**Happy in the
Green Field.** 1978.

Oil on canvas;
120 x 180 centimetres.

Village life, made up of
identifiable and unidentifiable
forms, represents a blend of fact
and fable.

Dancing in the Field. 1994.

Oil on canvas;
90 x 120 centimetres.

A general association with
Gujarati folk art and craft is
evoked in Madhvi's work.

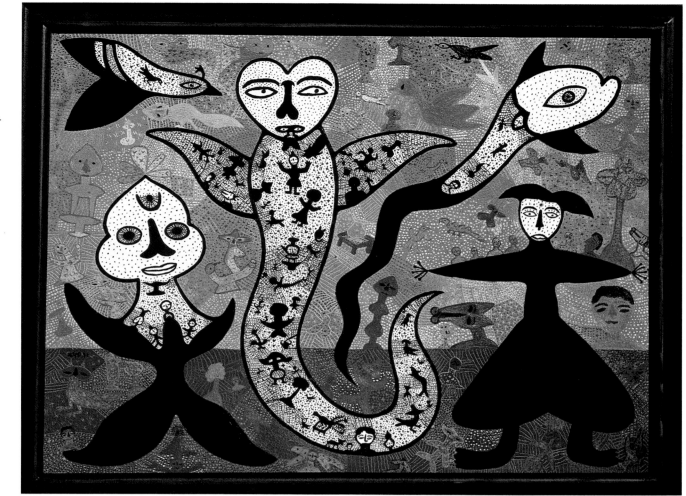

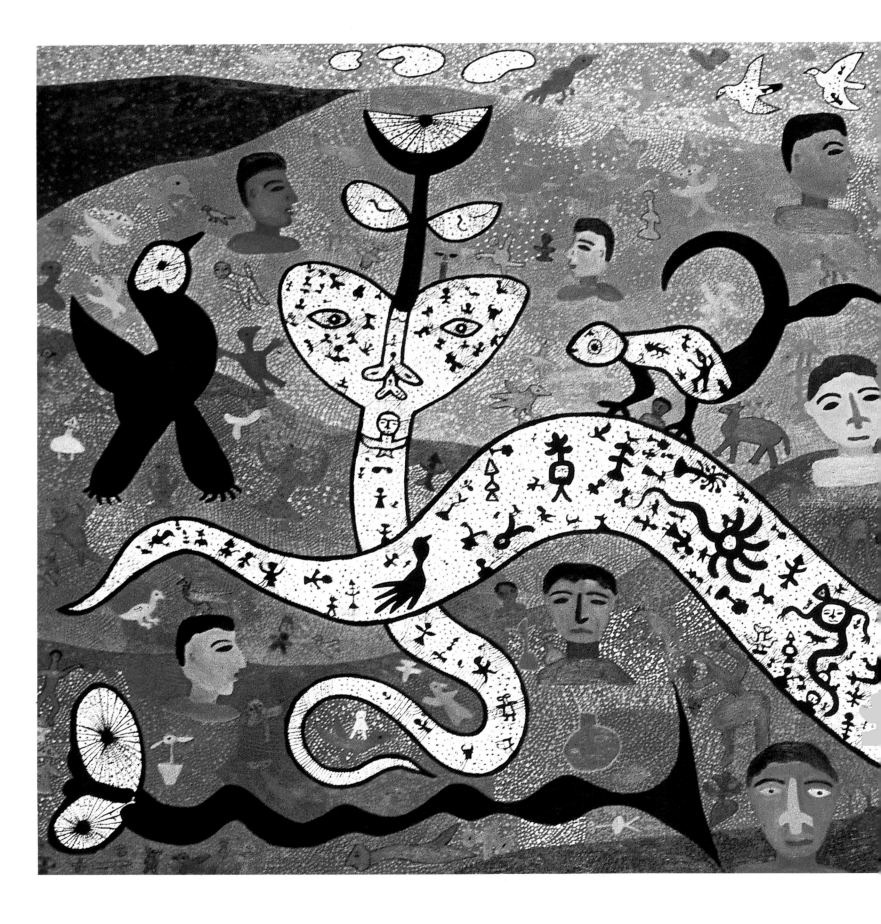

Kaliya Daman. 1993.

Oil on canvas;
150 x 300 centimetres.

Madhvi continually uses myth
even as she demystifies the epic
and introduces the element of
play.

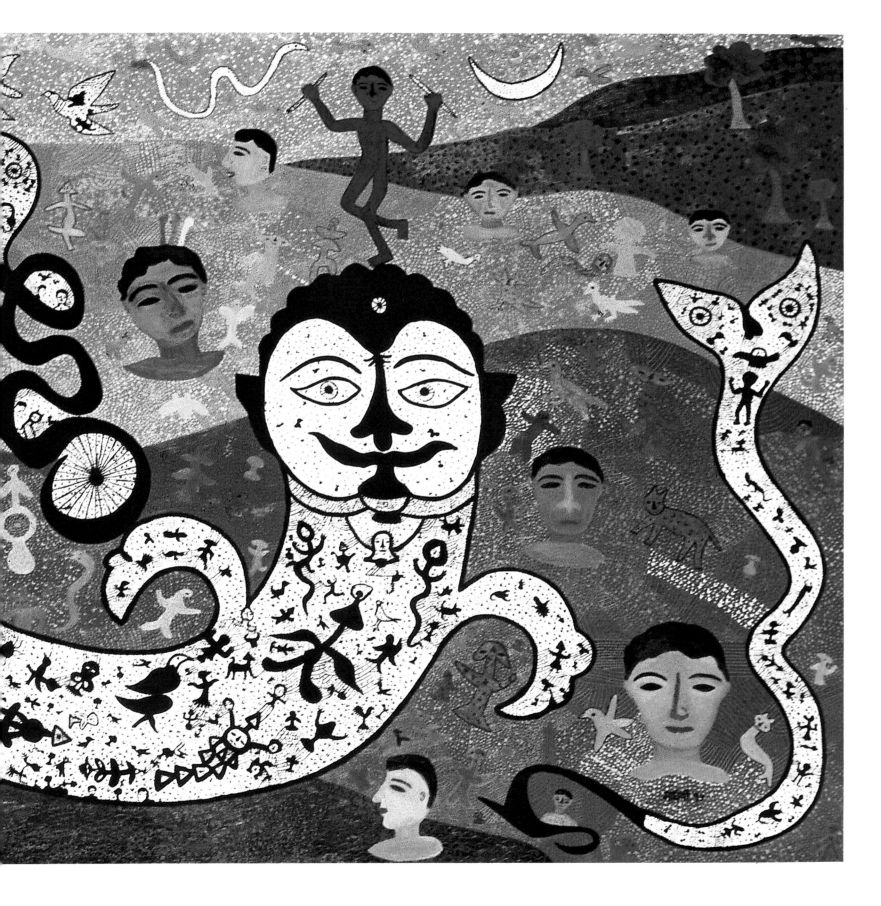

The Bull and Bird. 1993.

Watercolour;
30 x 40 centimetres.

Animal, divine, and human forms are frequently depicted, pregnant with their young.

The Bird. 1993.

Watercolour;
30 x 40 centimetres.

Always in intimate contact with its proto-real environment, the bird or animal form is at once toy, mythic animal, and icon.

Durga. 1992.

Oil on canvas;
120 x 120 centimetres.

Durga as Mahishasuramardini is a subject popular with the artist; she emphasizes aspects of divine *leela* (play, sport), even in the midst of violence.

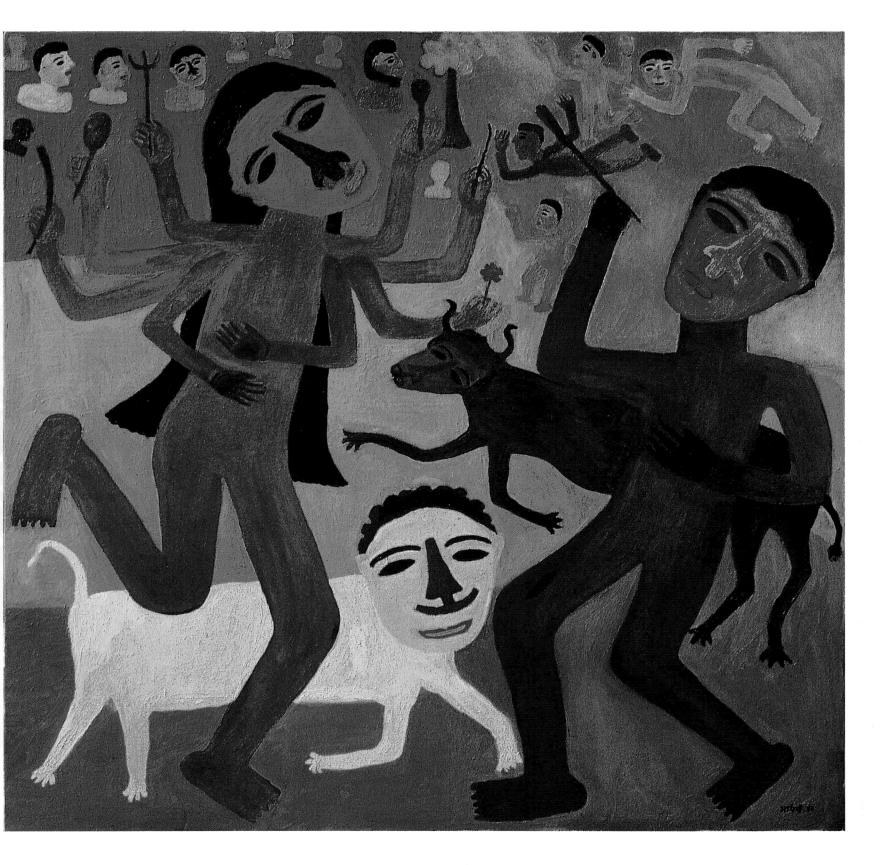

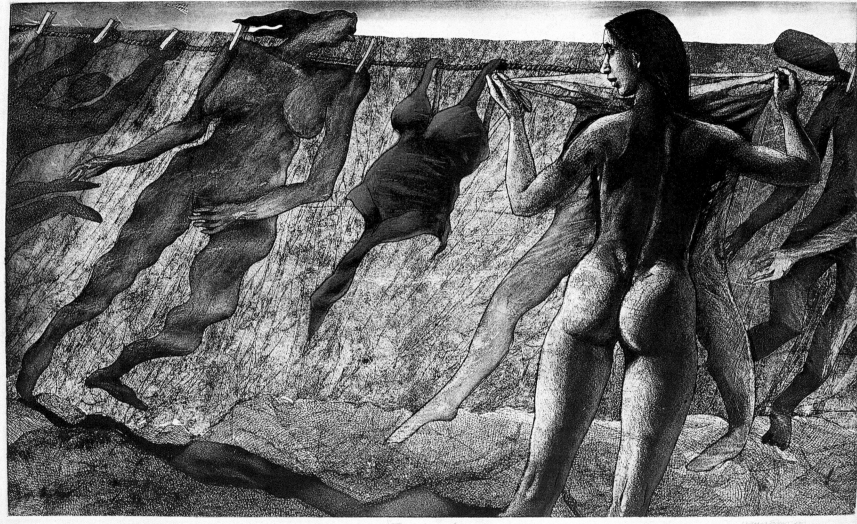

2/11 The Laundry yourname

Anupam Sud: The Ceremony of Unmasking

Geeti Sen

"I reject all decorations. That is why I reject clothing on my figures. The decorative element is totally absent in my work. It is the stark truth."

I

Anupam Sud (b. 1944) works essentially and only with the body naked.[1] A bold statement for a woman who in every way, by word, demeanour, and lifestyle, is modest and unassuming; who shuns publicity, and held her first major exhibition in 1989 after considerable persuasion and a gap of some eighteen years.

At her studio at the Delhi College of Art, she was inking and wiping the zinc plate, wiping it finally with the hand which she finds an essential tool. I watched as she placed the reworked plate on the etching machine, carefully pressed downwards under a piece of wool felt (to take a deeper impression), and then manually turned the wheel that made the roller run over the plate.

Anupam remarked casually, "It takes three months sometimes to make an etching — a painting takes much less time! I had made this etching three years ago, but I was not happy with it. Now I have destroyed the old image — to see if something new can emerge." An etching

requires of the artist precision, patience, and purpose. Did this reworking of the image etch out old, worn memories? Nothing in her atelier reminded us of the past; a few pictures pasted on the board were by her students. One print by the artist was pinned up on the wall with a thumbtack, so raw that it looked as if it could still bleed.

A line of bodies, like clothes hung up to dry on a washing line: torsos and legs dangling, one blood-red. With her beautiful back to the viewer, a powerfully built woman, naked, surveys the *Laundry* (1994). Are these identities from the past, washed up and hung on the clothesline like the reworked etching? She offers only one comment: "It is the outer skins of ourselves which are hung up to dry."

Anupam's concern is explicitly with the figurative; but the figure is more than a means for exploring the narrative, the epic, or the human predicament. For her the human figure becomes an end in itself. She brushes aside queries and distinctions between the naked and the nude, with reference to John Berger. "I focus on the nude for the sheer beauty of the body — that's all. For me it is much more vulgar to highlight or expose certain areas of the body. I remove the long hair on the female torso because there should be no distractions."

The human figure, stripped to its essence, is revealed, as much as the naked truth can be revealed. This process

Laundry. 1994.

Etching;
30.50 x 48.50
centimetres.

Anupam extends the use of the nude form in her etchings to the washing and drying bodies as multiple identities.

is the reverse of that age-old practice of the striptease, where the ritual discarding of clothes by the cabaret artiste, retaining of course, the hat, the shoes, the jewellery, and perhaps a veil, becomes entertainment, to tantalize and mock the viewer, concealing as much it reveals. In contrast the work of Anupam Sud becomes a gradual but logical process of uncovering and unmasking the body and identity of the self.

We might trace the birth of human forms through thirty years of her work. Initially, the artist's obsession is with the idea of giving birth. In *Earth Mother* (1967) embryonic forms struggle to emerge from within the swollen primordial womb-cave. Often enough, these figures are all arms and legs, impregnated within the enclosure of a rocklike formation; or they are found in subterranean passages in her *Time Capsule* (1969). They are filed away in cabinets in the dark interiors of the *Museum* (1972). They flounder, swimming through the waters of *Whirlpool* (1971) which could be taken to be the primordial waters of destruction at the end of the world, *pralaya,* the ruptured waterbag from the uterus. Faceless and anonymous as they are, these figures engage in bestial rituals like those by Hieronymus Bosch in his *Garden of Delights;* burrowing through anthills or eating through sprouted beans in the *Box* (1971) where only shafts of sunlight penetrate into the gloom.

The coloured viscosity print titled *Whirlpool* and the etching in black and white titled *Box* were made during the years 1971-72 while Anupam studied at the Slade School of Art. London opened up for her new visions: she began experimenting with the human figure, and also to write a series of small haiku-like poems titled *Windows*. Now mutated torsos are glimpsed through a series of her etchings also titled *Windows* (1973). A male torso is seen through one windowpane, the buttocks of a female through another, a hand stealthily

reaches up from the window below. These torsos, significantly, are headless, but fully formed, sculpted with sinews and muscles — unlike her earlier work of the apparently primitive amphibians.

In torsos that achieve such perfect balance, the absence of the face makes a statement, as in a work titled *Composition* (1972) which was exhibited at the British Biennial. This was the first occasion when she handled a 20 x 40 inch etching plate. Centrestage, a man reaches out to play a game of marbles while the woman gropes her way in the shadows of the picture frame. The importance of the hand as a tool had already been stressed by Anupam. Now she suggests that the hand forms the start of this composition, being used to press down memories on paper from the past.

II

On her return from London, her figures are possessed of a singular quality of immobility; they are like studies of still life. The head, if and when it emerges, is entirely faceless or cast in shadow. The subject matter is enigmatic, raising doubts about the identity of the person who might be prominently placed, but who remains passive and often victimized. Consider her three etchings titled *You* (1973), *Biography of a Crime* (1973), and *Homage to Mankind* (1977). Each of these is imbued with a sense of undisclosed mystery. The accusing finger in *You* is placed in the immediate foreground of the picture, pointing to the figure of a man, suited and seated behind a desk. The collar merges into the windowpanes beyond — there is no head and no clear identity. Yet the situation and the person are real; a cigarette lies on the desk, unsmoked.

A broken white line descends diagonally, vivisecting the man into two fragments. The dotted line is a device improvised by Anupam, she suggests, to

balance the composition. Yet, it also introduces an element of doubt about the meaning of the picture and the fragmented (or double) identity of the man. Etchings from the mid-1970s carry an autobiographical content. Scathing irony reinforces that sense of stark nakedness in her work of this phase. The most powerful is her *Homage to Mankind* which casts the muted shadows of the Taj Mahal into the background, as the referent to that all-enduring symbol of love. In the foreground rises the human witness to and victim of this love of today and yesterday. Standing upon a monitoring box, his powerful frame is strapped to blood transfusion — to ensure the continuity of life and render him captive. Ours is an age of reliance upon machines. The artist's mother, a woman of indomitable strength and wrongly diagnosed to have cancer, was reduced through medication to an invalid for the remaining fourteen years of her life. The artist offers one comment: "The figure is all patched up — as good as new! Even the brain is being monitored"

Three portraits from the 1970s exist in oil, of her father, her mother, and her mentor Jagmohan Chopra. These testify to Anupam's competence in rendering realistic studies. They also suggest that she deliberately chose to work in the graphic medium, allowing for a combination of the real and the unreal as construed by the artist. "It was a sort of challenge: to work in a medium for which there was little encouragement provided in India, or in fact, any professional equipment." In 1967, when Anupam graduated from the College of Art, Group Eight, a professional group of printmakers in Delhi, was founded at the initiative of Jagmohan Chopra. Almost thirty years later, she still works on the etching plate, while heading the department of graphics at the College of Art.

III

The difference between oil paintings in

colour and etchings in black and white is relevant to Anupam's sensibility and to her choice of subject. Black and white pictures possess an element of the austere, by converting the image into shadow and light — thereby invoking, at times, the values of good and bad. The artist employs these effects to great advantage, by using chiaroscuro to heighten differences and summon up the psychic qualities in her figures. We begin to sense alienation, the "otherness" in images of men and women who, on the face of things, are portrayed in "real life" situations. The situations now are commonplace; but the titles to her work take on a double-edged, even haunting, meaning. *Thanks to Power* (1976) may just refer to a fan purring noiselessly in a room where people languish on a hot day; but it may refer to a different kind of power, that controls and executes, and the privilege of having electricity. *The Ride* introduces a man and a woman together on a bicycle along a road that seems to go nowhere, but which contains a road sign at the end announcing "No Limits". What does the "ride" mean for this couple, apart from being an uneventful journey — till they suddenly come upon this sign? *The Ride* compels us to reconsider the "normal situation" no matter how commonplace it might appear, as the artist probes below the surface appearance of people and things. She comments: "Marriage brings about a state of mind. Everything which was earlier declared wrong is now permissible. I have never seen myself as a bride. My sister, on the other hand, fantasized about marriage." This comment significantly establishes that she views her images at this stage of her work as an outsider.[2]

We now enter a phase of Anupam's work of greater realism where her figures are no longer phantom-like passive victims. They interact, they gesticulate, they react to the world around them through themes of social relevance. A major breakthrough is provided with that unforgettable image *Darling, Get me a Baby Made!* (1979). In this poster-like etching the painter inserts the newsprint advertisement of the "test-tube baby", and photo images of the two doctors responsible for this daring experiment. Above is the workshop where the babies are being manufactured, by men disguised by their surgical masks into bandit-like goons. Below are the women, sexy, volatile, eager for the experience that might change the course of their life and their values. Grouped about a telephone, a strange connection is established between the telephone wire that snakes around like an electrocuted umbilical cord, to disappear into the navel of an aspiring candidate.

The focus in Sud's prints of the 1980s is on figures in the context of their urban environment. Streets, pavements of cement, broken walls, barbed wire, and battered lampposts — elements which define and circumscribe human existence — begin to form an essential part of her vocabulary. These elements bring about a play between light and shade, between life and death, as her commentary on people who live precariously at the edge of survival. Some figures assume a heroism as they rise above their situations. Take her rickshaw puller in the etching *Way to Utopia* (1980) who is charged with superhuman energy. "The rickshaw puller becomes a symbol; he takes you from one destination to another"

At the same time in the 1980s Anupam embarks on a series titled *Dialogue*. In essence, these explore the subtleties, the nuances, the give-and-take in human relationships. *Dialogue* (1984) depicts a couple seated before a ramshackle house which is distanced from them by barbed wire. They share no sense of intimacy or belonging; their attitude is one of resignation. Another of the *Dialogue* series, on the other hand, is concerned with a different kind of relationship. In one of her few open landscapes, two men are seated on a bench, deeply engrossed in conversation.

IV

Despite her deep convictions in this matter, Anupam's works carry an explicit and concerned search for identity in her projection of women. In the etching provocatively titled *Pickup Girls* (1980) two girls, naked, are engrossed in some game along a street pavement. This may be a game of marbles, or of dice, or possibly gambling for money. Electric lights from the windows above flood the street, silhouetting the figures of the women so they appear more conspicuous as bold, intensely dark forms against pools of light. In the immediate foreground another female form emerges, to look down at the street below. Her naked body is exquisitely modelled in chiaroscuro, but the face is obscured with her fine black hair blowing across, caressing the shoulders. The woman reaches out, furtively it would seem, to a basket of small round shapes on the table — could this also be money?

That the artist is fully conscious of the mysterious power of her etchings is evident from a casual remark, made with her wry, unmistakable sense of humour. "I have a tendency to give titles that have a double meaning to them — so that anyone can pick up what he or she is capable of"

The actions and attitudes of the women are patently clear; but not the meaning of the picture. Baring the two figures in silhouette with their faces obscured is a deliberate ploy, a choice made by the artist. Nothing could be more provocative or startling than the human body revealed in its entirety and combined with faces in shadow. A mysterious aura emanates from such women, as that of the scent of their bodies — arousing in the viewer the predatory, animal instinct. Viewed thus, the woman becomes an object of carnal pleasure rather than the subject of the painting.

This, briefly, is the viewpoint taken and discussed by Berger, where he draws the distinction between the nude and the naked.

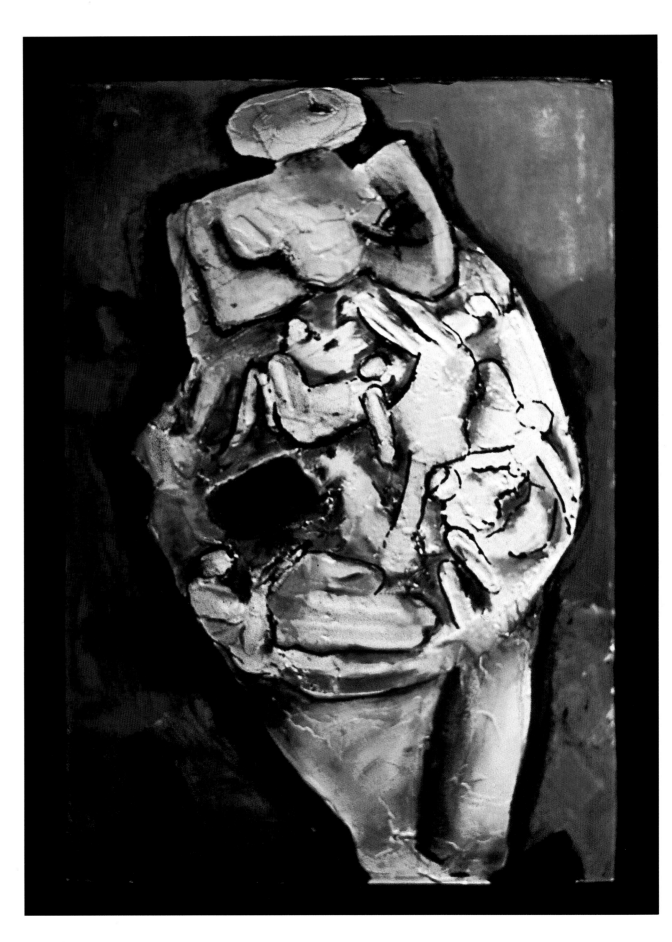

Earth Mother. 1967-68.

Oil painting;
100 x 75 centimetres.

The large uterine cavity of the
primordial mother breeds
numerous forms.

**Homage
to Mankind.** 1977.

Etching;
65.50 x 51 centimetres.

Against the shadowy image of
the Taj Mahal, modern man is
seen as a prisoner of medical
monitoring.

**Darling, Get me
a Baby Made!** 1979.

Etching;
50 x 64 centimetres.

The scientific intervention that
reduces human reproduction to
a laboratory function here elicits
a cynical response.

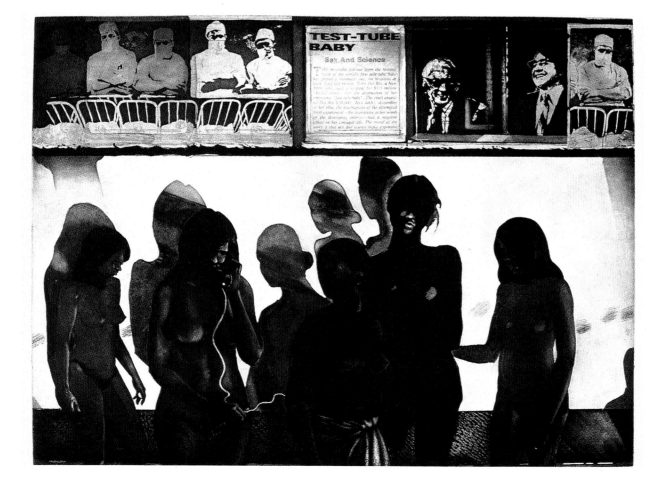

Berger writes from a male point of view; although it is a viewpoint most sympathetic to the female:

"To be born a woman has been to be born, within an allotted and confined space, into the keeping of men. The social presence of women has developed as a result of their ingenuity to living under such tutelage within such a limited space. But this has been at the cost of a woman's self being split in two. A woman must continuously watch herself."

And again, to stress the essential difference, he observes:

"Men act and women appear. Men look at women. Women watch themselves being looked at. This determines not only most relations between men and women but also the relation of women to themselves Thus she turns herself into an object — and most particularly an object of vision: A sight."[3]

Would this be the way by which a woman artist might project her image of women? There are important differences in *Pickup Girls*, with reference to Berger. These women, all three of them, are neither supine nor immobile, nor are they in themselves self-conscious "objects" of desire, as say, in a painting by Titian or Rubens. Each of them is engaged in an act which concerns them, by which they wholly ignore the spectator. None of them invites attention, by looking out of the picture frame to beguile and arrest the viewer. In Anupam's etchings, this is a woman's world, and complete in itself.

Anupam responds, "My work is not about sexuality; people interpret my etchings and ask me if they are about homosexuality or lesbianism, but I do not judge people on their sexual life. I like the human body — when light falls upon it and modulates the form, the

tonalities. It stimulates me and inspires me to work. It is not only the woman — it is also the man. The male torso is the most perfect form!"

Her reference to the male body becomes the most substantial argument against those who would see a latent eroticism in her depiction of women. Equally, perhaps more so in the 1980s, her work pivots around the male nude. Four years after her print of *Pickup Girls* is her etching titled *The Dice*, a viscosity print made at a workshop at Bhopal. Three men, naked to about three-fourths of the body, grow together as out of some common destiny which binds them. Yet each represents a different person with a different outlook: one looks for opportunity, the second gambles away his chances with dice, and the third contemplates the choices open to him. While the facial features are sharp and aquiline, the bodies are superbly built and beautiful.

The second factor which argues against the deliciously erotic is the stark sense of austerity about her images. Her women are never projected against curtain drapes or potted plants or the like, or in the conventions of Indian art and poetics.[4] The third factor is a more subtle device of technique, by which each of these torsos of men and women in *The Dice* or in *Pickup Girls,* is purposefully distanced from the spectator. Even in cases when the figure seems up front and brutally close to the viewer, as in *The Grill* (1988), he is summoned up behind bars. As the artist observes, "But who is behind the bars — you, or this man? There are always two sides to viewing a picture!"

This also becomes her viewpoint of watching, reflecting, noting that absurd combination of the real and unreal, of the bizarre and the commonplace. The artist herself, the commentator, remains detached and uninvolved in the situation. Indeed, it

would seem an integral part of her personality to maintain this discreet distance — even though the subject may be a naked torso.

V

"To be naked is to be oneself.
To be nude is to be seen naked by others and yet not recognised for oneself. A naked body has to be seen as an object in order to become a nude. (The sight of it as an object stimulates the use of it as an object). Nakedness reveals itself. Nudity is placed on display.
To be naked is to be without disguise."[5]

Reviewed in retrospect, Anupam's recent etchings of the 1990s become the most bold, introspective, and challenging.

On the part of the artist there would seem now to be an increasing identification with her subject. That subject almost invariably is the same woman, possessed of a strength and nobility, a certain hauteur which separates her from her immediate circumstances. It might be noted in comparison that these are indeed very different in spirit from her "situational" paintings of the 1970s and 1980s. As she puts it, "There is some inner eye through which you look at yourself. There is the self — and there is the rest of the world. Most people make themselves (see themselves) as innocent, vulnerable, fearful. But this would be hypocrisy."

In the main, these images concern her new series on masks, worn by women (and men) who are stark naked — in the sense of being removed from all contexts; at once poised and yet vulnerable; and often, of shielding herself with a mask which is then removed.

A visit to Japan had made her reflect upon the appropriateness of the mask to close or disclose identity. Her work for the Fukuoka Museum titled *Preparation for the Next Act* was the result. But there were earlier intimations of this in her personal experience. As she observes: "I began

to see that life is composed of wearing a series of masks. At college I wore the inevitable mask of a devoted teacher; at home, I shed that mask to become a devoted daughter; and then, to escape that role, I would wear the mask of the artist — I hardly had any time to be just myself! *Persona* is an outcome of that realization — that you change one role for another, one mask for another."

In her etching *Persona* (1988) Anupam resorts to a device where she purposefully returns to an age-old symbol of vanity. A woman naked stands before a mirror holding up to herself a mask with just a pair of slits for the eyes to view the world. On the table before her lies a wig, to complete the disguise. It is not clear as to whether she is in the process of wearing the mask or of removing it. A face in the mirror reveals the shrunken older shroud of the woman.

It must be noticed immediately that the artist's depiction in *Persona* does not subscribe to the ideals or aesthetic norms of the woman and mirror conventional image which is abundantly used in Rajput and Hill painting nor would this be characteristic of her body of work and her convictions. By contrast to that convention, we note that her woman stands, not viewing herself in the mirror, but defiantly with the mirror placed behind her. Her gaze is not to look into herself but to look out of the picture and confront the viewer. Again, this confrontation becomes more complex — the onlooker confronts her naked figure but not her face — for the face is masked. Or is it in the process of being unmasked?

There are layers of meaning that confound in Anupam's *Ceremony of Unmasking* (1990). Here the woman is released from her self-fascination for her own image. It would be relevant to mention here a series of four recent collage sketches by the artist, which are autobiographical in content and most revealing. There is no sense of timidity here in depicting herself. In one of them she projects herself in profile, naked to the waist, holding up a mask

to screen just the face — to protect herself, to "play a role" of the many roles that she has mentioned.

Anupam's body of work possesses its own intrinsic logic of development. This is a process in the search for identity, through a long journey over some thirty years; from anonymous embryonic forms, struggling to be born through *Earth Mother,* to the superb mastery of torsos in her compositions titled *Windows,* to the faceless, undisclosed mysteries of *You* and *Homage to Mankind.* Even when she turns to commenting on Indian society in those bold indelible images of *Darling, Get me a Baby Made*! and *Pickup Girls*, it is never the faces but the torsos and animated gestures which tell the story. The face remains immobile, passive, unused to expressing sentiment — even in her *Dialogue* series where the confrontation between man and woman requires expression. Finally, it is only with her mask series that she turns to the face; and the face is now in the process of being unmasked.

At a time when the discourse between the Self and the Other is being related not only to political and plural identity, but also to gender studies, the work of Anupam Sud becomes acutely relevant. This is a gradual, marvellous unfolding of identity, with an increasing preoccupation of the figure not as object but as subject, marked more and more with personal traits. The face has now assumed a distinctness and persona not to be seen in the anonymity of her earlier figures — yet it is shielded still by the mask.

The mask series by Anupam is a breakthrough, to a more complete realization of the figure. With each step she has come closer to arriving at "the stark truth", in the sense of truth being revelation of the human form.

Notes
1. With references to the distinction made by John Berger between the naked and the nude in *Ways of Seeing*, London: British Broadcasting Corporation and Penguin Books, 1972, section 3.
2. The discourse on the Self and the Other is perhaps one of the most significant in relation to the work of Anupam Sud.
3. Berger, op. cit., pp. 46-47.
4. For further examples of such similies in Indian poetics and sensibility see Daniel Ingall's Introduction to *Sanskrit Poetry* from Vidyakara's *Treasury*, translated by Daniel H.H. Ingalls, London: Oxford University Press (2nd print), 1977. Also see Jyoti Sahi, *The Child and the Serpent, Reflections on Popular Indian Symbols*, chapter 10 on "The Feminine Figure in Indian Thought", London: Routledge and Kegan Paul, 1980.
5. Berger, op. cit., p. 54.

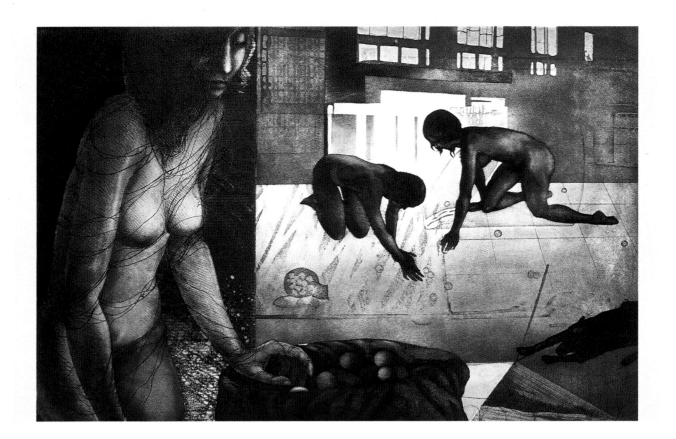

Pickup Girls. 1980.

Etching;
33.50 x 50 centimetres.

An attachment to material objects is suggested by figures in vulnerable postures.

Dialogue. 1984.

Etching;
33 x 49 centimetres.

As a series, these etchings define subtle shades of communication between human beings.

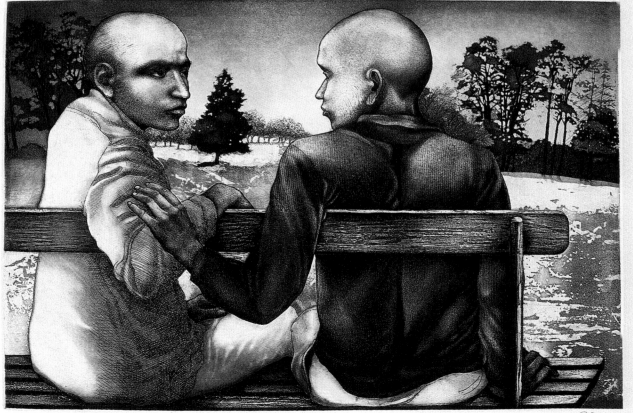

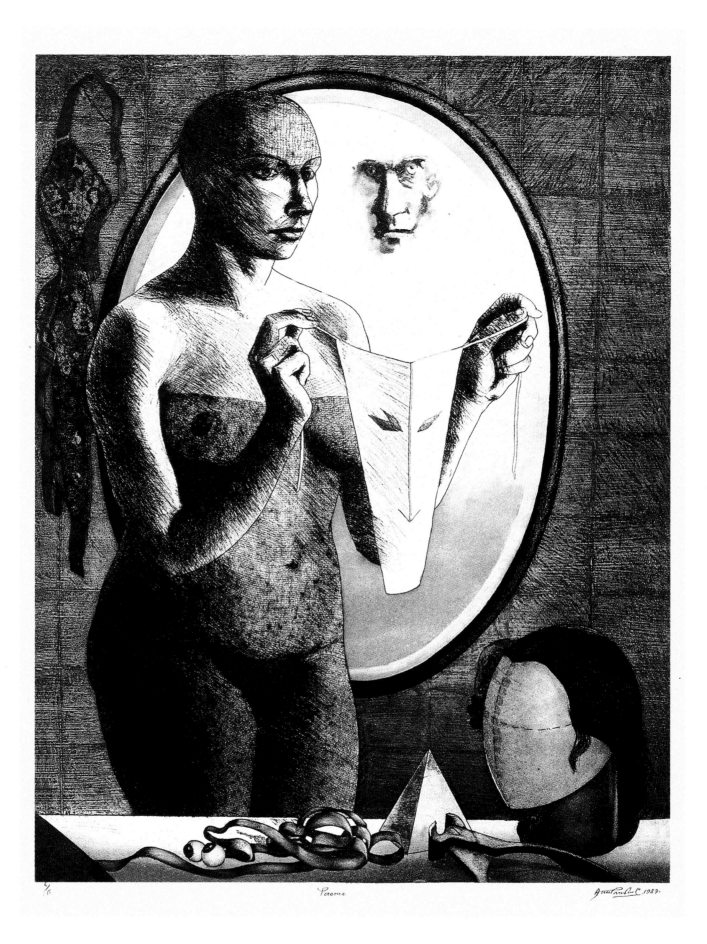

Persona. 1988.

Etching;
67 x 49 centimetres.

The wearing and shedding of masks suggests that in different situations different roles are enacted.

Nilima Sheikh: Human Encounters with the Natural World

Mala Marwah

The work of Nilima Sheikh (b. 1945) stands before us at a time when varying theories relating to modernism in Indian art are being closely argued. Her working of an aesthetic that relates art to the artisanal has enriched our reading of the modern, and owes as much to her teacher at the Faculty of Fine Arts, Baroda, Professor K. G. Subramanyan, as to the artists of the Bengal school. Subramanyan, himself tutored by the master Binode Behari Mukherjee in Santiniketan, has encouraged the alignment of art and craft with great conviction, just as he has the study of Western and Eastern art without prejudice or condescension, while expecting to see the imprint of personal comprehension and style in the final result.

Nilima has received this along with the greater legacy of Santiniketan, where earlier studies under Abanindranath Tagore and E. B. Havell at the beginning of this century helped in pointing the academic studio art of British art schools in India (of the 1850s onwards) to the riches at Ajanta and Rajasthan, Mughal and Pahari painting, the Far East and Sri Lanka, apart from the removal of barriers between various media and arts. Interpretations of Indian modernism have both endorsed and questioned the artisanal contribution to our graphic lexicon, and for this reason Sheikh's work is more completely assessed against the larger background of modern Indian art, both for its own artistic qualities and for its theoretical substance.

Sources and Choices

*B*ackground: The artist-theorists who Nilima studied were presenting the counter to European academicism. Scrutiny of this attitude also asks us to acknowledge that most aesthetic choices following the Industrial Revolution were political statements as well, and in the case of India her colonization necessitated a response that was not so much a negation of Western art as an attack on the politicized cultural factor it represented. This is borne out by the interesting evidence of dissident voices at Santiniketan including, notably, those of Rabindranath and Gaganendranath Tagore, as well as Ramkinkar Baij on the matter of style models in which they included Western examples when found applicable. The affinity lay in the conscious intention of evolving a new form, and despite some visibly embarrassing examples they achieved their objective to a substantial degree.

*T*he Matter of Modernism: Here it is necessary to gather that the "form" mentioned above was the *fin-de-siecle* culmination, not the beginning, of what may be called the modern element in Indian art. The methodological contribution of the Bengal school will become clear after we have recorded the changes that took place at this time. I

Wakeful Night. 1986.
Tempera on paper; approximately 45 x 30 centimetres. Collection of Max and Jyotsna Zims, Paris. Photograph: Gulammohammed Sheikh.

The division of the painting into panels allows us the spatial divisions of the stage, and engages the viewer in both a voyeuristic and participant experience while following the events described. The central figures are literal; the man against the doorway has the capacity of a symbol.

Edge of Wind (from the series *Song, Water, Air*). 1993.

Casein on cloth;
183 x 60.10 centimetres.
Collection of *The Times of India*,
New Delhi. Photograph:
Prabhjit Singh.

The lashing storm travels
downwards to the small figure in
the corner below. The conceptual
treatment of motifs above
encircles the woman in a dun
space where small white dots
beat out a muffled staccato.

Bhadon River in Spate
(from the series *Song, Water,
Air*). 1993.

Casein on cloth;
183 x 60.10 centimetres.
Collection of *The Times of India*,
New Delhi. Photograph:
Prabhjit Singh.

This painting is seen from the
height of the sky and laterally,
creating a dimension of space in
dramatic excess to that
encompassed by the frame. The
nearness of the large water
birds, with their cry and the cool
rush of wings draws the viewer
to their level; while far below the
great river moves grandly
towards a preordained
destination.

Hillside Flock. 1986.

Tempera on paper;
approximately
35 x 18 centimetres.
Collection of Max and Jyotsna
Zims, Paris. Photograph:
Gulammohammed Sheikh.

Delicate grading of colours is
special to the texture of the
tempera and requires control
and foresight. Behind the soft
and vividly massed hill, a distant
mountain is painted to suggest
atmospheric light, moving from
the rich umber below to the
blue-grey above.

use the term "modern" here in the specific historical context of the popularization of the results of the printing press in India (1777-78 to 1780 onwards) — although prints made in England had reached India earlier — with its unprecedented and transforming effect on the handiwork of the traditional painter. This performed the role of dispersing the academic verisimilitude of prevailing Western art by the hundreds in the cheap form of prints. The eighteenth-century Indian painter faced the onslaught of lithographic prints with European subjects and styles and began, with his tempered experience of academic perspective and rendering, first to reproduce and subsequently to interpret. This interpreting with its uniquely personal quality led to the creating of a new style altogether and often appears in startling individual examples among the vast body of what is called Company painting, as well as popular painting of the time. *Individual aberrations of this kind are a seminal factor in the style-making process, and logically mark out a clearing which is the closest we may get to the modern experience in Indian art.*

It was the first modern miniaturists, therefore, who dealt with the problem of new form frontally, in the face of a threat to their very livelihoods, and without any intellectual or material defences, in contrast to the ideology-based nationalism of the Bengal school. In effect, the modern experience in Indian art is so closely connected with changing identity in changed circumstances that individuation became its most important factor, in direct contrast to the internationalism of European modernism. It is the work of the eighteenth-century artist that must form the groundwork of any appraisal of Indian modernism, most certainly its mutations in contemporary Indian art. We may, therefore, with profit put aside the methodological red herrings of European modernism and post-

modernism offered as having direct parallels in the Indian experience in the fine arts.

Portfolio: Pictures and Ideas

It is here that the specific contribution of the Bengal school, as mentioned earlier, becomes clear — clarifying the attitudinal similarity Nilima's work has with it. It was nothing less than the rescue of the artisanal struggle of the eighteenth-century painter from the patronizing bid of the products of British-run local art schools, to whom adherence to European styles had become an ethical achievement. This adherence not only misrepresented the instrinsic qualities and refinements of European art, but also encouraged didactic face-offs where inventiveness was lost sight of in the crush.

Nilima has contributed to the healing with assured ease. I refer, in the main, to her working out of a style which has the fresh inventiveness of a combined aesthetic, bringing together the conceptual poetry of the miniature and the compositional clarity and mood of the seventeenth-century Japanese woodcut, while employing naturalistic rendering in the case of specific images, as a figure, animal, or vegetation. There is a coordinative sympathy between her style and her subjects, which refer to nature and incidents from everyday life, the drama of the home, the ambiguities of human relationships, animals, and children at play; Indian painting offers a rich bank of similar experiences contemporary to their own time, as popular legends and ballads, which have currency till today. Nilima refers, among other subjects, to this vital source, locating a timeless human theatre in the present and basing her creativity on experience.

Her special love for Far Eastern painting includes the Ukio-ye, or Pictures of the Floating World, showing people in commonplace

activities and locations with warmth and candour. One of the figures often repeated in her work is that of a woman crouching, washing clothes, or scrubbing a metal dish, and other subjects include a child at a sweet shop, an old-fashioned pharmacy, a courtyard where a small theatre of domestic human activity unfolds. Some of the quality of the Japanese drawing is also seen in her rendering of figures as in the illustration showing the two women from the 1984 series, *When Champa Grew Up*. The young girl and the winnowing fan are drawn with poetic economy; the older woman metamorphosed into a symbol of evil. Both figures are drawn with the accuracy that can only come from observation but remain character figures allowing us to conjure mood and psychology beyond description.

Nilima also uses the multi-planal perspective of the Indian painter as in *Wakeful Night* where views of several rooftops alternate with a peep into a neat, softly lit kitchen, the mother feeding her infant before two sleeping figures in the centre, the night with its prowler and tree brushing against the doorway. She has also fairly controlled the practice of dividing a single frame into panels which allow simultaneity in the description of events, transgressing singular space and scale relations. This format may see the same picture worked on a small as well as a large scale, something one has often been struck by in examples such as the spectacular *Hamza Nama* series painted for Akbar in the sixteenth century. By allowing this format to speak of personal/extended experience, Nilima transforms a so-called "older" formula into contemporary artistic language and proves the easy transitions that are possible between past and present, if the thing said and the skill brought to it are entirely truthful to the testing standards of the creator.

Other stylistic features recognizable as her own are her treatment of foliage and fauna which she sources from Indian and Persian painting, but transforms compositionally as in *Samira in*

Dalhousie where the landscape, treated like a painted textile, forms a lush background to the vulnerable face of the child before. Abstract notations such as dotted areas, or cues such as a dash of colour, or an ambiguously conceptualized form which could be read as wings, a leaf, or a piece of paper are judiciously placed in quite the same way as a word in a poem, which may often have more than one meaning and is necessary to the pattern of the verse. *About Seasons,* a work that stands midway between a painting and a drawing, shows these small aerial shapes between the open window and the chair before the table; the effect is one of a poem.

This style speaks effectively across the technical devices of the various media Nilima has chosen to work in, as oil on canvas, tempera both on paper and cloth, as well as drawings for a children's book, theatre design for proscenium and the outdoors including painting on banners and screens. This same style has come to be specially identified, however, with the tempera she has chosen to work with for more than a decade now, specially as certain compositional and textural effects in particular are possible only on the medieval Indian miniaturist's traditional *wasli,*[1] or hand-prepared paste-board she has perfected the use of. The method is laborious and involves careful laminating of several sheets of handmade paper which are coated and covered with whiting in several layers before being painted on with soft and brilliant cake colours with the use of a fixer; Nilima is particular to point out such craftsmanly details as the use of white as an integral part of the composition. Colours are rendered opaque with the use of whiting or marked lightly across a coloured area to suggest partial visibility, as skin under fine fabric, or the detail of a distant mountain as in *Hillside Flock.* As the Indian white (*khari*) takes time to dry to its correct dense value, its use requires special control and keen foresight.

Nilima's deep interest in the *wasli* and its effects is closely linked with her theories regarding form. In an article written by her in *The India Magazine* (July 1990) titled "On visiting Nathdvara" — an empathetic and comprehensive appraisal of the status of today's painter of traditional forms — she carries her visual thesis into words to say that the miniaturist who paints today in Jaipur or Nathdvara is also, by virtue of his place in history, a contemporary artist, and the benefits to be had from both a technical and a stylistic exchange between the urban and traditional artist are essential to further discovery in Indian art. She specially points out the nearly complete absence of practical knowledge of the highly developed skills of the traditional painter on the part of the urban artist, and states significantly that the way to "conserve" a living tradition must include a built-in device to stop it from imitating itself and thereby becoming mechanical. In this she has stated her own position as well.

If anything, her concept is similar to that of the eighteenth-century painter's tackling of diverse styles from his position of the historically aware. Her work is also better understood in relation to that of her seniors, K. G. Subramanyan, painter A. Ramachandran, potter Ira Chowdhury, for all of whom the "craft" of their art is a positive ideological factor. Both Subramanyan and Ramachandran have never lost sight of the fact that painting is primarily a visual experience, or that mural and sculpture, weaving and book illustration require the same craftsmanly — and sometimes extra-artistic — ingredients as painting, printmaking, or writing on art. Exactly the same approach to materials has been traditionally the very premise of the potter, for whom the "art" is entirely dependent on the crafting for it to have any meaning. Chowdhury's conceptual treatment of form and embellishment would be a close source for Nilima whereby pottery, no matter how sculpturesque or esoteric in its shape, must retain its original relationship to the factors that have caused it to exist. This is quite different from the concentration of attention on the form and the subject with the skill itself, no matter how refined, remaining auxiliary to the thing said or, in other words, where the results justify the means to the point where the form itself becomes the subject. For Subramanyan, Ramachandran, and Chowdhury — among others — the process is part of the result in more than a physical way and is part of their philosophy of art and towards the actual use of materials. In these two approaches lie the methodological differences that separate the stereotypes of the "traditional" from the "modern" and "illustration" from "art".

It is interesting to remember that the Progressive Artists' Group (Bombay, 1948) which allotted exclusive credit to itself as the champion of international modernism, haughtily dismissed in the process the Bengal school and, later, several Baroda artists as "illustrators" who did not know how "to paint". Amrita Sher-Gil had used exactly the same terminology for the Bengal school. Nilima's response to Sher-Gil's historicist reading of the modern has been to include Sher-Gil's work along with Abanindranath's as part of her legacy, and this is done in a spirit of detached admiration without the political albatross of the progressive as a virtue. Sher-Gil did not extend the status of legacy to the Bengal artists. For her it was combat; for Nilima it is an aesthetic cornucopia.

Again, Nilima's use of the tempera, usually associated with the jewel-like finish of the miniature, to speak both on social issues and poetic/personal subjects, is an audacious achievement which — certainly in the visual arts — proves the fallibility of conventional coordinations of "form" and "content". Of this attitude the dramatic series *When Champa Grew Up* is a most unforgettable example, with its subject of the death of a young girl for dowry (or groom-price) and the range of emotions shown in expressions ranging from innocence to evil. The artist uses restraint in the telling. In one of the paintings illustrated, the graceful figure of the

bride seated in her meticulous kitchen is shown lit up gently, the outlines of her figure and dishes in a light ochre, while on both sides the darkened panels reveal the ghoulish figures that are her death.

The same vulnerability of human experience is seen in the series of large panels, *Song, Water, Air*. This series depicts combinations on several levels, as in the references in certain sections to the seasons, along with history, anecdote, and experience. All the panels together exemplify this range, from references to the legend of Sohni-Mahiwal and the story of the Ramayana to historical figures and to the non-heroic and anonymous human factor, whose voices rise and subside in song. Both the loveliness and terror of nature are seen as transient as the relationship of the human factor to this overwhelming landscape. In *Edge of Wind*, land and water collide in a series of jagged chunks of colour wherein patches of fields, trees, and housetops are seen in the

haze. This painting is treated more conceptually than all others in the series and provokes a participant feeling of a world breaking up, receiving the edge of the wind. In the lower right corner a small swept female figure raises her hands to her head, facing a world dissembling.

The view that equates art and craft is neither recent nor fashionable, as proved by Nilima's artistic antecedents. However, it is substantial enough to question the same internationalism that on the one hand espouses the causes of freedom of expression and on the other turns form into a fetish that is the ideological opposite of aberration. This fetishism cannot logically exceed even the farthest limits of aesthetic hedonism and is as close to artistic annihilation as perfection can make it possible to be. In this context the rejuvenation of the human principle must remain paramount despite the most cynical readings of progress. If, therefore, ritualistic

happenings and constructs address and display the symbols of ethnicity, radical power, and the purest formal excess that symbolize this progress, Nilima's attitude to her work, by no means an isolated experience in India, may well answer many questions raised by these excesses.

Notes
1. *Wasli* (Urdu) is a piece of wood, parchment, paste-board, or slate: from *wasl* (Urdu) meaning connection, meeting, marriage; patch or addition as in lamination.
Reference: Platt's *Urdu, Classical Hindi and English Dictionary*; Duncan-Forbes' *Dictionary of Hindustani and English*.

When Champa Grew Up - 6. 1984.

Tempera on paper, approximately 20 x 34 centimetres. Collection of Leicester Art Galleries and Museum, UK. Photograph: Prabhjit Singh.

In a space austerely arranged a disturbing drama unfolds, where the shy young bride receives her mother-in-law's berating. The fine lines on the winnowing fan and grain are treated with the same care as the richly woven covering on the wooden bed and the bricked terrace step on the right.

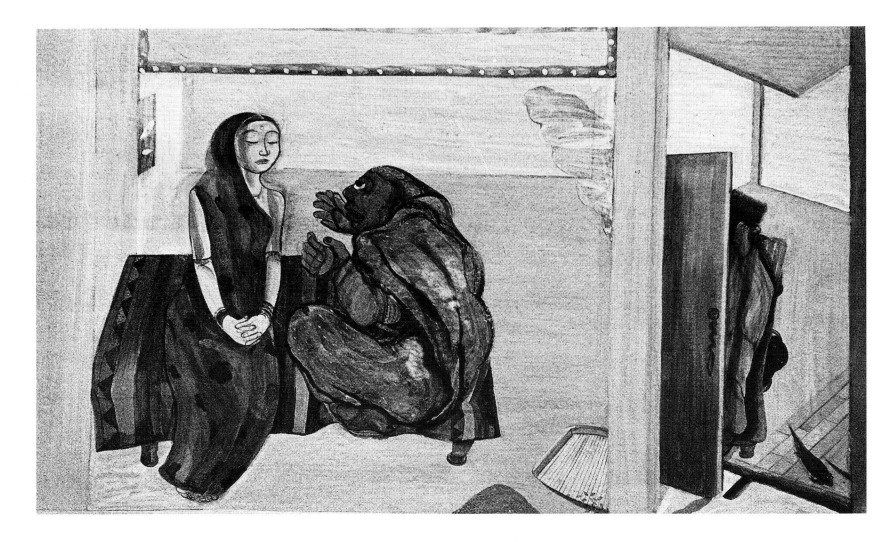

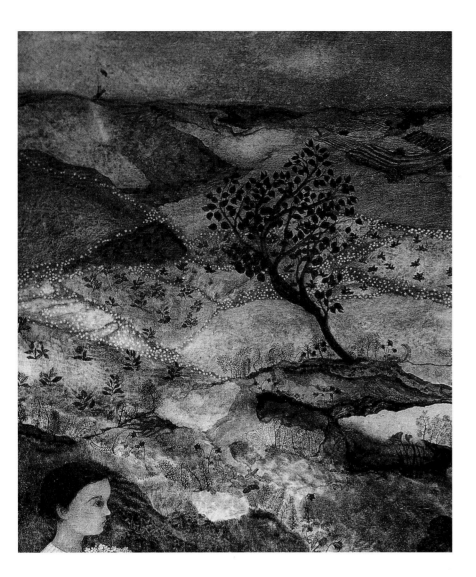

Samira in Dalhousie. 1976.

Oil on canvas;
approximately
100 x 70 centimetres.
Collection of Prema Srinivasan,
Madras. Photograph:
Gulammohammed Sheikh.

The rich embroidery of the
hillside which uses both massing
and detail, is transformed into a
living, organic whole with the
vulnerably placed face of the
small child, the artist's daughter.

**When Champa Grew
Up - 10.** 1984.

Tempera on paper;
approximately
20 x 34 centimetres.
Photograph: Prabhjit Singh.

This example from the *Champa*
series further emphasizes the use
of "direct speech" in the visual
sense, where the overall mood is
described through symbols. In
the innocuous array of domestic
items surrounding Champa lie
those which prove to be her
destruction.

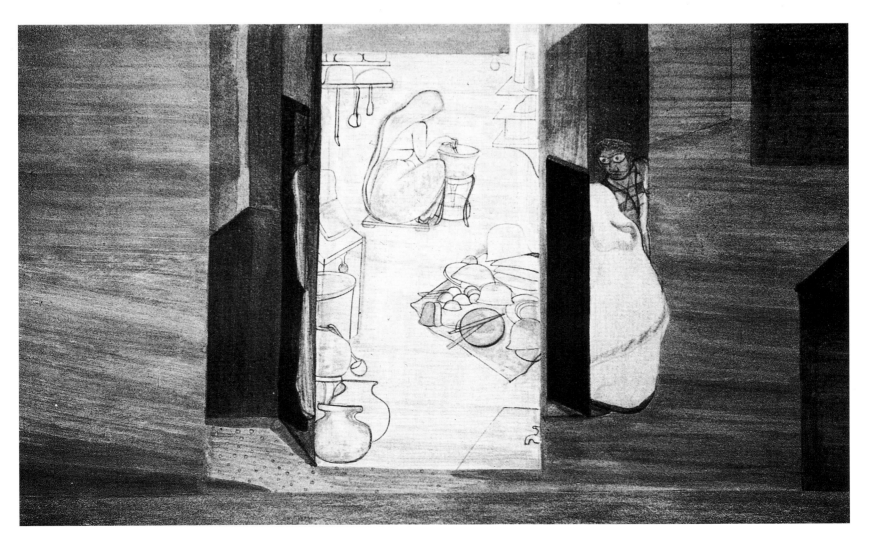

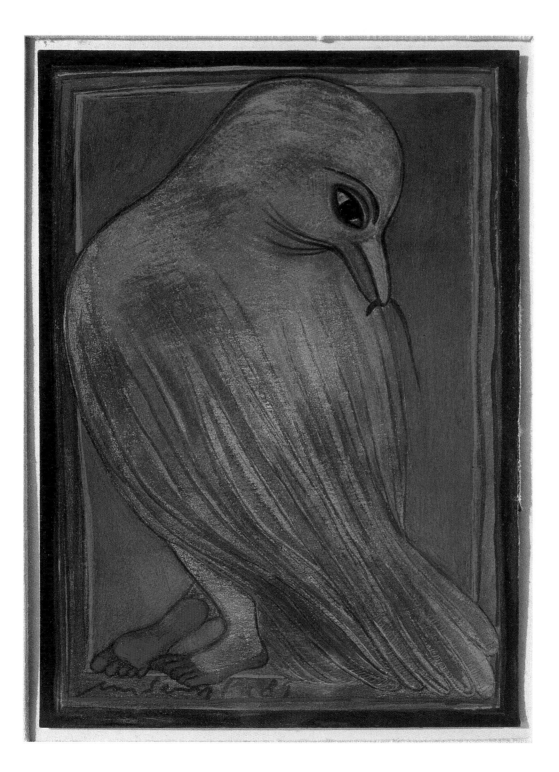

Gogi Saroj Pal: "Between Myth and Reality"

Uma Nair

A vision, a point of view, and a way of seeing is what adds to the mystery and authority of the works of Gogi Saroj Pal. Arduous hours of labour might also describe the trajectory of her own life, itself an odyssey in quest of a language and form for her vision. A childhood romance with painting, her dream to be an artist, and the compulsion to express herself brought her to the threshold of an art career.

Beginnings

Born in 1945, much of her childhood was spent gaining impressions that were to become the mainstay of her artistic vocabulary. In 1961, she graduated from the College of Art in Vanasthali, Rajasthan, after which she went on to a diploma in painting at the College of Art, Lucknow (1962-67). Her first foray into the art world was as a graphic artist in 1965, when she exhibited thirty-odd works at the Lucknow Information Centre. During this period Gogi worked on woodcuts, linos, lithographs, and monoprints. Due to the scarcity of zinc after the Chinese war and the unavailability of zinc plate she concentrated on woodcut intaglio printing. The process of the deep embossed impressions fascinated her, for the intense effect that was produced. Along with its three-dimensional effect Gogi introduced colour on to the wooden plates — the engraving was almost relief-like and it was here that she learnt the nuances of colour pigment.

At this point of time Gogi was greatly influenced by the muralist Giotto's work *St. Francis of Assisi*. The simplicity of form, concept of nature, and panoramic view of an almost Indian pastoral scene was what she related to. Other than that, Ben Shahn's series of five lectures to students at Brooklyn University from the book *The Shape of the Content* went a long way in shaping the artist's methodology. She did, however, go back in time to her own home and library where she would read the works of Tolstoy, Tagore, Steinbeck, and Hemingway, which fuelled her search for a personal philosophical purpose.

The years from 1965 to 1968 saw a series of exhibitions at the Lalit Kala Akademi in which Gogi made her debut with oil paints. As she worked on figurative forms on canvas the compositional value of the figures became more important. It was in 1968 at the Delhi Shilpi Chakra exhibition that her figuration verged on a more solid and lucid framework. But she was still undecided: "I was closer to Dadaism," says she, "I filled my senses with Camus, Sartre, and Dante but I realized that in that mode I was unable to find a form that could do justice to my vision of India. Here too I could see in the post-Independence era a very different India from the India I had known in my childhood."

Kinnari. 1989.
Gouache on paper;
17.50 x 12.50
centimetres.
The image of migratory birds flying about the water pools of Santiniketan symbolized the spirit of freedom for the artist.

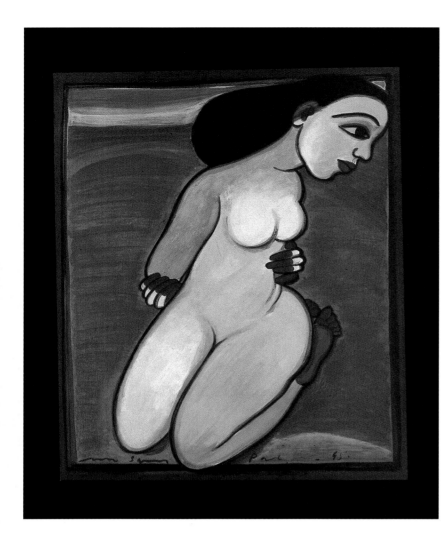

Naika. 1995.

Gouache on paper;
50 x 37.50 centimetres.

The woman as *nayika,* drawn
from the miniature painting
tradition, is shown bearing all
the marks of feminine attraction.

Kamdhenu. 1989.

Gouache on paper;
25 x 30 centimetres.

The mythic wish-fulfilling cow is
used here as a symbol of the
subservience of women.

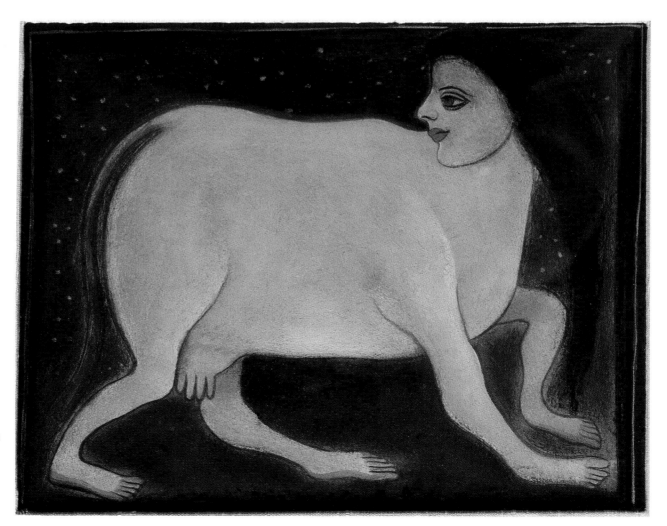

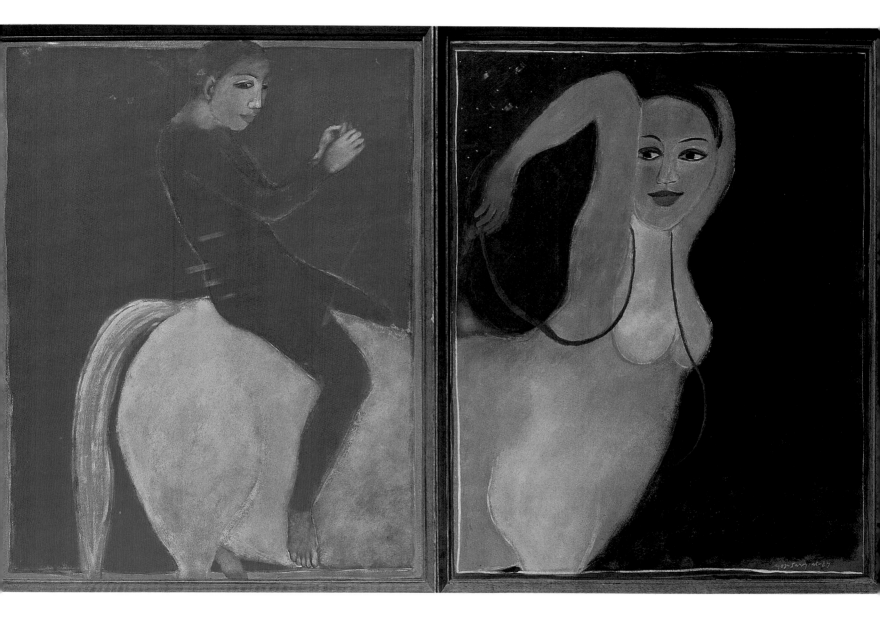

Swayambram. 1989.

Gouache on paper;
70 x 110 centimetres.

The woman-beast analogy is
used as a direct subversion of
the *swayambram* ceremony in
which a bride chooses her own
groom. Here, the woman is both
a mount and coveted bride.
Swayambram won the Lalit Kala
Akademi National Award in
1990.

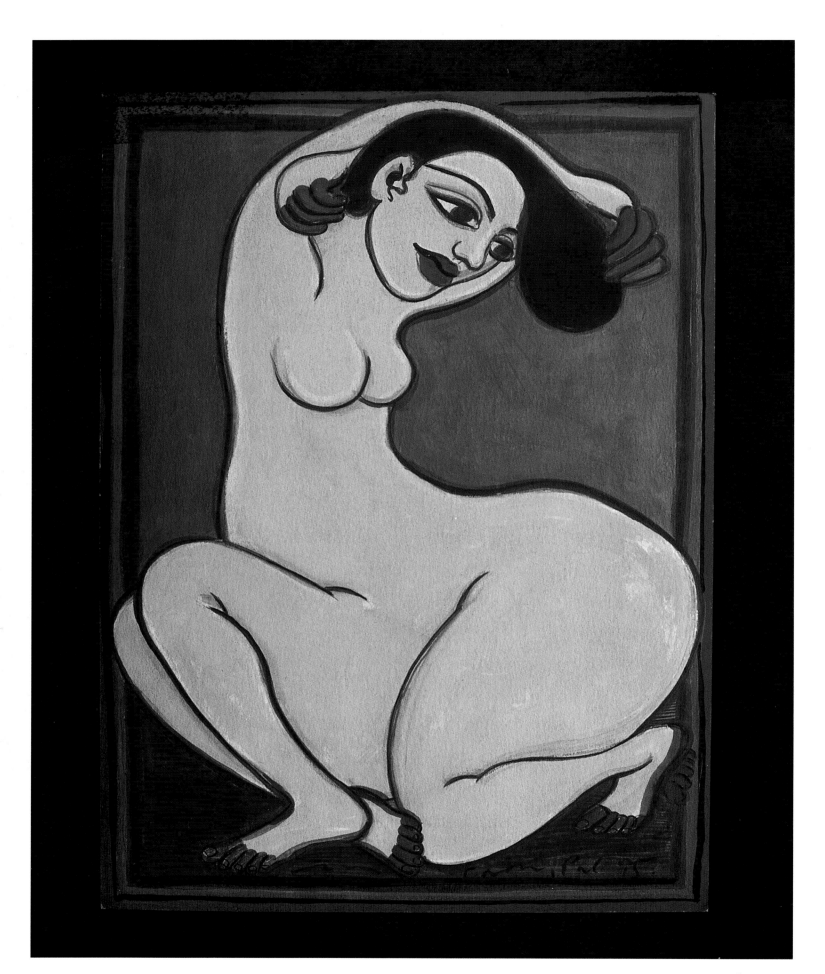

Shivpriya. 1995.

Gouache on paper;
37.50 x 25 centimetres.

Shivpriya, another name for
Parvati, is a variation on the
theme of woman as seductive,
mute, and submissive.

Dancing Horse. 1995.

Gouache on paper;
57.50 x 37.50 centimetres.

The image of the woman centaur
was inspired by a medieval
terracotta from Vishnupur. It also
recalls the image of the *burraq*
of Persian tradition.

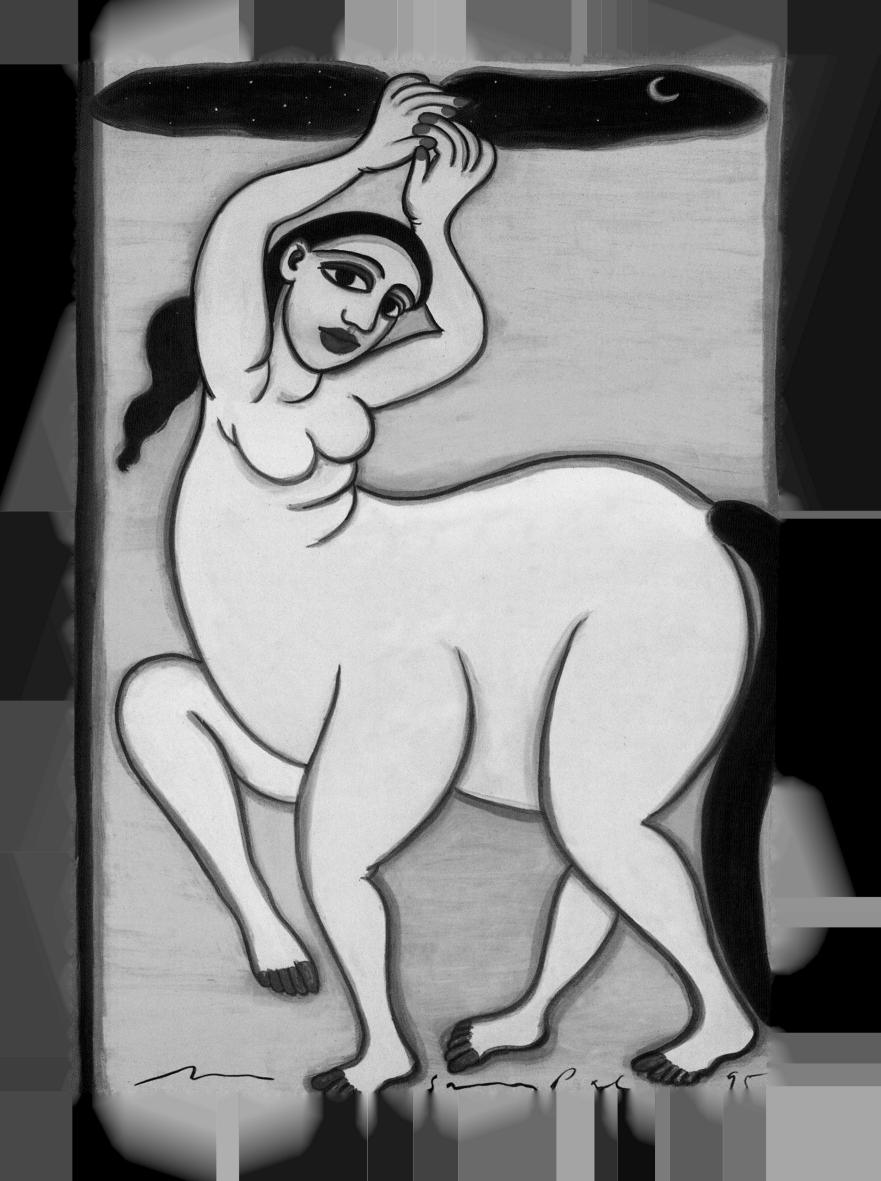

Evolution

Of her own evolution in terms of images and colours some years can be marked as major milestones. In 1970 she did a series called *Reminiscents* based on a set of experiences she had gathered in a slum in old Delhi. Living among the wretched and the needy, she developed her own sensibilities; understanding the need for independence and its value in a patriarchal society.

Within the sombre shelter of her room in the Jama Masjid area she would paint into the small hours of the morning. Her immense patience to sit for hours on end in the *ibaadat* or praying posture, working vertically over her paintings, prepared Gogi for a novel kind of approach. Her perception too seemed to vary and unify within the images of recognition. Two memorable sojourns at this stage were her representations at the Third World Print Biennale in London and Baghdad in 1980 and the Fourteenth and Fifteenth Print Biennale in Lubjiyana in Yugoslavia in 1981-83. Having attended these, it was in 1983 that she went back to her concern for the woman and began making a distinctive statement in her creative oeuvre.

A strong contender against history, Gogi recognized that it lacks the vitality of memory. It is from this focus that she picked up a metaphoric language that wiped away the burdens of the past and invented images — her works were crowned with wistful female faces which were quintessential portraits of sensitive people seen in introspective moments. The artist reconciled two ways of looking at women. A woman was both the subject and object of introspection and absorption, painted with an engaging directness.

In 1983, she painted a series entitled *Being a Woman.* There were dramatic social changes compelling her to look at the anonymous widows of Benares, the insecurity of women who face the responsibility or the denial of motherhood, and the lie of choice and self-determination. The woman sometimes became *Kunti* (1966), at other times she was the caring, ennobling *Mother Earth,* and in 1986 woman assumed another aspect as *Hailey's Comet.* Gogi relentlessly explored and reviewed the *samskara* (Hindu rites) of being a woman and in doing so was observer to the many paradoxes that exist in the social milieu.

Symbols from Mythology

"Once on a visit to Vishnupur, I came upon a medieval terracotta; it was the figure of Menaka being steered by Kartikeya. The image of the half-horse-half-woman with all its visual and sexual implications remained with me," Gogi says. "Instead of portraying it as it was I decided to represent it as an image that spoke — so the eyes became suggestive, the mouth sensuous and expressive but the sum total revealed a self-conscious attitude." From this was born her *Naika* series — it was 1989 and she decided to question the ethos of tradition and mythology. The *nayika* (heroine) has been an intrinsic part of drama, dance, and any storyline in classical Indian art. She was at most times submissive, diminutive, and servile to the male presence which dominated and controlled aspects of her existence. The *nayika* was the obvious emblem of Indian womanhood, her moods always matching her lover's advances and retreats. From her study of the Vedas, the Puranas, and other ancient texts, Gogi picked up the image and stood it on its head, working at a contemporary synthesis of both history and reality as it exists today. The maidens were women who were symbols of their own situation but they were no more closed to the dialectic of remembering and forgetting, no more unconscious of the defined calibrations in society, no more susceptible to

being dormant, but observers who were aware and responsive. *Home Coming* was what she called her series of hybrid mythic images. She worked on large canvases, a riot of lush green tropicana gave sanctuary to her *Eternal Bird* figures. Small and petite, these bird-women looked diminutive and forlorn as they hovered suspended in a darkening sky or alighted tentatively on the periphery of a verdant forest. The forest recalled the painter's home in the hills of Himachal Pradesh.

Another bird-woman figure that she called *Kinnari* personified womanhood's expansion in terms of vision and experience. She recalls her days at Santiniketan in the year 1989. "I spent hours awaiting the migratory birds, hoping they would fly in soon, and when they did they would enjoy themselves on the surface of water, skimming its breadth and sometimes dipping in to feel its depths — to finally bring out a tiny fish. I felt they were the only creatures who were really free. Though they were light and delicate to the point of fragility their wings became a symbol of freedom — the forests were their philosophy."

The proportions of her works too verged on the smaller format. No matter what the symbol, the women depicted in their moods and functions could be from any walk of life. What emerged was an attempt to transform personal and universal experience into allegorical visual statements. *Kamdhenu* (1989), the mythic wish-fulfilling cow, became a passive emblem of Indian womanhood who performed an internally supportive function. Gogi gave *Kamdhenu* a modernity grounded in the conservatism of her time. "I was overwhelmed when I thought of the service the cow renders to society — it's amazing how after it all, she is degraded and ill-treated." The voice of dissent and dissatisfaction was apparent with the attendant strain of rebellion. To Kamdhenu, she added the *burraq* or dancing horse as an equally obvious symbol of exploitation. Sometimes she would place on top of the horse-woman a

sinister-looking male figure to suggest sexual abuse and debasement. "Here it is a question of choice," she says. "Why cannot the woman be the one to decide? Why should she be the factor for contention?"

Exhibitions and Treatment

Gogi's impassioned questioning is revealed in the emotive and expressive tone that fills her frames. Her characters too project moods that evoke memorable responses abetted by the tonality of colours and the texture of their rendering. A hallmark at this stage was her project in the International Exhibition of Contemporary Art in the Non-European Countries entitled *To Encounter Others*, at Kassel in Germany in 1992. The title of the project was *Swayambram*. The paradox was subtle for the relationship she was entering into. Within Indian tradition, freedom ends at that moment of willing consent because thereafter the woman performs the role of the *nayika* on the stage of life. What is ironic is that the role is one of subservience and servility. This role formed the centrepiece of her installation which she called *Memory Wall*. "A family christens the wall around the fireplace," says Gogi. "It is here that the unforgettable moments the family cherishes and wants to remember are framed and arranged. My assemblage portrayed a symbolic recollection of encounters with the life and birth of consequent creative visual images and endeavours." Through it all Gogi's focus on the hybrid mythic image did not change. Sometimes, however, the figure would be draped in an *odhni* covering the head and at others a transparent sari. Though Gogi repels the ornamental and the decorative, her images are embellished in rich, polished colours. Beauty takes a prominent tone, as does the whole question of revealing the woman as she is.

"The focus on a single female figure, albeit a hybrid one, exudes an obsessive interest, which suggests a state of absorption with the self as well as with the condition of women in the unjust patriarchal socio-cultural system that still prevails," states Gogi. What comes through is a vivid exposure to the myth of antiquity — she unconsciously invites the viewer to explore her mythic images with their hands, stroke and feel them if possible. Her figures are painted in colours that are fluid, full, and sensuously sublime. The gouache technique reveals the predominance of tight surfaces; it imparts a tautness and sensitivity to her compositions. In the most tenuous way these women are not merely introspective or even self-reliant but mesmeric because of their wilfully gay sense of abandon — they move across the limited space and sometimes enfold or envelop it and even frame it.

The artist also does away with ambiguity and complexity. She concentrates on lucidity and lusciousness swathed in a sea-bed of colour. In her presentation of mythic women as nudes, she sometimes drapes them in transparent saris. The images become not merely fascinating, but on account of their structural complexity reveal a sculptural sensuality. Gogi treats curvatures too in a complex organic manner; owing to the progressive decrease in weight as the curves descend the degree of curvature increases constantly towards the lower part of the bodies. Thus the breasts and the rump often have a simplified roundness that has been accentuated to give a tactile feel of density.

Gogi's forte lies in devising art forms and expression. In painting the Ayodhya incident in 1993 on the banks of the Saryu river, she played here with a philosophy of physical displacement, rendering her landscapes in bright blues, greens, and a flaming orange, framing the single eye at eye level. This eye was *Sihanvlokan*, the all-seeing eye (literally, the lion's retrospective look). She then moved from landscapes to tapestry; she wove into the glorious red and gold threads, tassels and long hair as embellishments. The motif of the all-seeing eye recurred in her installation *Red Saryu has Eyes* for the Indian Triennale in 1994. *Red Saryu has Eyes* was a strong statement about the social milieu of contemporary India. This is why even in her mythic images the viewer was always drawn to the eyes of her figures. Arresting and attractive enough to hold your glance, Gogi's eyes would look back endearingly, inquisitively, and sometimes with a desolate look of dejection.

Later Years

In the midst of this phase, Gogi had to face the death of her only son, a promising young man on the threshold of his own debut into the art world. The little bird-woman came to a tumultuous halt — the wings ceased to open up for flight, the eyes sank to the depths of darkness. Amidst her grief she worked to complete *Red Saryu has Eyes* — "The concept of the installation has grown from my conventional format paintings and sculptures," Gogi explains. "The installation is not a one-time experiment and is not outside the parameters of my visual imagery or my creative concerns. The imagery for this installation started taking shape after the fulfilment of my installation project *Swayambram* in 1992 and a recent painting *Red Saryu has Eyes*. The thought process of *Sihanvlokan — Red Saryu has Eyes* was that all the animate and inanimate elements of the universe, the gods, mankind, the mortals, the immortals, the stationary and those who move, have been perpetual witness to inequality. They have become immune and their eyes have stopped seeing and reacting."

Gogi's recent work marks some noticeable changes. Gone are the rough, rustic textures and simplistic images that confronted the viewer. The impressionistic streak of imagery has been replaced by a polished, greatly smoothened texture that survives on appeal and beauty. The eyes draw you, the contours invite you, and the colours entrance you — her mythical women

have come full circle. While Gogi retains her quality of colour, the materials and maidens assume an odd vulnerability, as if they have been unprotected from the random strains of a cruel world. Like perfection, perseverance recurs like a mantra in these works — but the colloquial tone of the rebel is not entirely lost.

Gogi's works do, after a point of time, become a notably militant statement against subtle forms of authority. As she exalts the abstract of her work with her colours, one realizes her pursuit of a creative life on her own terms has made her a feminist exemplar. Yet, she distances herself both from feminism and from politics. She is not an active participant in either but has in a strategic way become observer and narrator — she has realized the reality of the role of religion — it is the instrument through which man spells out his social system of values. Here is a crucible of history that carries the various strands of meaning, constantly focusing on sensibilities and the realities of living within spaces defined for each of us. At the heart of it all is Gogi's own identification with history and memory: one reconciles to the fact that history is perpetually suspicious of memory and its true mission is to suppress and destroy it. The artist in question remains of this world and out of it.

Figure Acknowledgements
All photographs by Ved Nayar.

Sihanvlokan — Red Saryu has Eyes. 1993-94.

Multi-media installation. Weaving, gouache on paper, lacquered structure, papier mache, ceramic, terracotta, bronze, stone, and enamel; 6 x 3.6 x 3.6 metres.

An installation commenting on contemporary India, it was exhibited at the Eighth Triennale, India in 1994.

Home Coming. 1990.

Acrylic on canvas;
125 x 180 centimetres.

"I flew over the mountains, valleys, rivers and lotus pond." Here, the mythic bird Kinnari has strong associations of the artist's own memories of the hills of Himachal Pradesh.

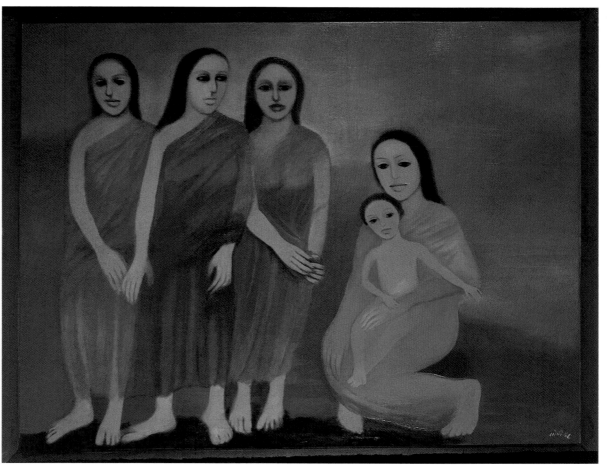

Hailey's Comet. 1985-86.

Oil on canvas;
125 x 160 centimetres.

This is among the early paintings in which the artist explored different aspects of womanhood.

Nalini Malani: "Memory Stress and Recall"

Kamala Kapoor

Background

She works in her crowded studio which is perched like an eyrie at rooftop level four ancient floors above Dave Shah & Co. on a busy side street off Lohar Chawl, Mumbai's commercial heart.

Down below in the wholesale electrical and hardware market, the *patiwala*s who ferry loads as well as the unemployed who hang around looking for spot jobs, have all heard of her. Some of them have become friends over the last two decades that Nalini Malani has been clocking in for a ten-to-five work schedule; others have been documented in her *Hieroglyph* series that took ten years for on the level articulation. Ten long years, "to actually feel the experience on my skin, for it to become a scar on the body", before she felt she was no longer being patronizing to her neighbours who had long ago accepted her as the maverick "*chitra kaam wali*", who likes spending all her time making pictures.

Malani, who is married to psychoanalyst Shailesh Kapadia, and has two schoolgoing daughters, seems to straddle the two very separate and

presumably hermetic worlds of home and studio with apparent ease. One would like to think she also enjoys living in the gap between — a reflective space, a place for reverie, where life works its own ways — even as the simultaneous dichotomies between her two worlds hold each other in perpetual balance.

References and Issues

Marked by an evolution in style, material, and impetus, Malani's work today spans a remarkable range. Both its consistency and its diversity trace an eclectic and exploratory path that traverses a rich modern tradition even as it occasionally extends back to the distant past, bringing to mind the quickened contour of a nude from a Degas Brothel Monotype, a posture seized with a *Sia Kalam*[1] twist of loaded brush, or Binode Behari Mukherjee's quiet, monochrome world, unhurried and deeply evocative.

Acuity in presenting the image's authenticity, observations of everyday behaviour, and the erotic and emotional disruptions that surface through a dialectic of revelation and concealment, all set the provocative narration in motion in her work by generating a sort of friction between the expected and unexpected.

Yet, to call attention to the painting's narrative content would be self-defeating, for Malani does not

Mutant II. 1994.
Acrylic and charcoal on canvas;
150 x 110 centimetres.
Herwitz Collection.

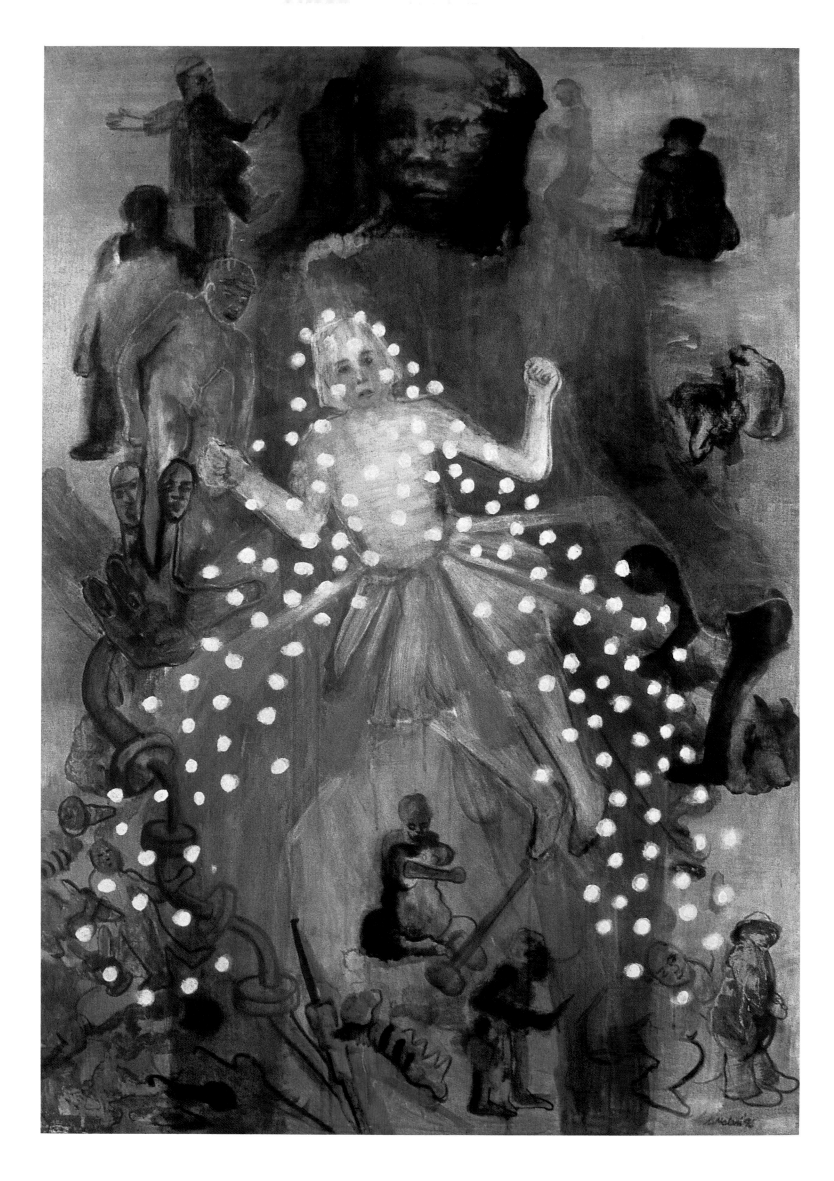

propose such straight readings. And although the power of narrative which prefigures all the action is intimated in her work, its resolution is not; one gropes for threads of meaning but the specifics are withheld. Also, while the shapes, forms, compositions, and contexts may suggest a narrative reading of the image, it goes thus far and no further. The works are more about the relationship between image and idea, and issues such as those of identity, authenticity, and illusion that get thrown up as a consequence.

More and more, her works typify references that come from every type of urban reality — socio-political, psychological, and autobiographical, where the other or the self becomes the subject. The former explores relationships and situations such as those of dependence and exploitation, the victims and the aggressor, or the colonized and the colonizer; the latter, layered from direct experience as well as from dream and memory, are journeys towards self-discovery.

The Figures, the Form, the Space, the Structure

In all these works by Malani, the human figure continues as always to assert its claims. Her probing analysis of the human body in movement and repose has, however, never been mimetic or merely responsive to pictorial needs. As such she often breaks with realistic figuration in order to break with the limitations of representation. And whenever she resorts to the representational syntax, it brims over with semantic ambiguities.

Malani's understanding of bodily rhythms and tensions which has resulted in a recodified vocabulary of forms over the years, has been served by a visual memory (she never draws from life) that stores both the image and its effects. Likewise, the context in which she

situates the figure is frequently abstracted. These staged settings, which also owe their origin to recall, are often shuffled to suit the ever-changing circumstances or whichever aspect of the specious present needs to be painted. As she enlarges her cast of characters, distributing the action all over, the effect is sometimes like unrelated frames from films that intercut each other, allowing the boundaries to blur so that the montage resembles large Renaissance paintings with their tumult of activities.

These works, often oil paints, may extend into space within which an overlay of forms, structures, and time are perceived, and where images appear and disappear like pale ghosts through luminous colour washes. Seldom a means of self-indulgence or mere painterly gratification, the fluctuations of sensuous colour and light in her work, and their confrontations with shadow and darkness, become a metaphor, as of some obsessive inner vision.

Imagery and Style, Subject and Appropriation

Often, cross-currents between mediums and techniques eddy to and fro as oil paint effects become indistinguishable from those of watercolour, or when monoprint, xerox replication, and watercolour overlap in shared picture space. Much the same happens with imagery and style, where she has quoted and cross-matched shades of Goya, Delacroix, Ravi Varma, Degas, Binode Behari Mukherjee, Amrita Sher-Gil, Frida Kahlo, *Sia Kalam* paintings, and Persian miniatures.

"For me a single subject cannot possibly be contained in one frame, so I have to repeat the idea by cloning and recycling images," explains the artist, whose works are legitimately hybrid. She sometimes seems driven by a need to collapse history into a field of references; it is

clearly not just to parody techniques or reanimate her works with mythic icons of the past, but probably to play off the strengths and differences in style, image, and source. Or to capture a particular reflection or a certain tempo lodged in memory, and turn it around, making the familiar into the new with the power of imagination. "Every theme in art comes from somewhere," says the artist, whose appropriations, superimpositions, and juxtapositions are invariably reconfigured to her own ends in variable strictures of adjacency.

Early Works

Malani's early works in the 1970s, executed in a realistic manner, and depicting family situations and feminist issues, gave way to make room for a more urgent questioning in the 1980s. Here, problems of globalization, nationalism, the Third World, and neo-colonization were examined in works like *Old Arguments about Indigenism, Of Monsters and Angels,* and *Flux of Experience.* In these, hunger, poverty, and homelessness became obsessive, much like in the crowded *Hieroglyph* watercolour series dominated by monochrome repetition and juxtaposition. Essentially, variations of the anguished human motif studded these latter compositions like push pins of ricocheting pattern, a pulse that irrevocably punctuated both the paper and one's conscience.

Then there were the series that dealt with the psychoanalytical registers of the unconscious: *States of Mind, Control, Duplicity, Conversations,* and *The City* comprised the groupings in her show in 1989 where the malignant and the maladjusted shuffled through the beleaguered bylanes of a city wreathed in the shoddy twilight of carbon monoxide fumes. Some of these were offset from time to time with the enigmatic images of fantasies and dreams in paintings with titles like *Invented Figures* and *Narrative of a Dream with Two Angels,* their otherworldly vision invariably

woven through with the nightmarish logic of acute socio-political concern.

Biographical Profile/Ideology

Clearly, Malani is an artist of deep convictions. Hers has been a somewhat radical left-leaning political view ever since her student years in Paris, where in the early 1970s she rubbed shoulders and ideas with a stimulating cross-section of thinkers, writers, and artists. "One could chat with Simone de Beauvoir at her favourite cafe in those days, or listen to Claude Levi-Strauss, Noam Chomsky, or Jean-Paul Sartre speak at the Sorbonne," she remembers of what was a politically charged and influential time. It was just two years after the student revolution of May 1968, and the atmosphere was rife with controversy, activism, and confrontation. The experience instigated a period of agonized self-questioning for the artist, who was also deeply and lastingly influenced by the writings of the poet Aimé Ceasare and the writer and psychiatrist Franz Fanon (*The Wretched of the Earth*), both Martinicans.

One has to emphasize here that over the years the intense excitement of ideas shifts and pulls like some relentless undertow beneath the surface of her ruminations, and surfaces in works foregrounding her deep involvement and concern, while never fetishizing either. And if her views appear to be something of the risk-taking variety, they are shared by many in the arts. Having got internalized over the years, these views have become sort of subtle keystone presuppositions all the way from the choice of subject matter to the handling of it.

Born around the time of India's Independence to parents who had to flee Karachi and their considerable assets during Partition, and who settled in Calcutta to carve out a new life from scratch, Malani studied at Loreto Convent and later at the Sir J. J. School of Art, Bombay. While still a student at J. J. she was given a studio at the Bhulabhai Desai Institute, a unique cultural institution that hummed with vibrant creative interaction — music, dance, theatre, and art — where, among others, established painters like V. S. Gaitonde, Tyeb Mehta, and M. F. Husain also had studios.

It was here that Malani's penchant for making books began with her daily practice of drawing and painting in a diary. Assorted editions, including *Dreamings and Defilings,* which was about interfering with art history, and *Cast Off,* which was a reaction to the colonization of tribals by Orientalists, evolved over the years. Among these were the accordion books (1989-91) some of which opened to five metres, unravelling a pleated continuum of paintings and monoprints on both sides, and books such as *The Degas Suite,* named after the artist's monotypes of women which came in editions of thirty. In each book the overlapping processes with their transformative dimensions became important. Subtle variations and alterations in image, colour, medium, and technique animated the many layered surface, giving each book its own individuality.

The books, which could be carried around in one's pockets, evolved from a "rootedness in the past" when paintings were not always framed and hung on walls, but were held in one's hands to be looked at and then passed on to friends. The very tactility of the books' handling and their ready availability for viewing, made for an intimate and thus more profound experience.

Recent Trends

With Malani, the pendulum of possibilities swings free of predictability. She could be described, perhaps, as a balanced post-modern artist who smudges the boundaries between past and present and between traditional art practice and the avant-garde. So even as she is increasingly working with new mediums such as installation, video film, and performance, she reverts to this "rootedness in the past" using traditional sources, materials, and ideas towards non-traditional ends.

An interesting case in point was the *City of Desires* project in 1992. Here she painted ceiling-high pictures on the walls of Gallery Chemould in Bombay, in protest against the neglect of the rapidly disintegrating nineteenth-century frescos of Nathdvara in Rajasthan.[2] A "sharing in the collective unconscious of the artists of the past" who painted on the walls and ceilings of temples, palaces, and homes as in Bengal *pat*[3] painting and the Jaipur frescos,[4] encapsulated the viewer in a "wrap-around experience". Malani's site-specific paintings on the gallery walls were whitewashed two weeks later in an erasure that became a symbolic act of solidarity with the plight of the Nathdvara frescos.

Implicit in this is the undermining of the commercial viability of art where art is either impermanent or cannot be bought or sold, relating Malani's work in many ways to the Conceptualist Project. Yet, it is more the exigencies of anxiety and a need to push beyond the frame that are registered in her new mediums. Her installations and site-specific works are never a world apart. Holding as they do the suggestions of narratives and ideas, they are extensions into space, light, and three-dimensional structure of the suspended action of her paintings.

Malani admits that her earlier attempts at installation, among them a transparent walk through reconstruction in mylar embodying the experience of Lohar Chawl, did not work too well. She has since begun to seriously transform space. Objects are not simply hung or placed. They play off one another in terms of form, construction, and matter, as well as perception and imagination.

Just as in her paintings, the web of allusions in her installations are embedded in their time and cognizant of it. Sometimes the artist relates

them to other times as well, as in her *Medeamaterial* project at the Max Mueller Bhavan, Bombay, in 1993 which was based on Heiner Mueller's version of the ancient Greek myth where sexual jealousy, domination, subservience, political power, gender issues, and environmental degradation cut across centuries. Consisting of an 11.4 x 2.4 metre composite of paintings, a theatrical performance (a collaboration by actress and director Alaknanda Samarth), installations, video projections, and sculpture, *Medeamaterial*'s multiple references established a realism where shifting focuses abet the freedom of disparate connections even as they underscore the terrible tragedy of the myth.

In her most recent installation, the painted mylar robes of Medea — a late addition to *Medeamaterial*, which in 1995 was shown at the South African Biennale along with other Indian contributions under the collective title *Dispossessed* — three-metre-high robes hang ceremoniously from ceiling hooks roughly in the shape of a cross. Shored up by rocks clustered on the floor which bear Mueller's haunting quote from the play: "I, no man or woman, live in the empty middle" in scattered letters, the robes seem suspended in memory and time.

A multiple-part structure, the robes are in fact one robe in its three aspects, each one corresponding to a critical stage in Medea's life. The lyric pinks and tangerines of the bridal robe and the arboreal blue-green arabesques of the robe of Medea, the wise and respected alchemist, evoke hope, joy, and degrees of magical transformation, while a pulse of crimson gore stains and spatters the plangent death robe that forms the central axis. And as

City of Desires. 1992.
Site-specific paintings covering the walls of Gallery Chemould.
Malani painted and then erased these wall-paintings in protest against the destruction of the Nathdvara frescos.

the colours, strained through layered mylar, turn darkly effulgent and the brushmarks slowly animated, each robe acquires an electrifying sense of emotional presence.

It would, however, be facile to conclude that Malani's work traffics in trauma. Consider her recently exhibited watercolour grisailles on paper, *Artist's Laboratory*, where androgynous mutants stared at one from every side. Never individualized, these mutants were signifiers: genetic mismatches, biotechnical misfits, or mediations on pan-sexual ambiguities, they dwelt in a world where crisis was at once stilled yet sentient. It was evident that what interested the artist was not so much the harrowing grotesquerie as the violence of the sensation.

It seemed appropriate somehow that with their limitation of means — a frequently used device with this artist — these monochrome works with ragged edges were not framed. Instead, they were pasted on the gallery walls, their non-high-art quality and display enabling them to function as posters and billboards, allowing the viewers their autonomy for interpretation and making for a more direct experience.

Bloodlines, the other part of this exhibition, comprised oils on canvas. Unstable relationships played themselves out in works like *Wuthering Heights*, while in *The Voyager* the interplay of ghostly outline and rugged figuration, no more detailed than a shadow, hovered as if between the real and unreal. In *Mutant II*, an acrylic and charcoal on canvas, the intensity of thought processes seemed to catalyse the paint so that it suddenly blossomed into a shower of dot-matrix petals, and in *Remembering Pina Bausch* the empathic appeal issued from suggested choreographed movements in red chalk against a scrim of charcoal drawings of the human body practising a dance/theatre of attitude.

Then there was *Fragments*, a composite of eight canvases, each punctured with the

artificial arrangement of a window within which the monochrome microcosm of the complete human body could be seen. The built-in contradiction of the backgrounds, with their opulently coloured segments of the human anatomy blown up for scrutiny, underscored the brutal sense of bodily fragmentation. Lastly, a vertical structure strove for organization as it posited the central question of cruelty and violence in the eponymous *Bloodlines*, where Malani's images, some flush with a slow spreading light, others subsumed in darkness, inhabited diffuse, menacing space that was sometimes like a deepening abyss, at others like some bottomless pool. A swelling, baroque composition that was as unsettling as it was visually compelling.

Throughout, her sensuous chromatic insurgencies, fluency of paint handling, and fascination with visual staging and ordering, extended her enquiry to works which continued to hover between deeply felt emotional responses, ideological positions, and visual strategies. The blurred infusions allowed for interesting slippages between all three, the balance tipping sometimes in favour of one or another.

With these, her most recent works, Malani combines some of the classical painterly sensibilities of, say, a Tiepolo or a Titian with modernism's insistence on the importance of material and idea. The images and their implications seem to dwell between dissolution and integration — their resolution, it is implicit, can only be apprehended in the contradictions of fragmented form. At the same time the setting becomes a map of the world, or a stage-set of the mind as deliquescence solidifies into object and light glows from beneath layers of transparent washes. It is a world that has few resting points and often no gravity as the artist mediates between a free landscape and an impulse for order.

Increasingly, she also mediates between an

expanding range of mediums and artistic practices; a metaphoric current connects them all. What came next — a complex dance/theatre/installation/video film project in collaboration with the actress and Kathakali dancer Maya Rao staged at the National Centre for the Performing Arts in Mumbai at the end of 1995 — has proved that Malani is moving on, trying to extend her horizons. Meanwhile, she is once again back to making accordion books, a welcome reversal in times when the accessible and pleasurable threaten to become an archaism.

Notes
1. The *Sia Kalam* is a collective painted record of the dervishes and nomadic tribes of Central Asia in the fifteenth century.
2. Nathdvara frescos, painted on the walls of what was once an ancient gymnasium, are being despoiled and disfigured by nails driven into them for purposes of hanging clothes and by the fumes from the food being cooked on the premises. Neither the appropriate government bodies nor the Pushtimargis — both priests and devotees — seem concerned about the fate of the frescos.
3. Bengal *pats* painted by *patuas* or scroll painters who also performed alongside their works, have constituted a virile pictorial folk tradition through the centuries.
4. Jaipur frescos refer to the paintings made under royal patronage on the walls of forts and palaces in and around Jaipur in the sixteenth-eighteenth centuries.

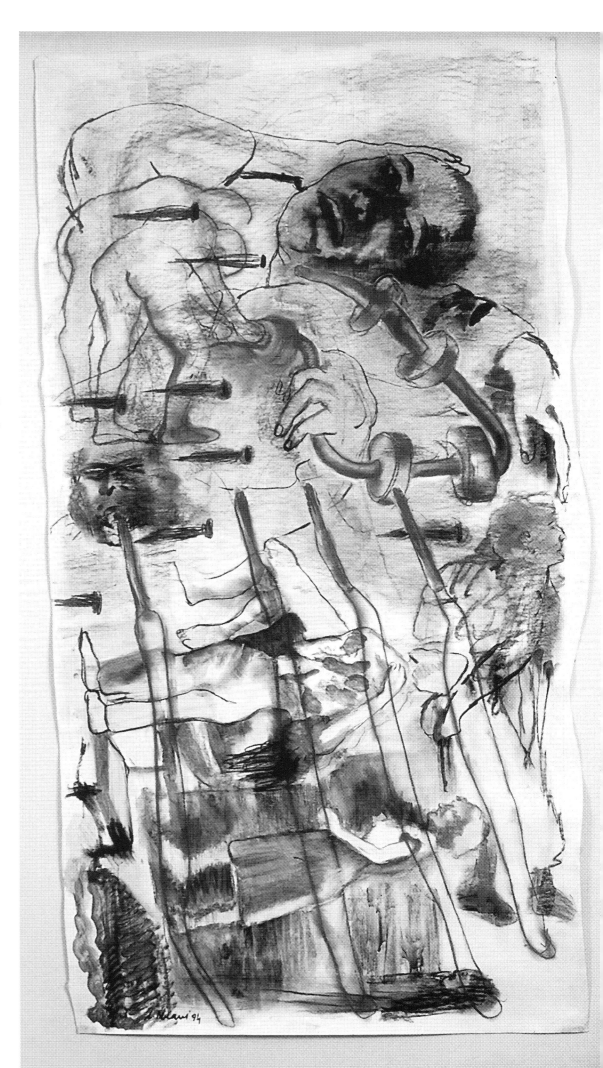

Remembering Pina Bausch. 1994.

Chalk and charcoal on milk carton paper; 140 x 70 centimetres. Collection: Mok Wei Wei, Singapore.

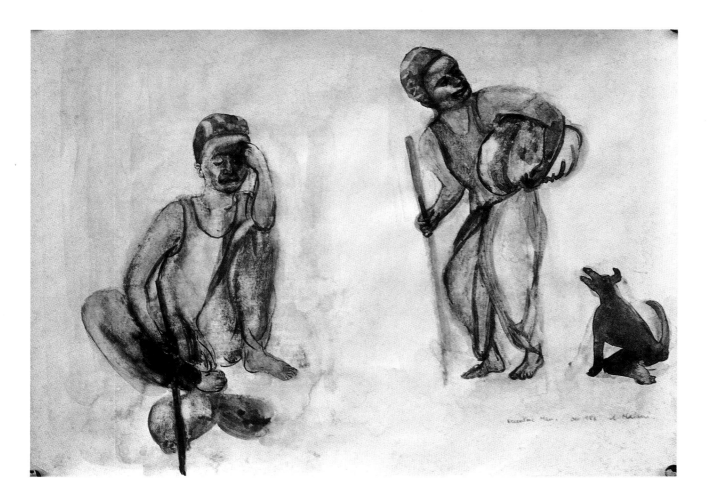

Eccentric Man with Bundle. 1985.

Watercolour on paper;
27.50 x 37.50 centimetres.
Herwitz Collection.

Urban reality with its numerous
nuances of power and
exploitation is a recurring theme.

Medea and Jason. 1993.

Acrylic and soft pastel;
75 x 90 centimetres.
Collection: Max Mueller Bhavan,
Mumbai.

Alaknanda Samarth as Nina. 1992.

Acrylic and soft pastel on paper;
62.50 x 100 centimetres.
Private collection.

Medeamaterial project
featuring Alaknanda Samarth in
front of Malani's painting. 1993.

Photograph: Benoy Behl.

Inspired by Heiner Mueller's play
based on the ancient Greek
tragedy, this event involved
installation, sculpture, and film.

Latika Katt: Towards Dematerialization of Material

Amit Mukhopadhyay

In more than the philosophical sense it would seem that the fate of man and the fate of sculptural forms have run parallel to each other in an agonizingly intense stripping down to their basic essences. Sculptural forms have moved from immobility to faltering steps of infancy, to the threatening frenzy of structural melting. To what extent does the art remain in any traditional (or semantic) sense, sculpture? A primary question that ought to be asked today is how the free-standing human form has changed into just a "scribble in the air". Is it Alhazen's intromissionism, Al-kindi's extramissionism, or Descartes' "walking stick theory" that changed the world of sculptural forms?[1]

Head. 1993.
Cowdung;
90 x 90 centimetres.
An association with primitive forms and anthropomorphic shapes is apparent in Latika's head studies.

Neoplatonist Ficino while expressing the grand human activity and celebration of creativity wrote: "For this reason man, by a certain natural instinct, ascends to higher things, descends to lower ones. And when he ascends he does not forsake the lower ones, and when he descends, he does not relinquish the higher things. For if he were to abandon either one, he would incline to an extreme and cease to be the true bond of the universe."

What Ficino was pleading for was *Harmonia est discordis discors,* a harmony of opposites in which the opposites remain themselves even as they become a new entity which transcends the opposites. Ficino's ideal form would then just not stop at rendering what can be seen but demands a transformation of vision, a transcendence of and through illusionistic objects. This was also in compliance with Plato's distinction between *eikastike* and *phantastike* which the Greek sculptor Lysippus exploited fully, by not making men as they really were but as they appeared to be. Perhaps measuring, numbering, and weighing proved to be the most effective aids to prevent the domination of the classical soul and hence the device of image-making into two kinds allowed the imitator of things to show the actual and the apparent, the measured gap exposing the appearance from the real.

While viewing space as contained and containing, artistic activity depended upon a belief in man's mental capacity to join interior and exterior space where the primary aim of the artist would be to represent earthly beauty through line and motion. Hence beauty is at once the form of body, and yet not the same. The paradox of dematerialized materialization recognizes no absolute separation between the realms of sense and intellect. The Pythagorean and the Platonic, the geometric and the idealistic, the real and the illusionistic were all hooked in one frame, revealing the crisis of the Renaissance and subsequently leading to the origin of modern art.

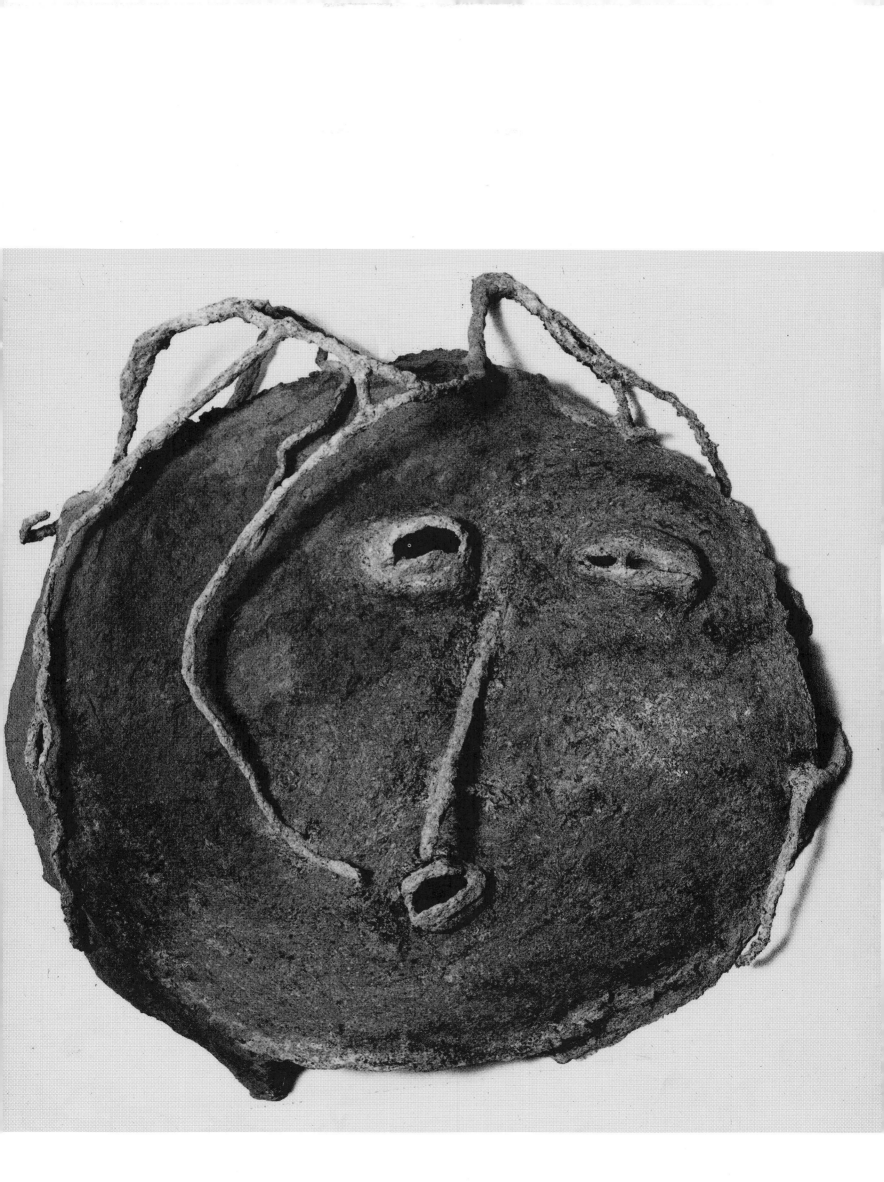

The Body and the Base as Matter

The crucial problem facing a modern sculptor was not to make a work which was harmonious and perfectly balanced, but to get a result from the marriage of material and space by mixing real with imaginary forms obtained from established points and perfecting it, making them inseparable, one free from the other, as are the body and spirit. A similar view was expressed by Henry Moore: "The understanding of three-dimensional form involves all points of view about form-space, interior and exterior form . . . they are all one and the same big problem. They are all mixed up with the human thing, with one's own body and how one thinks about everything. This talk of representational and non-representational art, spatial and non-spatial sculpture, is all nonsense. There is no cutting it up into separate compartments. It's all one."

Husserl's formula was that in every experience of spatial objects, the body, as the perceptual organ of the experiencing subject, is co-perceived and in this the meaning of "I am my body" establishes its central position in poles of action. But how can we make clear what is meant by "I am my body" without reducing the body to an object? If a radical coenesthesia is possible, it would obviously lead to destruction of my body insofar as it is mine. There is this inherent paradox in the philosophical and artistic discourse from naturalism to modernism. The grand question which the Sophists raised as an antithesis between *nomos* (law, convention, and custom) and *phusis* (nature) was whether the social restraint which law imposes on nature is a good or bad thing; it underwent radical transformation and took the forms of direct confrontation between *logos* and *nomos* in the modern era and I would like to add between *logos* and *phusis* in the post-modern condition, especially in the withering away of

the sculptural base. The idea behind such a tactical manoeuvre is that if the base is rendered meaningless both physically and psychically, sculpture can perhaps regain meaning free of its confines. Philosophically speaking, it also pulls down the sense of gravitational dependence so inherent in the anatomy of man. The plinth, the base, the pedestal is also a biological reaffirmation of the traditional qualities and essence of man. As far as biological essences are concerned, man perhaps retains them, but the very idea of the modernist man is in a moment of crisis.

Towards a Definitive Formulation

The dematerialized materialization which occurs in the early works of Latika Katt (b. 1948) refers both to the body-spirit problem and the subject-object problem. Critically speaking, it questions the relationship between visual and conceptual form (the real and the illusionistic, the real and the imaginary).

The sculptural strategy in the *Decay* and *Growth* series of works is attenuation of mass correlating the paradoxical position: Abstraction from matter leads into matter. Obliquely, one can see literal objects metaphorically and vice versa. Thus philosophico-aesthetic ambiguities match the linguistic ambiguities. Here, in this philosophical frame of mind, Latika may find an ally in Ficino. The materiality of sculptures and the intended artistic representation may still hold us back from entering the polemics of modern sculpture.

Release of the Ficino Tension

Since I have used the linguistic model of dematerialized materialization as an opening argument, it becomes my primary responsibility to release the Ficino tension. The fundamental

opposition between the classical and modernist modes of representation rests on transparency and opacity. This can also happen within the modernist modes especially when the triumph of the individual is presented in open nature — say, for instance in D. P. Roychowdhury's *Triumph of Labour* or in Ramkinkar's *Santhal Family,* transparency sealing the fact of materiality and transforming it beyond materiality, empowering the image to represent the real or even the fantastic. Opacity suggests that the sculpture retains an irresistible materiality conditioned by the ego-image, the self and/or whatever social, ideological, or environmental conditions bear upon a given artist. The former is obviously an open approach stimulating the vision, the ideal; the latter a more closed mode of representation inviting touch and proximity.

Between the Earth and the World: An Unresolved Struggle

Latika's mode of touching, of modelling, involves an action of the hand running along the surface, pushing, digging, stretching, scribbling, and leaving the mark of authorial identity. While working on the theme of *Growth* and *Decay* (two series of works dialectically opposite to each other) through exaggerated touching, she presents the transferable identities of not just the material but of herself as well. By ordering the chaos, perhaps, she wants to restore the organicness of nature and when she involves in a frenzied dematerialization, a cry of despair upsurges. This apparent anarchic approach expresses a wild and primordial yearning to restore the spiritual and physical equilibrium. But did equilibrium ever exist? *Earth*, which she thinks is existing reality of the work of art, is ever-enclosed, unrevealed, undisclosed, always withdrawn in itself. In her attempts to open the earth, she sets up the sculpted forms in opposition to the "world" which is open, the unhidden realm, engaging herself in strife. She

leaves the struggle unresolved because in the struggle, each element, *Growth* and *Decay,* carries the other beyond itself, painfully leaving her alienated. The gestalt mark on the work is the truth of the dialectical struggle that the artist has undergone.

On another level, the artist as individual and her monadic conception of the world, the primordial senses (Latika attempts at reification often, especially through portraits and heads), and the gestalt psychology are in direct confrontation with each other. Latika is fascinatingly successful in expressing the conflict by a superb touching of the two dimensions of the surface and the third dimension of depth, a unique method of modelling. Cowdung — a relatively fragile material — used in *Head,* surprisingly helps her to achieve a sensory stimulation of the primordial forms, whereas *Innocence* provides psychic stimulation and she makes a valiant attempt to schematize the monadic vision. In the early years of work (a phase of raw sentiment) Latika produced a series of half-literal, half-metaphorical works entitled *Steps* and *Steps of Success Leading to What?* Here all attempts at schematization of the monadic vision fail; in fact, she discloses a secret desire to escape from the outside world in the direction of the inner. All antagonism seems to have come to a halt. Here, the external world is subsumed into the internal through a quasi-metaphysical introspection: the futility of being. The steps of success emerge from the head (intellect?) creating an open-ended space; the head disintegrates in the process which is symbolic of disintegration of prevailing social values.

The dissolution of objects continues right up to the end of the 1980s with *Decay* and *Growth* as recurring themes accompanied by similar themes like *Death, Deterioration, Landscape,* and *Seascape.* It seems that Latika has been running along two tracks. While intensifying the process of dematerialization (with change of materials) even further in the realm of nature, she simultaneously tries to hold back the same process by returning to the body as if the body is intended to be separate from the environment. While most of her abstractions are drawn from vegetal nature (though they are not botanical exactitudes), it is surprising that she introduces the figure in *Growth.* This depiction of primordial essence of the figure lying in an amorphous state perhaps can be seen as a symbol of the primeval, suggesting an unlimited material substance residing in nature.

Perhaps it is evident by now that Latika's sculptural forms are caught in continual tension between integration and disintegration. This makes it difficult to detect evolutionary criteria in her art, even though she has consciously developed the monadic concept all through with minor deviations now and then. It is difficult also to trace the roots of her monadic vision. There are no statements which can relate her to any socio-political ideology; perhaps there is a family ideology?

The biological orientation in Latika Katt's sculptures makes them appear plant-like, rock-like, or animal-like without being representational, and convincing enough to name them as vitalistic. As such her work has more to do with the intimate needs of sensuous, visual tactility than with anything else. She tries to solve the craving for organic presence by some restricted traditional means: mass, form, and surface. Hence, her art is primarily an art of metaphor and not an actual demonstration of structural principles. This factor gives her works a unique place in the Indian art scene.

From Romantic Isolationist to Democratic Artist

A radical change takes place in Latika's oeuvre with the introduction of the *Sati* series of sculptures in 1987. This forces us to abandon the fiction of anthropologically valid developmental constants in art. The creative surplus in the artist already offers the advantage of keeping her range free of arbitrary determinations. The fact that she sets no final point unflinchingly proves that she indeed possesses the quality so important to her — that of independence. In the *Sati* series she achieves two things: instead of giving touches to the material she makes visible how the world touches us, and secondly, abstraction is advanced to become the most realistic method of representing reality.

The obvious result is that the gestalt marks are withdrawn, the authorial identity vanishes; instead, a collective social consciousness is recognized. The base eventually withers away and finally, "I am my body" is replaced by the "other". Removing herself from the earlier struggle between the earth and the world she now engages herself to place the "earth" (closed, hidden) upon the "world" (open, unhidden). In other words, what she tries is to reveal the earth through the world. Strategies of sculpture and strategies of being are fused in her fascinating pursuit of truth in art.

The *Sati* series, done in relief in small and medium sizes and brilliant in technique, firmly establishes a visual language, a mix of advanced abstractionism and minor narration. The suggestion of a burning pyre with a doll-like figure in the narrow gap is an attack on the traditional sati funeral ritual as well as its contemporaneous happening. Latika succeeds in elevating these reliefs beyond history by decidedly rejecting representation of the historical personality in the form of Roop Kanwar. In another relief there are friezes of the nobility who perpetuate the sati system. They are placed below the focal point which has the suggestion of the burning pyre. The doll-like figure or figures (representing probable satis) exist on a different level of meaning; the intention of the artist is to create a multi-dimensional, imaginative world that culminates in evoking a significance that goes far beyond the obvious. The meaning is so

precise that no guessing games in apprehending them can be allowed. From a romantic isolationist to a democratic artist, a "solidaire, solitaire" — that is the exact nature of Latika Katt's transformation as an artist.

Notes

1. Ancient intromissionism answered the question of what form of contact between the observer and object permits vision, by postulating a contact mediated by its mirror image or by artificial reproduction of its appearance. It served, paradoxically, both to explain vision and to express scepticism with regard to the power of the senses. Alhazen (*circa* 985-1039) devised an intromission theory which incorporated the concept of radiation of light into the eye. It was based on the principle that from each point of a coloured body, illuminated by any light, issues light and colour along every straight line that can be drawn from that point.

Alhazen's punctiform analysis of the visible object was directly based on Al-kindi's punctiform analysis of the luminous object. The first serious student of optics in the Islamic world, Al-kindi (d. *circa* 866) was an extramissionist. He rejected intromissionism, which, he believed, contaminated all visual theories except the Euclidean, because it attached no importance to the spatial orientation of the visible object with respect to the observer. Such a theory of vision he thought, was bound to fail to provide any explanation of the different aspects of, say, a head seen in profile and full. In short, intromissionism did not appear to accommodate the laws of perspective.

Descartes (1596-1650) revolutionized visual theory by questioning the pair of analogies which had dominated this theory since its inception. Advocates of the first analogy suggested that seeing the world was rather like seeing pictures of it. Advocates of the second analogy compared vision to the use of a walking-stick, the air transmitting an impression of the visible object to the eye rather as a walking-stick enables us to find our way around in the dark by transmitting touch to the hand. Descartes rejected the pictorial analogy in favour of the walking-stick analogy which he manipulated to formulate his theory of depiction.

Descartes believed that just as nothing travels to the blind man through his stick, no form enters the eye of the sighted. He wondered how images of objects could be formed, received by the eyes, and transmitted to the brain. He suggested that the mind could be stimulated by signs and by words, which, unlike pictures, do not resemble what they represent. And besides, no picture could resemble its prototype entirely; otherwise, it would not be a picture, but the thing itself.

Bibliography

Battock, Gregory (ed.). *Minimal Art — A Critical Anthology.* 1968.

Burnham, Jack. *Beyond Modern Sculpture.* London, 1968.

Cassirer, Ernst. *The Individual and the Cosmos in Renaissance Philosophy.* Philadelphia, 1972.

Ferkiss, Victor C. *Technology Man — Myth and Reality* . 1969.

Gombrich, E. H. *Art and Illusion.* London, 1960.

Harper, Philip Brian. *Framing the Margins.* 1994.

Hegel, W. F. *The Phenomenology of Mind* (translated by J. A. Baillie). New York, 1961.

Heidegger, Martin. *Philosophies of Art and Beauty* (translated by Albert Hofstadter). New York, 1964.

Herding, Klaus. *Courbet — To Venture Independence* (translated by John William Gabriel). 1991.

Hiriyanna, M. *Essentials of Indian Philosophy.* 1973.

Hyman, John. *The Imitation of Nature.* U.K., 1989.

James, Philip (ed.). *Henry Moore on Sculpture.* 1966.

Kemal, Salim and Ivan Gaskell (eds.). *The Language of Art History.* U.K., 1991.

Marcel, Gabriel. *The Mystery of Being.* 1960.

Nietzsche, Friederich. *The Birth of Tragedy and the Geneology of Morals* (translated by Francis Golffing). New York, 1956.

Oizrerman, Theodore. *Dialectical Materialism and the History of Philosophy.* Moscow, 1979.

Panofsky, Erwin. *Renaissance and Renascences in Western Art.* New York, 1969.

Read, Herbert. *The Philosophy of Modern Art.* U.K., 1952.

Wolfflin, Heinrich. *Principles of Art History.* New York, 1932.

Zis, A., T. Lymbimova, and M. Ovsyannikov. *Problems of Contemporary Aesthetics.* Moscow, 1984.

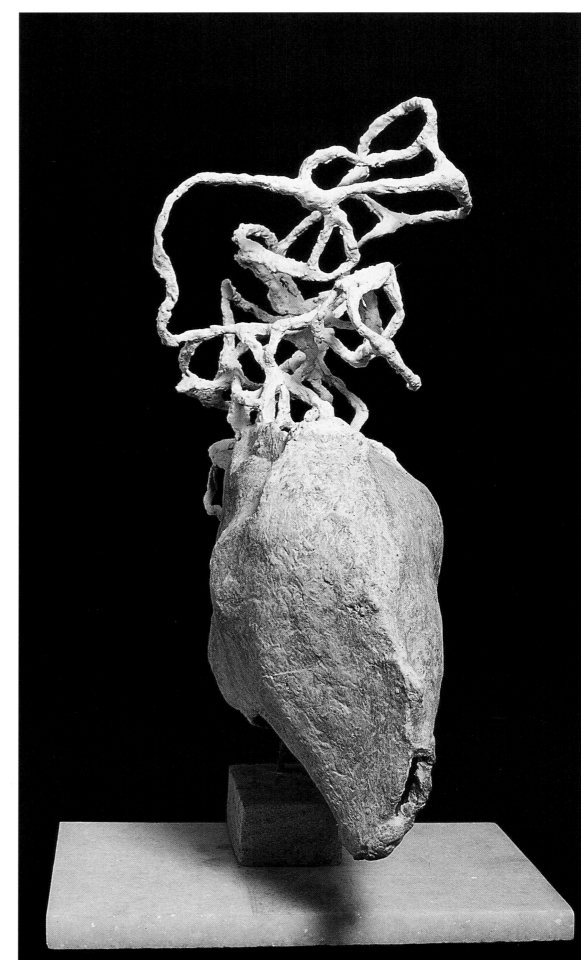

Growth-Head. 1993.
Papier mache; lifesize.
Human forms are invested with biomorphic and vegetal associations.

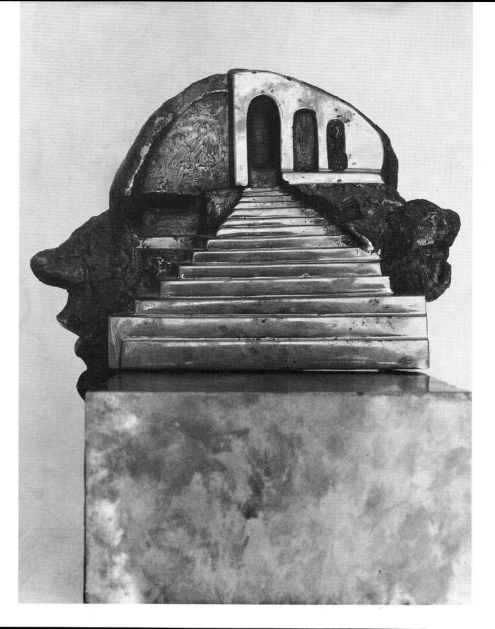

Steps of Success Leading to What? 1975.

Bronze;
45 x 45 x 30 centimetres.
Collection of the National Gallery of Modern Art, New Delhi.

A form inspired by the ruins of Tughlaqabad, it questions the value of worldly success.

Landscape. 1992.

Cowdung and wood.
75 x 75 centimetres.

Latika experimented with available local materials.

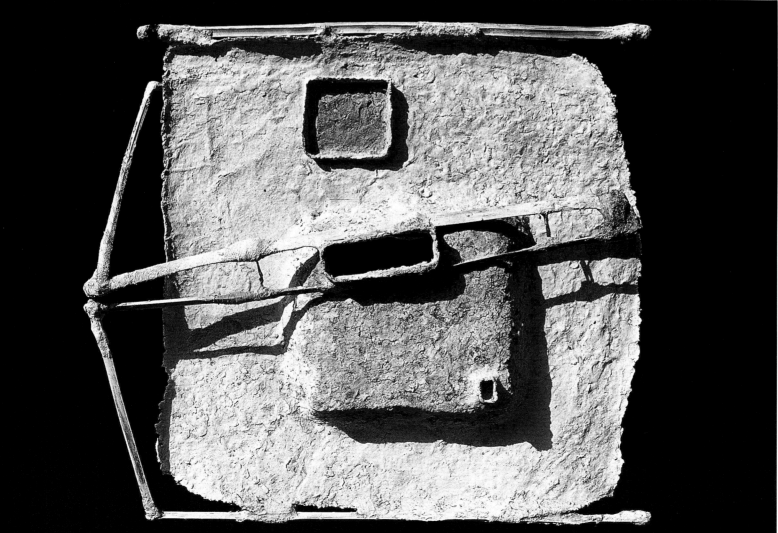

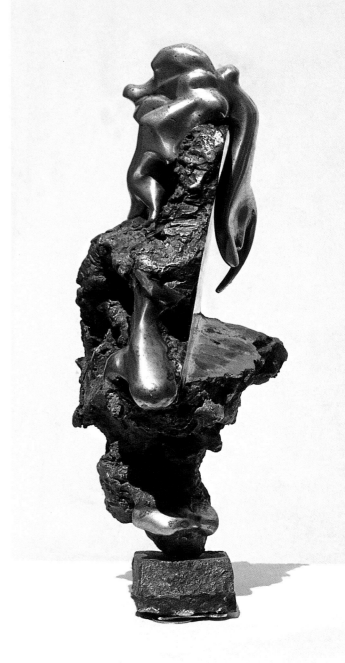

Deterioration. 1973.

Aluminium and brass;
30 x 20 x 20 centimetres.

Merging into nature, the
disintegrating human head
becomes soil for a growing
vegetal form.

Growth. 1991.

Ceramic;
135 x 75 centimetres.

Ceramic, a fragile yet strong
form, is used to depict the
continuous process of growth.

Deterioration III. 1989.

Wood;
60 x 30 x 30 centimetres.

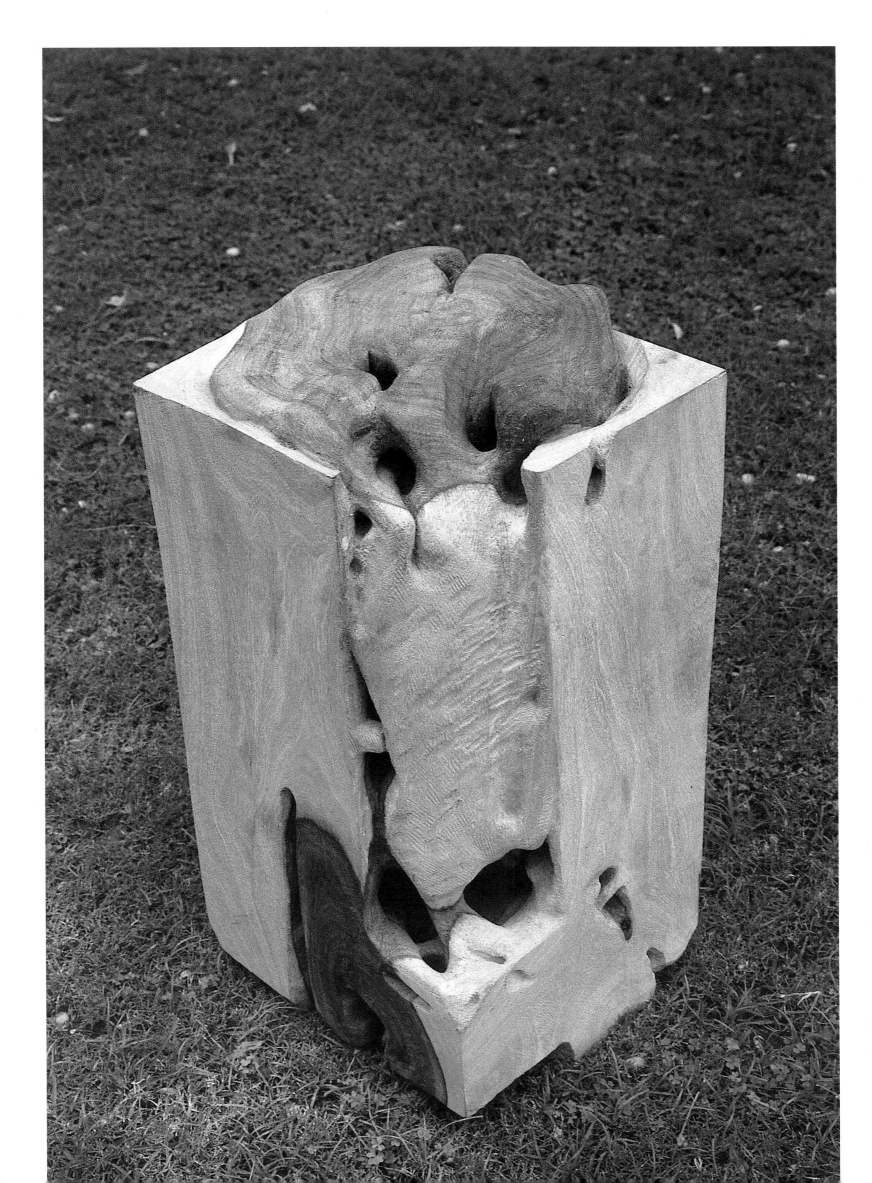

Navjot: Of Response and Responsibility

Chaitanya Sambrani

Prologue: Bombay that is — that is not [1]

A prismoid black grille lies on the floor, each section containing a plain plaster head, distorted but otherwise devoid of character. Another head lies discarded in front of it — an unassimilated outcast. An unframed square of canvas presents an impression of conflict and destruction in blacks and greys on the wall directly above. To the right, an eye-level structure of pigeonholes contains nine more heads, this time colour-coded to uniformity with the boxes/high-rise: order, hierarchy.

U nder these is a single "portrait" of anguish, followed by quotations from the works of admired Bombay contemporaries on small squares of framed glass. A printing roller carries impressions of a stubborn, part-effaced past, together with readymade frames and photocopied reproductions spilling out of a box: the apparatus of history making, of reproducing images and ideas mechanically. An apparatus that sustains the mythical frameworks which constitute the life-forms of urban environments.

The Argument

The preceding description relates to part of the work that Navjot had put on display at a recent exhibition at the Jehangir Art Gallery, Bombay, that included the responses of seventy-four contemporary artists to the metropolis. This work itself comes at the end of more than two decades of sustained and much deliberated practice, a period which has seen the gradual emergence of an acutely honed and committed subjectivity. It has not been an easy development; moreover, it has been a process that raises issues that I believe are of interest to the student of contemporary art.

This essay attempts to locate Navjot's work in three broad, interlinked frames, implying that it is not with discrete but with intersecting sets of ideas that I propose to deal while writing in response to her work. The first frame seeks to situate Navjot's work in its specific historical circumstances, namely the "political economy" of art production in independent India. The second as an adjunct to the first deals with the idea of political commitment and responsibility in cultural production, increasingly called into question in recent times. This would comprise a set of problems perhaps universally applicable to art practice in the late-capitalist/globalizing scenario of the late twentieth century. The third frame relates to a women's art. An interplay of desire, difference, and power as immanent configurations marks out new territories of being and of working.

I have no Fate Lines — Thank God. 1995.
Painted wood sculpture; 84 x 102 x 89 centimetres.

From the series *Images Redrawn,* Navjot here imbues her subjects with an iconic power, even as they interrogate the existing power structure.

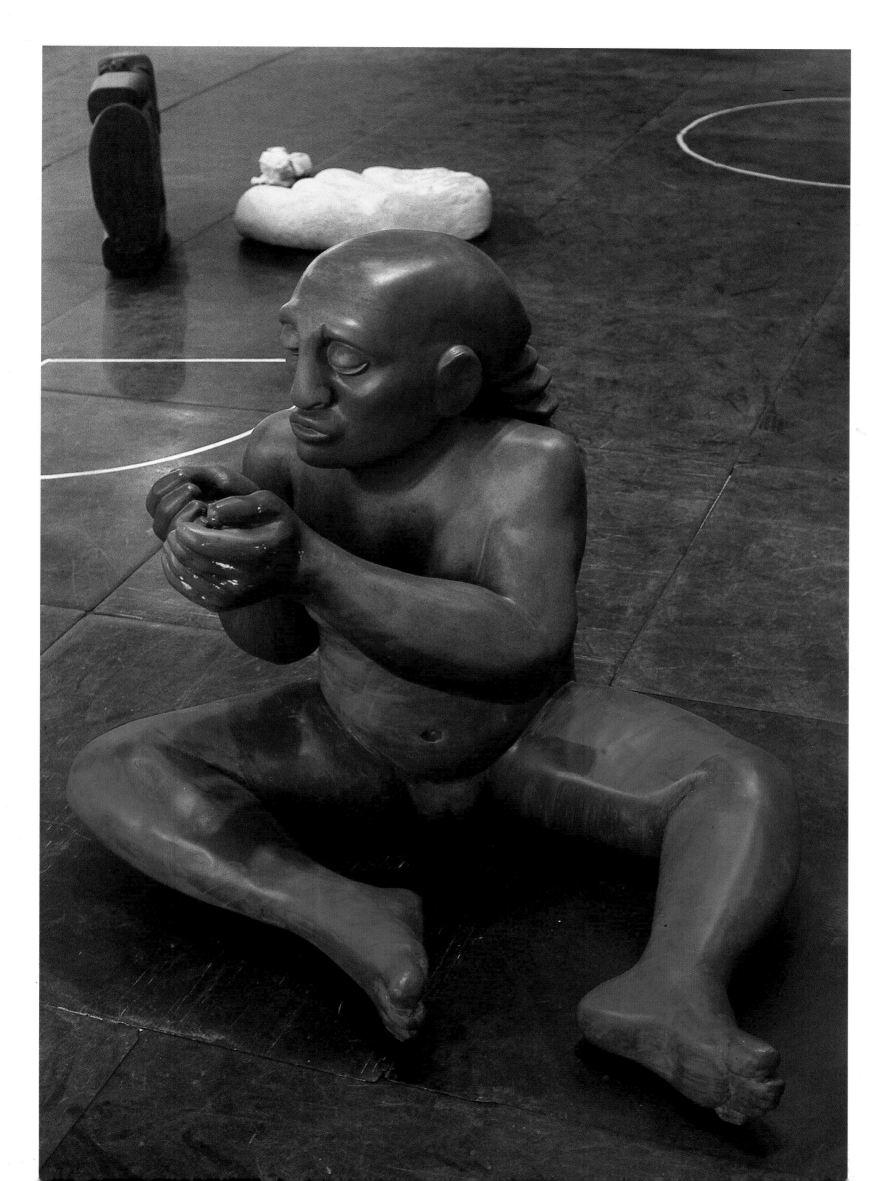

Images Phase II. 1994.

Acrylic on paper;
27.50 x 37.50 centimetres.

Navjot takes a fresh look at norms of "acceptable" behaviour by depicting different aspects of female sexuality.

Bombay that is — that is not. 1995.

Multi-media installation displayed at the Jehangir Art Gallery.

The artist's comment on anonymity and violence in the city, it was among the responses of seventy-four artists to the city of Bombay.

These, when seen in the context of an almost total male domination in the twenty years after Independence that usher in and consolidate modernist enterprise in Indian art, thereby come full circle to issues laid out in the first frame. The latter two frames involve a sort of theoretical contextualization; indeed, this is implicit in the very act of a writer "framing" the artist's work. As such, my concern with an enumerative/biographical account is secondary inasmuch as an element of subjective choice informed by these "framings" comes into play while dealing with Navjot's work.

The First Frame

Modernism as a set of values in the context of independent India has remained a contentious issue, whose genesis and development have been far from smooth and whose import is perhaps still open to debate.

". . . the characteristic feature of Indian modernism . . . may be that it is manifestly social. That is to say modernism may be seen to be contingent on the function of modernization, giving modernity itself an expressly historical rather than a mainly ontological mission."[2]

Kapur's argument in the context of modernist enterprise in Indian art speaks of the task of national-self-representation that was addressed particularly by artists of the first generation after Independence, especially by M. F. Husain, Satish Gujral, F. N. Souza, K. K. Hebbar, et al. Another direction stemming from this generation was that suggested by the work of Akbar Padamsee, S. H. Raza, and Ram Kumar after their contact with certain areas in the post-war European aesthetic. The late 1950s and the early 1960s saw a shift in affiliations to recent trends in American, Italian, and

Spanish art; and throughout the 1960s a proliferation of tendencies running essentially counter to "progressive" modernism made their presence felt on the scene; language, indigenism, and authenticity became the issues around which a polemic was set up. Simultaneously, there was a shift and expansion in patronage for "modern art" with the emergence of an Indian clientele displacing European and American buyers and with several new galleries opening up the market.

All along, though, and in spite of early Indian modernism's all too frequent references to the life of the nation in all its guises — from saints to labourers and from riots to transcendence — the concept of art as an economic institution and the role of "The Author as Producer"[3] within this institution remains, at best, partly acknowledged. There is rarely more than notional solidarity with the peasants and labourers who are the object of representation in much of the work produced by the first

generation of artists after Independence.

Navjot (b.1949) belongs to a generation which, as it emerged from the J. J. School of Art in the early 1970s, was marked by its almost singular isolation from the raging debates about authenticity and identity current at that time. A general lack of historical reflexivity during her student days resulted in a somewhat ironic freedom from an anxiety of influence. As if by default, Navjot was able to sidestep, albeit unknowingly, questions about indigenist positions in a truly independent modernism.

It is also important to note that most of the work during the first twenty years after Independence and virtually all of the pivotal interventions in Indian art during that time came from male individuals or groups. Even in the case of the few women artists practising in the 1950s and 1960s — Pilloo Pochkhanawala, Nasreen Mohamedi, and the early Arpita Singh, for instance — a notion of women's art is not arrived at, at least not with a conscious,

feminist stance. It is only in the 1970s that it becomes possible to speak of a conscious oppositional intervention in the male hegemony of modernism; and even with respect to Navjot's generation, such a consciousness is not always immediately apparent.

The Second Frame

Links Destroyed and Rediscovered, an installation with paintings, sculptures, screen-prints, films, and music that Navjot put up in 1994 at the Jehangir Art Gallery, foregrounded an issue that concerns the role of the creative individual in our circumstances, where the scale and frequency of escalating strife are matched only by the growing apathy about them. The task of remembrance then, especially that of unpleasant events, becomes that of an increasingly embattled subjectivity that seeks by way of its refusal to forget, to preserve a modicum of sanity that is creativity.

"It is the responsibility of the intellectuals to speak the truth and to expose lies. This, at least, may seem enough of a truism to pass without comment. Not so, however. For the modern intellectual, it is not at all obvious."[4]

The import of Chomsky's statement becomes clearer once an analysis is undertaken of the multilimbed apparatuses for the production and propagation of lies that "civilized" societies have incorporated within themselves. Consider, for instance, the employment of the might of the state towards the persecution of "non-Aryan" peoples in Nazi Germany, and later in the United States, "the land of the free", in the context of the Vietnam holocaust. It would be possible to cite quite a number of instances of such falsifications from our own circumstances as well, from violence against individuals who dare to challenge the latent fascism of policy/dogma, to women being declared goddesses after being ritually murdered, and on to government-sponsored

rewritings of history. And all over the world the patriarchal structures of commercial expediency, social conventions, religious injunctions, and morality have been working towards a perpetuation of falsehoods about fully one half of humankind.

What may the role/responsibility of the artist be in a situation where acceptable virtue seems to consist solely in getting assimilated into a mainstream culture and in subscribing to its contentions, however untruthful? What, further, is the stand one takes when the contentions of the mainstream are increasingly in conformity with the propaganda operations of the state-corporation nexus in this age of global capitalism? These are some of the issues Navjot has sought to address in her work. Answers have not always been readily at hand for her, and not always without inherent contradictions; however, the process itself throws light on possibilities for practice.

The very magnitude of an installation such as *Links Destroyed and Rediscovered* (occupying the entire space of the auditorium at the Jehangir Art Gallery) is significant; it speaks of a choice that Navjot made in terms of the material strategy through which to address her concerns. The installation consisting, among other things, of hundreds of metres of plastic pipe threaded through wooden frames over two metres high and painted panels on the walls did not represent solely Navjot's attempt at making her

Links Destroyed and Rediscovered. 1994.

Multi-media installation with paintings, screenprints, film, and music;
15 x 9 x 2.1 metres.
Installed at the Jehangir Art Gallery.

This was the artist's effort in collaboration with a musician and two filmmakers, to come to terms with the tragedy of the riots in Bombay in 1992-93.

statement about a society in the stranglehold of violence. It also stood for the concerted effort of a collective in that it combined her work with that of three of her women colleagues. Neela Bhagwat composed and performed the *bandish* accompanying the work, and films by Teesta Setalvad and Madhushree Dutta were played in tandem on a pair of video monitors. What emerged was not merely an expression of anguish and protest, but an affirmation of life implicit in the second half of the title itself, an affirmation expressed in a faith in collective effort and in the way thin lines of red plastic — the life-blood of the city — extended themselves symbolically over the landscape even though their outer cover of black was destroyed. In terms of Navjot's own practice *Links Destroyed and Rediscovered* represented a significant resolution of concerns that she had been exploring throughout her career, while at the same time marking her most ambitious experiment with materials and scale.

Navjot's involvement with an ideologically motivated set of artistic choices has its origins in the early 1970s. She recalls her years as a student at the J. J. School of Art (1967-72) as having been a time of little ideological orientation. The few class discussions with colleagues and teachers and the periodic visits of practising artists like V. S. Gaitonde, K. K. Hebbar, and especially Akbar Padamsee were a source of stimulation for her in what was otherwise a situation of a general lack of systematic understanding of world art. The general tenor of those years was rather one of an isolated linguistic search for self-expression; little thought was given to questions regarding tradition, history, modernity, and the complex relationships between art practice and social phenomena.

A person of great importance in the development of an ideologically oriented position in Navjot's work is

Altaf whom she met during her final year at the J. J. School, and whom she married in 1972. It was through him that she was exposed to Marxist social theory and to related values in art practice. During these years of formative political commitment Navjot taught in a school for physically challenged children (1972-74), in a mobile creche (1974-77), and later at several other schools in Bombay. As her commitment to an art rooted in a people's movement solidified, so did her determination not to show at private galleries. The only shows she participated in during this period (often jointly with Altaf and other friends) were either in public galleries or in communities where her work with the Progressive Youth Movement (PROYOM) took her. Navjot worked with PROYOM from 1974 to 1979, and during this period associated rather more with student activists than with artists. These were years of optimism bordering (in retrospect) on absolute belief in a classless society, a faith bolstered by the general feeling of impending and inevitable revolution.

Linguistic choices during the 1970s and early 1980s were as if a corollary to the postulate of a people's art: clarity of form along with a concern with a correctness of theme characterizes the works of these years. There is an eschewing of complex structures in favour of a clear, sparse grid-based composition emphasizing readability, at times even at the risk of becoming literal. A lot of this work is in black and white, a choice dictated partly by material and economic constraints and partly by easy reproducibility which would make it possible to screenprint it. Several of her specially done illustrations were published in the PROYOM journal, *Lalkar*, edited by Narendra Panjwani.

The grid as a structuring device is an interesting element in Navjot's work, one that underlines her basic compositional strategy right from the mid-1970s to the present, growing into a more obviously "constructed" three-dimensional form as in the case of her

recent work. The presence of the grid has two significant corollaries, the first formal and second, ideational. An artist Navjot has always admired is Nasreen Mohamedi, Altaf's sister. On the face of it perhaps not much could be said for an empathetic relationship between their work, the one seeking to integrate explicitly stated ideological belief with formal exploration, the other embarking on an ascetic practice of minimal compositions. Nevertheless, Nasreen's powerfully magnetic ruminations on line and space have had a visible impact on Navjot's compositions. On the ideational side, a grid could imply a mode of structuring reality, thereby attempting to give that structure a charge; an edge to be utilized for her discursive purposes.

Me, Myself (1978) marks what I believe to be a watershed — here for the first time, the self-image appears in Navjot's work in juxtaposition with elements of the world that she is looking into. The presence of a self-image at the edge of the frame remains a vital motif in Navjot's work till as recently as 1993. Me, Myself does not merely introduce a new motif; it marks the beginning of a new, more mature phase in which her formulations with regard to external phenomena have a self-reflexive consciousness. There is a definite shift in direction here, moving towards greater introversion, interrogating the position of the self within, even as it interrogates relations between entities in the world without.

I have noted above that the process of formulating positions for an ideologically motivated practice has never been a smooth one for Navjot. It seems pertinent at this juncture to point to an important characteristic of this process: all her negotiations with structures of theory are carried on at the basic level of a dialogue with the present circumstances of herself, not with a more abstract notion of the self, and this is a matter of conscious choice. This is a strength as well as a limitation, for, while a personal grounding

may make for a certain immediacy of expression, it may also lead to a solipsism with overtones of the literal as seen in the Beauty Parlour and Interiors series from 1982-83.

Another watershed comes with the Pavement series (1981) done at the time the A. R. Antulay government in Maharashtra demolished slums during the monsoon as part of the endeavour to beautify the city. The grid format is used here to create a severely skewed perspective, suggesting a sense of desolation and a feeling of being hemmed in amidst drastically receding space.

To my mind, these two works represent a preliminary resolution of Navjot's twin agenda of formal and ideational directedness; an agenda that underlines the more ambitious and complex works of the 1990s.

The Third Frame

The focus of this essay now broadens to take cognizance of specific issues of gender and of a conscious women's art. As we saw earlier, divergences from the mainstream in contemporary Indian art are already apparent during the 1960s in terms of a search for indigenist linguistic premises. A perspective informed with a consciousness of gender relations and marginality that Navjot and her women contemporaries bring to the cultural politics of Indian art comes, therefore, to be focused on already problematized territory.

Although an awareness of self-reflexivity is manifest in Navjot's work as early as 1978, an actual definition of a confrontationist mode of address with reference to a culture of male dominance makes its appearance in three series from 1986-87 titled Confrontations, Process of Self-Analysis and Actress. These are marked by references to the violated social and personal space of the female subject, often through the direct representation of an intrusive male presence.

It is in this last decade that Navjot starts

frontally pitting her work against questions regarding sexuality and violence. The body in this perspective does not remain the traditional site for the exercise of power, but is posited as an instrument of resistance. Figuration, especially with respect to the female body, makes reference to the savaged, subhuman figures of Francis Bacon — an artist Navjot admires greatly — while deliberately using roughly modelled, distorted figures that resist objectification, with an invasive male presence highlighting their abused status.

Navjot frequently represents women as archetypes, as fertility figures from prehistoric art, or as militant, conquering images of goddesses and heroines — Durga and the Rani of Jhansi, for instance — that form a part of her cultural inheritance. The use of the archetype is in itself a loaded and contradictory choice. For, archetypes such as these frequently represent the patriarchal strategy to typecast women, thereby rendering them assimilable into the mainstream.

Also inscribed into a palimpsest of images are symbols of womanhood that trace their lineage to the various traditions of world art and theology: the woman represented by luscious fruit or by stereotyped, reified images of motherhood. In her more successful works Navjot is able to pick these images up, to use them to transgressive effect. The apples are decayed, eaten away as though through years of virulent action, a "Madonna and child" is altered to a young woman with a girl child. Subversions are made with regard to "acceptable" norms of representation through these and through overt references to "deviant" behaviour like lesbianism and masturbation: Images of Women as agentive presences in a world of experience sealed off from the male gaze.

The collective title of Navjot's recent works is telling; Images Redrawn marks a return in more ways than one, for these works, while pointing to her own Images of Women series (1993), also indicate her intervention in the

historical process of the representation of women. The power apparatus of society is sustained, among other ways, through strategies of representation: the right to represent in a certain manner being translated into the right to possess, to consume. It is to the politics of representation that Navjot's work addresses itself. Her sculptural redrawings of women's images carry a certain monumentality of presence, an assertion of their occupation and dominance of their space, even as their silent, massive iconicity argues for a revision of structures of thought/ways of making that facilitate exploitation. In particular a work like *I have no Fate Lines — Thank God* speaks against a state of continuous subjugation under the legitimization of destiny. These images have been conferred a timelessness that goes hand in hand with a heroic presence, immutable representations of powerful beings that pose a challenge to those who venture to occupy the same space as them.

Notes
1. The title of an installation by Navjot, 1995.
2. Geeta Kapur, "When Was Modernism in Indian Art", *Journal of Arts and Ideas*, Numbers 27-28, 1995.
3. Walter Benjamin, "The Author as Producer", *Reflections: Essays, Aphorisms, Autobiographical Writings*, ed. Peter Demetz, New York, 1978.
4. Noam Chomsky, "The Responsibility of the Intellectuals", *The Chomsky Reader*, ed. James Peck, New York, 1987.

Flower Seller. 1976.

Pen and ink on gateway paper; 40 x 48 centimetres. Collection of Dr Zeenat Sadikot, Mumbai.

Navjot's strong political leanings towards a "people's art" are evident in her work.

Images of Women IV. 1993.

Acrylic on paper; 56 x 71 centimetres. Collection of Gallery Chemould, Mumbai.

The artist pays tribute to admired women: (left to right) Mother Teresa, Medha Patkar, Gangubai Hangal, Simone de Beauvoir, Joan Baez, Isadora Duncan, Neela Bhagwat, Nalini Malani, Geeta Kapur, Nasreen Mohamedi, Arpita Singh, Rekha Rodwittiya, Arpana Caur, Kathe Kollwitz, Amrita Sher-Gil, Frida Kahlo, Jayashree, followed by a self image.

**Tribute to a Painter
I Admire.**
(For Francis Bacon). 1992.

Acrylic on canvas;
183 x 122 centimetres.

Arpana Caur: Confronting Womanhood

Gayatri Sinha

Cut off from access to the high realm of History Painting, with its rigorous demands of anatomy and perspective, its idealised classical or religious subjects, its grand scale and its man sized rewards, of prestige and money, women turned to more accessible fields of endeavour: to portraits, still life, and genre painting, the depiction of everyday life.

— Linda Nochlin, *Woman, Art, and Power and Other Essays*, 1989

When the painting of "everyday life" by a woman assumes "man-sized" proportions, and a wilful dismantling of aesthetics, then painting becomes a mission of redressal. Arpana Caur's position in contemporary Indian art is unambivalent, her trajectory unbroken. Perhaps among all her contemporaries she assumes the feminine viewpoint to buttress her chosen position as social commentator. Yet, this point of view continually changes and defies Arpana's placement within a prevailing feminist credo. Most often hers is the assumed virginal standpoint, an unmarked *tabula rasa*, a blank slate, compelled to confront an environment of uncertainty. Her female protagonist freely mutates, to appear as a girl, as a young woman on the threshold of life, a widow, a woman past middle age — even Prithvi or Prakriti, Mother Earth herself. In this sense, Arpana uses many of the categories of the *nayika bhed* poetic and painterly convention from the innocent *taruni* to the middle-aged *prauda*[1] and completely divests them of romantic notions. This is especially marked since her art has been enriched through a free-wheeling exploration of Indian miniature painting convention.

Tentative Formulations

Arpana's introduction to painting came via sculpture after her tutelage under B. K. Guru. In the main, however, she is a self-taught artist. Her earliest exhibited paintings of 1974, of heavy muscular androgynous women, are in a sombre palette. From the outset, she located her figures in the Punjabi milieu adopted by Amrita Sher-Gil, of women with their veils and thick khadi salwar kameez — textures on which the *phulkari*s of Punjab could be embroidered. However, Sher-Gil's havelis and open spaces become congestive city pavements and darkened corners; and Sher-Gil's melancholic figures of the "other" Indian are appropriated by Arpana as the tragic self. The relative isolation of the small urban family and the complexity of Arpana's own situation, of a fraught childhood with divorced parents is seen in early paintings of her mother, her grandfather, and herself, of the family selectively severed and then rejoined.

Green Circle. 1994.

Oil on canvas; 175 x 120 centimetres. The young girl is the symbol of hope and vulnerability in Arpana's work.

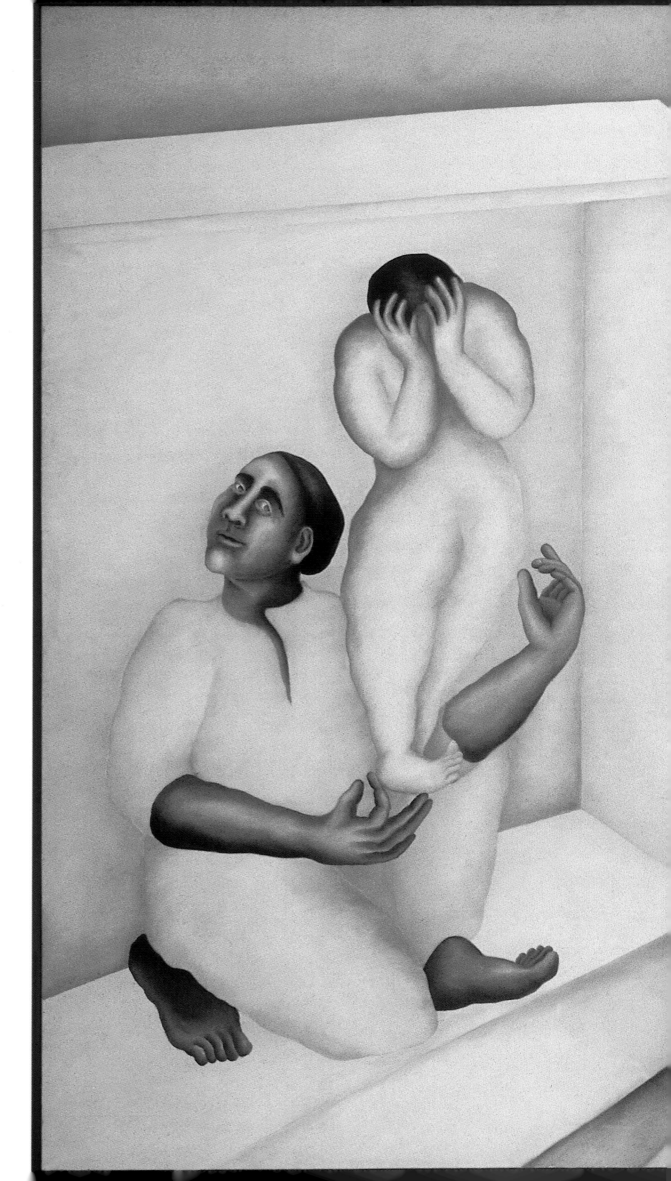

Juggler. 1982.

Oil on canvas;
150 x 270 centimetres.
Collection of the National
Gallery of Modern Art,
New Delhi.

A direct comment on the man-
woman relationship in which the
woman is rendered an object of
play.

This biographical, even cathartic, strain proffered with little self-consciousness was to recur with engaging directness during the first decade. *Women in Interiors* of the mid-1970s was an early series of paintings of women hemmed in by advancing, claustrophobic city walls and the crowded city skyline. The body, like the city, was treated as susceptible to encroachment and physical pollution with the eventual threat of effacement. These paintings also plotted a personal graph: Arpana and her mother lived in Delhi's crowded Patel Nagar, where draping the body was a necessary shroud of protection against the constant frottage of bodies on the dense streets. They then shifted to a working women's hostel where the lingering memory is of a frustrated, inchoate sexuality among the inmates. This continuing sense of homelessness inspired her mother Ajit Caur, to write her Sahitya Akademi award-winning work *Khana Badosh* (Homeless).

Arpana's means of protecting the woman/feminine force (and she assumes a protective role) is to desex her. Large and strong, she looms like an androgynous Bahubali; earth-like, her contours are akin to those of the undulating land. There is no hint of an expressive sexuality; woman and nature are both symbiotically tied in a circle of perceived threat and uncertain renewal. Arpana recalls herein an analysis on the poetry of Emily Dickinson: "She uses feminity to drive femaleness out of nature Dickinson endorses feminity's artificial or rather unnatural character; it is both of and against nature, since spring always loses to decay."[2]

Significantly, doubt and uncertainty on the personal plane are outwardly cathected as generalized concern. The individual and the world become interchangeable. The rape of Maya Tyagi in 1979 provoked Arpana to paint this widely reported but ill-addressed incident. The widows of the Chasnala mining disaster as victims and figures of social neglect confirmed her identification of subject. As the political situation of the 1970s became volatile, guns, policemen, and violence as in the series *Custodians of the Law* made their presence. These combined at this stage with her reading of the aesthetics of Basohli painting, a seventeenth and eighteenth century hill school. Arpana's identification of Basohli for its strong colours and spatial division was especially apt, for among all the miniature painting styles Basohli has a recognizably strong feminine type.[3] Whether *devi* or *nayika*, the woman in this hill school is painted with a strength that belies the demure, delicate *nayika* more usually seen, and Caur adopts the passionate tone, if not the sensual evocativeness of figures in Basohli painting.

Elements of Her Art

Arpana's concerns as an artist peak at two ends of a spectrum. On the one hand, there is the philosophic yearning of the individual to locate the self within a larger karmic logic, and on the other, a passionately felt response to the rapidly changing exigencies of a violent political reality. Punjabi literature was a natural influence; writers like Shiv Batalvi, Amrita Pritam, and Krishna Sobti were visitors to their home. In her readings, Sufi mysticism and Nanak's teaching of a *"grihasta udaasi"*, located within the Sikh philosophy of *udaasi* or melancholy, are especially relevant: of committed action even as the self or soul is uninvolved, even disillusioned. Notably, writing in Punjab flourished during the ravage-inflicting raids of Ahmed Shah Abdali, from 1757 to 1767. Waris Shah's *Kissa Heer* was written during those war-ravaged years, and it was such times that nourished composers like Bulle Shah and Ali Haider. Through her mother Arpana was exposed to the Punjabi writing tradition with its dominant strains of passion, philosophical mysticism, and *udaasi* which go back to one of the roots of early writing in Punjab. In the spirit of early Sikhism, her art is informed by both a reaction to violent repression, as well as the *bhakti bhava,* the feeling of religious devotion.

The body is like a pitcher of soft clay filled
 with sorrow.
It is made and unmade;
And each time it suffers.
This world is like a turbulent sea.
How shall we swim in it?
 — Raga Asa from *Hymns of Guru Nanak*.[4]

Arpana draws consistently on both literary and painterly sources of seventeenth and eighteenth century art forms.

In constructing her own forms, Arpana used Pahari miniature architectural forms in a prominent way with the series *Women in Interiors* (1975). The painting *The Change of Babes,* Guler, 1760 (Bharat Kala Bhavan, Varanasi) on the birth of Krishna was especially influential in her construction of an expressionistic architectural space. The high architectural walls that define the social space of the well-born *nayika* in miniature convention are redrawn by Arpana to bespeak the contemporary woman's stifling physical space. This series gains greater poignancy in contrast to Arpana's own later work of a woman's monumental presence in an unlimited landscape.

"Between Earth and Above"

The isolation of the individual in grief, creativity, even innocence, is a recurring theme. In the early 1980s a whole series was devoted to the subject of the *Missing Audience* (1981). The act of the artist singing alone, somewhat alienated, as in *Artist, Patron, Critic* (1981) or *Newspaper and a Woman* (1979) is early established. Alienation becomes more marked when the larger world encroaches. Lumpy

earth-like figures (reminiscent of Henry Moore) who contemplate a *Nuclear Game* (1980) or act as *Custodians of the Law* (1979) — large, imminent, and threatening — introduce the presence of a venal, violent establishment. Significantly, Arpana painted the common individual even while abstraction dominated Indian art; the common figure arrested in the act of dreaming, typing, or tweezing her eyebrows, are all painted with a warm humanitarianism.

The emotional or sentimental excess of these paintings and related aesthetic problems were seriously addressed in the early 1980s. The Pahari miniature tradition suggested its own solution; that spatial division can "edit" the narrative, and that the most violent acts of the beheading of Mahishasura, Putana vadha, or Kalia mardan are performed as an aspect of *leela* or play, lending the entire composition a dual *rasa*, muted in its violence. This duality became an inherent aspect of her work. It comes into direct play in the depiction of carnage, of the anti-Sikh riots following the assassination of Indira Gandhi in 1984. From an area of personal catharsis the focus shifted to the concerns of a community, and by extension to questions of race and humanity. Severed heads, heaps of corpses, and inconsolable widows gradually exhausted themselves to take on a more philosophical tone; man dominating man or in attitudes of selfish self-absorption became the recurring image in the series *World Goes On*. A painting from this series won her the Triennale award in 1986. As a natural apotheosis, Arpana followed up this series with the paintings *Widows of Vrindaban*, a moving comment on the forgotten white-clad, head-shaven widows who are destined to wait for an ever elusive Krishna. Deprived of their marks of feminine identification, they are compelled to play out a life in attitudes of prayer and waiting.

How should I tell you her condition
O lord of her life,

Krsna;
the blaze of her parting
now burns her so grievously that death
would be a blessing.

— Bihari, *Satasai*[5]

The *World Goes On* series was remarkable for its shift from claustrophobic interiors to the larger landscape, and for the levels of perception afforded by the earth/sky/water configuration. The quest for the elusive sky/water dimension of metaphysical yearning and dematerialized space becomes a recurring philosophic concern.

The grouping of figures of the miniature format is also adopted by Arpana for an interrogation of social hierarchies. Most often women in replica, initiated with the Vrindavan series, are used to drive home the social and individual dimension. The Hayanari device of seventeenth-eighteenth century Rajput painting, also seen in Orissan art — in which women are compressed into the body of a horse, or an elephant as in the Gajanari style, usually to bear a male patron on his sojourn — is subverted deliberately as an image of oppression. Still later, the woman figure appears with serial regularity. However, whereas in the miniature format the intent is decorative, in Arpana's hands the half a dozen women who appear single file, heading out of the picture's frame to nowhere in particular bespeak a faceless drudgery and monotony. Then again, she turns them out of profile to confront the viewer full face with a sightless, tragic gaze. In evoking the direct confrontational gaze, Arpana introduces a Brechtian note in her work. The references to myth, to the disappearing Krishna, distraught *yoginis*, and ecstatic Sufis is fractured by the confrontational gaze and its silent interrogation.

Here, in contrast the treatment of the male figure especially invites comparison. Just as the feminine grows and expands to assume archetypal proportions in her painting, the male has correspondingly shrunk and diminished. In the early stages man

appears as the *Juggler*, in subversion of the Chola period Shiva-Nataraja icon (who holds the deer and other life-forms on his fingertips), nonchalantly tossing about ball-like figures. In later years, the man is transfigured into a singing Baul, an indifferent Krishna, a gun-toting faceless policeman, and finally a nameless construction worker or tailor. Sometimes, as in her small gouache works, armed men crowd into a woman's body like busy spermatozoa, invasive within, and already potentially violent. Even within the chosen form of expressive distortion the figures are sufficiently naturalistic to create a strong emotional resonance. Notably the release of the confined woman finds a parallel in the gradual marginalization of the male figure, as he becomes the unknown "other", and from aggressor slips into the state of the victim of aggression in the paintings of 1984 and the nameless worker in the *Prakriti* series.

The City Betrays

In 1989 an exhibition organized by Sahmat, a cultural activist group, in Mangolpuri, an outlying Delhi slum, provoked her to draw in elements of the city's freewheeling mechanical and human detritus: cycles and autorickshaws, workers and their tools. They become a grey graffiti scrawl that busily works itself into a corner of her canvas, even as they are too insignificant to merit close attention.

Indeed, the city starts to mark its invasive presence. There is a progression from closed interiors to vertiginous landscapes, to approximate the crowded city of anonymous hard-pressed labour.

Arpana invariably paints serially; the earliest paintings in the series have an abrupt, cathartic quality — the symbolism is heavy while, as the emotional tempo wears itself out, the tone becomes more and more contemplative. The sight, one day, of an old Sikh tailor stitching women's sari blouses in a ramshackle tin shed shop prompted her to paint him. Repeatedly,

she returned to this image — of an old man spinning out sexy garments for nameless warm bodies. *The Body is Just a Garment* (1990-93) — the oft-repeated image of the weaver Kabir, who sang of the original weaver — became the recurrent motif in the series.

Sukh dukh doven kapde
Pahre aye manukh

(Happiness and sorrow are both like garments; we wear one, discard the other)

— Kabir

Clothes appeared to partake of the life force as they skimmed across space, fully suggestive of absent bodies (a device familiar in the work of the French artist Sophie Calle). Even as small drawings of garments continued to float across her canvases, the original concept mutated. Women embroidering, cutting a large leaf, like a garment symbolic of Prakriti herself, appeared in paintings like *Prakriti* and *Resilient Green*. From the socio-psychic image of the harried tailor, the artist's concerns now embraced ecology, a yearning for the elusive green and blue of a resting peace. Characteristically, the woman in Arpana is both Prakriti and faceless servitor — a mother pregnant with violent sons, and conservor — who patiently darns and embroiders. There is resistance in these ordinary stances. Arpana's use of the stitched blouses recalls Zarina Bhimji's installations of charred children's Lucknowi kurtas as a racial memory of the violent Partition. However, the image of women sewing quietly, within the acceptable parameters of feminity — an image challenged by women artists as one of moralizing domesticity — is in a way liberated by Arpana as the woman is placed outdoors, embroidering larger destinies. Instead of a feminine, income-producing function, it becomes a political comment on women's productivity. Arpana repeatedly uses the symbol of the embroidered

cloth to suggest several interrelated issues — the process of socialization of the young girl and the "veiling" of her body, the cloth as garment and winding sheet, and finally, as a symbol of the transience of life itself. The constant sense of the transience of time registers in her work; "Painting has given me a sense of relative completeness," says Arpana. Everything else is in a state of flux.

A recent work by Arpana, *Where Are all the Flowers Gone* (1995), brings together several strains in her work. Symbols of violence — guns, saws, sharp tools — coalesce in the nuclear holocaust. Commissioned by the Hiroshima Museum, Japan, this triptych contains the kind of progressive symbolism that Arpana has developed: of the figure surrounded by the potential for violence followed by large flowers, lush and life-like, and finally the evanescent blue of release. Arpana has for some years now begun to imbue elements of sky, earth, and water with greater metaphorical meaning. "I prefer Nature and Natural objects to People," said Frida Kahlo. In Arpana's work concepts of freedom, growth, and generation are reduced to patches of colour, notably green and blue, with the human being constantly striving between apparent reality and aspiration.

Arpana Caur's identification with a political voice that espouses feminist causes is perhaps one limited interpretation of her work. Arguably, like Kathe Kollwitz, she is a pointed commentator and like Kollwitz uses a restricted palette, large forms, and strongly expressive faces to comment on social events. Again, like Kollwitz, who was obsessed with "the themes of war, hatred, poverty, love, grief, death and struggle",[6] Arpana develops on the disjunction between maternity and motherhood: the one is likely to breed violence, rather than satisfaction. It is my contention that Arpana as a socially reactive artist, painting apparently representational works, juggles these categories: the social crisis

becomes a vent for personal anxiety. In her work she needs to abstract the real, even as she needs to blend the personal in the generalized. The question of the autobiographical content is never fully acknowledged, yet the emotional links with her women figures are strong. This is the statement of art as selfhood, and painting as a means of resolution. In that sense, the artist speaks with both a private and a public voice; in the effacement of the first lies the fulfilling cathexis of the second.

Notes
1. M. S. Randhawa, *Kangra Paintings on Love*, Publications Division, Ministry of Information and Broadcasting, Government of India, 1994.
2. Camille Paglia, "Emily Dickinson", *Sexual Personae*, Vintage, 1991, p. 658.
3. M. S. Randhawa, *Basohli Paintings*, Publications Division, Government of India.
4. *Hymns of Guru Nanak*, translated by Khushwant Singh, with illustrations by Arpita Singh, Orient Longman, 1991.
5. Bihari, *The Satasai*, translated by K. P. Bahadur, Penguin Classics, 1990.
6. Whitney Chadwick, *Women, Art and Society*, Thames and Hudson, 1990, p. 272.

Threatened City. Diptych.

Oil on canvas;
1.8 x 3 metres.

In her paintings of the 1970s the city is depicted as harsh and threatening. Gradually, the city itself is threatened by encroachment and the pressure of population.

Widows of Vrindaban.
1987.

Oil on canvas;
125 x 150 centimetres.

In reversal of the popular tradition, elderly widows rather than young *gopis* await the arrival of Krishna. The lush gardens of Vrindavan here breed knotted, stunted trees.

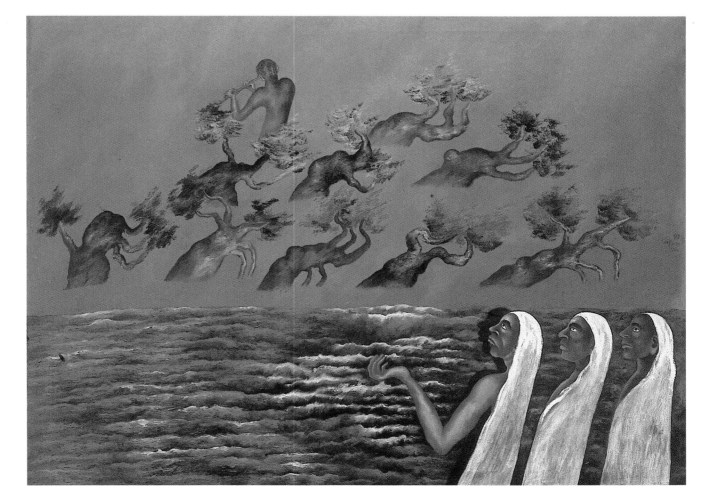

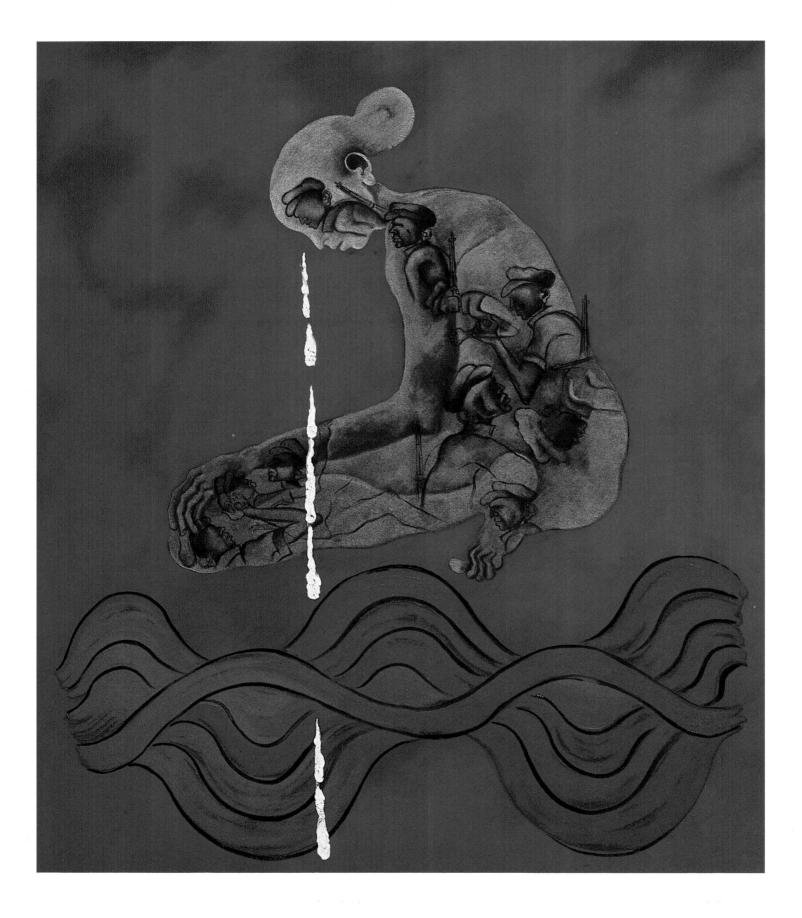

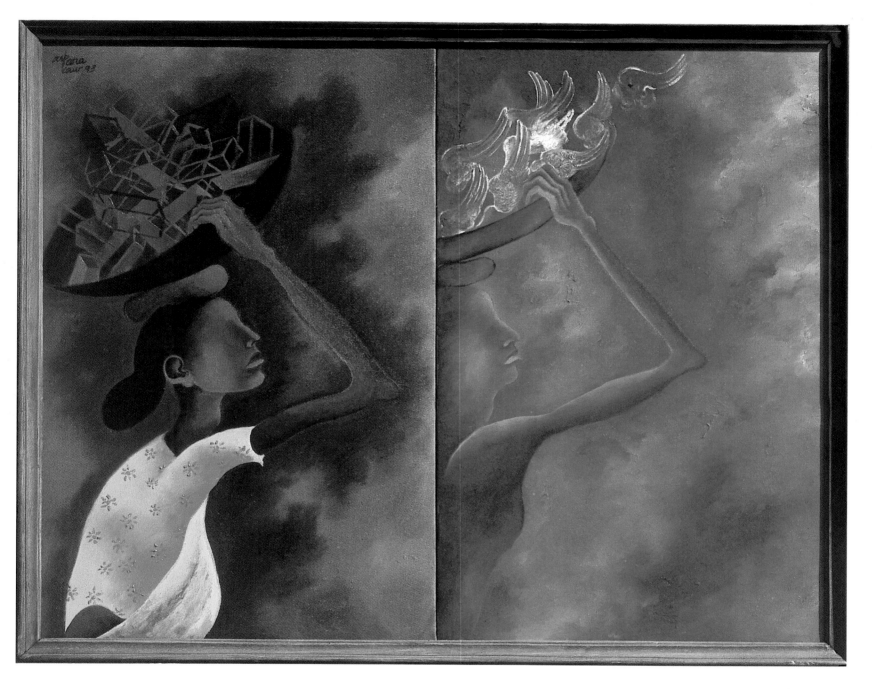

Yearnings. Diptych. 1993.

Oil on canvas;
90 x 150 centimetres.

Blue as the colour of release and
metaphysical yearning assumes
a symbolic presence.

Soldier's Mother. 1995.

Oil on canvas;
150 x 125 centimetres.

Violence, a common refrain in
the artist's work, here is seen as
inherent to the life process.

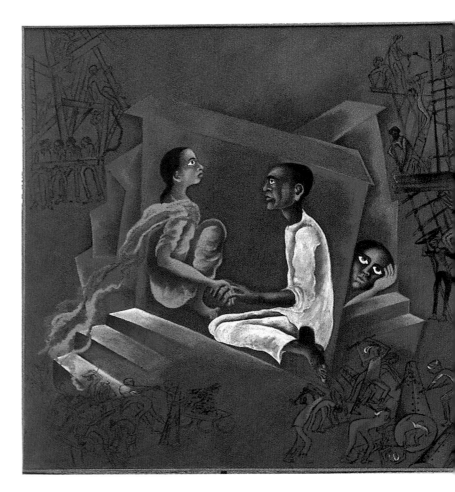

Where Are all the Flowers Gone. Triptych. 1995.

Oil on canvas;
1.8 x 3.6 metres.
Commissioned by the Hiroshima Museum of Modern Art, Japan.

Arpana uses the triptych format to juxtapose the ideal and the real, the individual pitted against violent reality.

Resilient Green.
Triptych. 1991.

Oil on canvas;
1.8 x 5.4 metres.
Collection of the Glenbarra
Museum, Japan.

Concern for the preservation of
ecology marks this work.

Index

Subrata Bhowmick, the Design Editor of this volume, was a graduate student of the National Institute of Design, Ahmedabad before studying in Europe and Japan. With 49 prestigious national and international awards to his credit, he is presently Creative Director with MUDRA, a leading Indian advertising company. Formerly Design Director with the Calico Museum, Ahmedabad, he is now Honorary Director, Kanoria Centre for Arts, Honorary Member, World Graphic Biennale, Czech Republic, and Ambassador of the International Trademark Centre, Belgium. His specializations are textiles, fashion, product design, and photography.